Setting Agendas in Cultural Markets

This book draws on agenda-setting theory to examine how cultural organizations relate to media in order to increase their visibility, valence and eventually build their public image. Most organizations have a keen interest in their symbolic presence because their media visibility influences public knowledge, perceptions and even behaviors. Diminished public funding, in combination with the global proliferation of cultural entities, creates a competitive environment, leading to a transformation of cultural industries. In this book, I scrutinize several questions: How do cultural organizations acquire symbolic significance? How do they become prominent in media content? Which mechanisms and processes should be examined by cultural managers as they set out to achieve salience? Is there a relationship between media and public salience? In other words, if an organization becomes symbolically prominent, in what ways is the public influenced, both in terms of perceptions as well as behaviors?

Philemon Bantimaroudis is a Professor in the Department of Cultural Technology and Communication at the University of the Aegean, Greece. He holds a PhD from the University of Texas at Austin, United States (1999). He was a Visiting Professor at Northern Michigan University, United States (1999–2000), the University of Cyprus (2012–2013) and an Academic Visitor at Cambridge Judge Business School, University of Cambridge, United Kingdom (2008). His research interests include media and culture and political and international communication.

Routledge Research in Communication Studies

1 Populist Political Communication in Europe
*Edited by Toril Aalberg, Frank Esser, Carsten Reinemann,
Jesper Strömbäck, and Claes H. de Vreese*

2 Setting Agendas in Cultural Markets
Organizations, Creators, Experiences
Philemon Bantimaroudis

Setting Agendas in Cultural Markets
Organizations, Creators, Experiences

Philemon Bantimaroudis

Routledge
Taylor & Francis Group

LONDON AND NEW YORK

First published 2017 by Routledge

2 Park Square, Milton Park, Abingdon, Oxfordshire OX14 4RN
52 Vanderbilt Avenue, New York, NY 10017

*Routledge is an imprint of the Taylor & Francis Group,
an informa business*

First issued in paperback 2019

Library of Congress Cataloging-in-Publication Data
CIP data has been applied for.

ISBN: 978-1-138-94468-8 (hbk)
ISBN: 978-0-367-87480-3 (pbk)

Typeset in Sabon
by codeMantra

To Katy, Christos, Pavlos and Anna-Julie

Contents

List of Figures and Tables ix
Foreword: Setting Agendas in Cultural Markets xi
Preface xv
Acknowledgments xix

Introduction 1
Leisure Time, Creative Industries and Urban
 Transformations 4

1 **Agenda-Setting Theory: A Brief History** 13
Agenda-Setting Influences at Different Levels 14
Fragmentation of Agendas and Specialized Interests 17
Organizations and Agenda Setting 18
A Shift toward Culture 19
What Drives the Agenda Setting Process? 21
Relevance and Uncertainty 22
Beyond the Need for Orientation 24
Cultural Agenda Setting: Motivations and Orientations 24
Are Cultural Experiences Relevant? 28
Cultural Uncertainties 30
Consumer Motivations in the Cultural Domain 33

2 **Cultural Markets, Organizations and Experiences** 37
Developments in the Cultural Domain 39
Cultural Industries and Cultural Theorists 42
Cultural Attributes 46
Cultural Economics 47
A Digital Culture 51
Culture and Competition 54
Culture in the Form of Texts 55
Cultural Convergence 59

"Rational Edutainment" and Popular Entertainment 62
*Concluding Remarks about Prominent Attributes in the
 Cultural Domain 66*

3 **Cultural Segmentation and Media Agendas** 69
 Segmented Agendas 71
 Geographic Agendas 72
 Demographic Agendas 76
 Lifestyle and Personality Agendas 82
 Popular and "Rational" Agendas 84
 Multiculturalism and Cultural Agendas 93
 Concluding Remarks 95

4 **Cultural Agendas, Digital Technologies and Media Platforms** 98
 The Transformation of Cultural Production 99
 A Record of Digital Transformations 101
 The New Agendas 104
 Promotion Agendas 105
 Content Agendas 111
 Technology Agendas 117

5 **Agenda-Setting Influences and Effects in the
 Cultural Domain** 124
 Cultural Hierarchies and Prominence 125
 Salience: An Evolving Construct 129
 Media Salience 130
 Public Salience 131
 What Are the Main Influences of Cultural Agenda Setting? 137
 Organizational Agendas and Media Agendas 143
 Cultural Agenda Setting and Future Explorations 145
 Third Level and Agenda Melding 147

 Epilogue 150

 Bibliography 155
 Index 165

List of Figures and Tables

Figures

5.1 Volume of searches on the Google platform for the
 Louvre, the British and the Vatican museums 134

Tables

1.1 Orientations and motivations for cultural consumption 35
2.1 The most expensive films of all times 47
2.2 Attributes of the cultural sector 61
2.3 "Rational edutainment" and popular entertainment 66
3.1 A typology of lifestyles, uses and gratifications 87
4.1 Significant technological innovations in movie making 121
5.1 The world's most visited museums, 2013 126
5.2 The world's most significant museums 126
5.3 The 25 best museums in the world, according to travelers 127
5.4 The most influential books of all time 128

Foreword
Setting Agendas in Cultural Markets

Contemporary expansion of the communication landscape creates significant opportunities and obstacles for cultural organizations and products. To reach their existing niche audiences or to expand those audiences requires a nuanced understanding of the plethora of communication channels now used by the public. Under the umbrella of agenda-setting theory, Philemon Bantimaroudis, a leading scholar in the application of the theory to cultural enterprises, presents a rich exploration of this new environment regarding the salience of various cultural activities and products.

Beyond the obvious practical applications for the diffusion of culture in a world of overwhelming information and messages, this book is a major contribution to the growing scope of agenda-setting theory, a trend that has been described as the centrifugal expansion of agenda setting far beyond its origins in Chapel Hill half a century ago regarding the role of the news media in directing public attention to the important issues of the day. The media's influence on the public's agenda of issues is still the dominant focus of agenda-setting research, but increasingly the core idea of the theory, the transfer of salience from one agenda to another, has been applied to a variety of other domains.

Here the domain is the cultural industries, a greatly understudied area in contemporary communication research. It is an area with a rich variety of organizations, experiences and goods to examine. These include museums, art galleries, movie studios and other media production companies, book publishers and theme parks. The wide array of cultural products and experiences produced by these organizations merits scholarly attention, as do the vast array of creators of these products.

In line with agenda setting's metaphorical notion of agendas, cultural performances, experiences and goods can be arrayed vertically and ranked. What the research on cultural markets adds is a body of new information that moves beyond the traditional measures of cognitive perceptions to actual behavior, such as attendance at events and purchases of goods. This is an important elaboration of the consequences of agenda setting effects among the public by various communication media, and, arguably, a more solid measure of salience in which to

ground agenda-setting effects. Another potential measure of salience is the extent of word of mouth, which is especially important for the success of movies and many other cultural activities and products. Use of this measure has the potential to clarify, at least in part, the role in agenda setting of interpersonal communication, an area marked to date by considerably diverse results.

In cultural settings, agenda setting also is marked by a key distinction from the traditional research on political communication. Unlike the largely homogeneous agendas of public issues across many media and among the public at large, cultural agenda setting is characterized by a plethora of distinct and independent agendas, both at the first level of agenda setting—which organizations, activities and goods to focus attention on—and at the second level—which attributes of these organizations, activities and goods to take into consideration. Concomitant with this broad array of agendas are the extensive variety of niche audiences and their motivations found in the cultural marketplace.

As a consequence, it seems likely that the exploration and subsequent mapping of the cultural domain will considerably broaden our theoretical perspective on the agenda-setting process.

Simultaneously, research in this domain will advance our understanding of the new communication channels that compete for public attention. Given the tremendous variations in media and public cultural agendas, we can better understand the variations across these channels of communication and their agenda setting effects on the public. Most likely in the cultural arena, there is not a single, relatively uniform agenda-setting process, but rather a number of distinct processes. There already is considerable evidence that the expertise of niche sources expressed in press releases about public issues and the reputations of organizations can influence the agendas of mainstream media (McCombs, 2014), including the cultural agenda (Weidman, 2016). And recent research from another arena, technology, documents the considerable influence of niche blogs on the mainstream media (Weiss-Blatt, 2016).

Given the tremendous variation that exists across the media agendas advanced by the numerous players in the cultural marketplace and the variations in the niche cultural agendas among the public, Bantimaroudis raises a series of key theoretical questions prefaced by the rich discussion in *Setting Agendas in Cultural Markets*:

How is salience achieved in the cultural domain?

Are the mechanisms that lead to salience in the field of culture similar to agenda setting's traditional domain of public affairs?

Are there culture-specific processes that result in successful agenda setting in cultural settings?

Which attributes or combinations of attributes best achieve salience among the public?

Attention to new measures of salience across a wide variety of agendas involving the expanding media landscape will provide answers to these questions and broaden our perspective on agenda setting effects. Cultural agenda setting opens a new substantive arena for research and expands the theoretical boundaries of agenda setting.

Maxwell McCombs
University of Texas at Austin
July 2016

References

McCombs, M.E. (2014). *Setting the agenda: The mass media and public opinion* (2nd ed.). Cambridge, UK: Polity Press.

Weidman, L.M. (2016). Attributes of a cultural/consumer product: Oregon wine. L. In Guo & M. McCombs (Eds.), *The power of information networks: New directions for agenda setting research* (pp. 206–220). New York: Routledge.

Weiss-Blatt, N. (2016). Role of techbloggers in the flow of information. In Guo & M. McCombs (Eds.), *The power of information networks: New directions for agenda setting research* (pp. 88–103). New York: Routledge.

Preface

In our modern world, most of our daily experiences are mediated in nature. We have learned to attribute significance to certain experiences because the media tell us they are important and therefore they deserve our attention. The main themes of this book deal with leisure experiences, the choices people make during their free time and how they choose to spend this time. However, there is a second dimension that deserves our consideration. The value we attribute to these leisure experiences is derived from mediated hierarchies of significance. Different types of media rank organizations, cultural goods and creators according to their perceived significance. They present, in a hierarchical order, the most "important" museums, universities, galleries, restaurants, movies, authors, books, libraries, theme parks and so on. In this book, I argue that, in telling us which cultural providers are the most significant, the media influence public perceptions of leisure experiences. However, the most noteworthy linkage is between perceptions and leisure choices and behaviors. In other words, do the media tell us how to spend our free time? As the media evaluate various leisure choices and assign symbolic values to them, they tell us that reading a particular book might be more "important" than watching a television program; or they might tell us that a certain book is more "valuable" than other books we might have in our library. As the relationship between media and public perceptions has been established, does this mean that we will reach a decision about spending some of our free time reading the book? This function of media influences people's perceptions about the value of leisure experiences and, to some extent, our leisure selections.

Agenda-setting research examines and analyzes mediated experiences. The intellectual fathers of this paradigm recognized that most of what we learn about the modern world is derived through various types of media. From the age of newspapers to the modern realm of digital media, our perceptions of the world are profoundly shaped by journalists, politicians, advertisers and public relations practitioners, as well as a host of groups and ordinary individuals utilizing multiple media platforms and digital tools.

In the 1990s, as a doctoral student in Austin, Texas, I became acquainted with the foundational principles of agenda-setting theory. I recognized then that the agenda-setting paradigm retains a pronounced relationship with the political domain. Politicians are by definition agenda setters. Over the years, media and politicians have formed an undeniable, symbiotic relationship with one another. Therefore it is not surprising that a significant volume of the agenda-setting research that has been generated over a period of several decades is focused on the civic domain. My own initial steps on agenda-setting research were made in this very same arena.

After almost a decade of studies in the United States, returning to my birthplace—Greece—has had a reframing effect on my own agenda-setting explorations. My personal interest in political communication receded as soon as I came in contact with the Greek political scene. On the other hand, Greece remains a significant cultural destination. With a history stretching over thousands of years, every corner of the country has its own tradition, its own story. And many of those wonderful stories have not been told, or at least have not been told well. I started realizing that the cultural domain provides numerous opportunities for investments, new ideas and innovation in conjunction with old stories and old treasures from the past. Greece possesses excellent cultural assets derived from its long history. In this understudied domain, the establishment of new cultural agendas can be related to advancing favorable perceptions about different available leisure experiences as well as potential selections that might bring more visitors, consumers and leisure-seekers.

This small book examines different possibilities for the formation of cultural agendas. Drawing from a long tradition of agenda setting research in the civic domain, I attempt to explore new routes of investigations in cultural settings and enterprises. For example, the role of museums as agenda setters is explored. To what extent are such cultural providers capable of establishing dominant agendas to advance their symbolic presence? I focus on museums, galleries and art-house films, by definition the weaker players in the cultural domain, because it is common knowledge that popular entertainment industries, such as television, blockbuster movies and popular music spend billions of dollars on promotion. However, even popular entertainment industries deserve our attention in terms of their agenda-setting capacities. Their sheer economic power does not always guarantee a symbolic dominance in media content. As I surveyed various examples of cultural entities, I strove to maintain a balance between different types of cultural providers. Although I use many examples drawn from Greek cultural markets because Greece is a geographic area with a rich cultural heritage, my intent is not to narrow my focus on just one country, but to use this example as a starting point for the exploration of international cultural agendas. In fact, I draw evidence from several different national settings as I survey the diverse characteristics of global cultural markets.

As various organizations and cultural creators attempt to establish their symbolic presence in highly competitive global markets, the extent to which cultural agendas can influence public perceptions of authors, organizations and experiences is open to debate. Furthermore, at a higher level, is it possible that our leisure selections—visitation, purchases, attendance, or participation—can be influenced by the symbolic significance of those entities? Although there is plenty of available information in regards to what drives people's leisure choices, I argue that cultural agenda setting should be considered as an additional explanatory paradigm of leisure activity. In this context, I hope that the evidence I present will generate interesting discussions that might lead to noteworthy future explorations.

Acknowledgments

Many years ago, I had the privilege of attending wonderful classes with some of the greatest teachers a student can find. I should like to name just a few, because of the profound impact they have had in my life: Demosthenis Katsarkas, Peter Pringle, Kittrell Rushing, Robert Fulton, Marilyn Roberts, James Tankard, Stephen Reese and my dissertation advisor, Maxwell McCombs. Those amazing teachers, along with many others, influenced my thinking and, subsequently, my teaching. While in the United States (1990–2000), they introduced me to the field of media studies, which later became my career. My parents, Christos and Anna, lovingly encouraged my educational pursuits. They were the first teachers of my life. Furthermore, since 2008, I have enjoyed a wonderful research collaboration in this field with my colleagues Stelios Zyglidopoulos and Pavlos Symeou. And, of course, I am indebted to my wife, Katy, and my children, Christos, Pavlos and Anna-Julie, for their love, patience and support.

Introduction

Time is a precious commodity. In our finite human existence, we quickly become aware of the scarcity of time. The average person, in the so-called developed world, lives approximately 75 years. Of this brief existence, around 25 years, or one third of the entire human life, is spent sleeping. Some 11 years are consumed by work or work-related activities, a figure magnified significantly by the time spent commuting to and from work. Further substantial portions of time are spent taking care of our family and ourselves. However, the remaining 25 years of human existence is described as leisure, when people invest their time in experiences from which they acquire different forms of gratification. Furthermore, as they seek such experiences, they become motivated to satisfy various perceived needs.

This small book is about the latter third of our time, focusing primarily on cultural organizations or industries, as they are popularly called, that target our leisure time as a strategic corporate choice. Their main activity is centered on providing people with a wide variety of cultural products in the form of media content or leisure experiences, addressing different identities and lifestyles, perceived needs and individual gratifications. Cultural industries try to influence our knowledge, understanding and perceptions as well as our choices in relation to our leisure time. As they design and promote a multitude of different cultural products and services, they set cultural agendas, influencing our leisure perceptions and selections. To set cultural agendas, cultural producers systematically assess individual knowledge, attitudes, preferences, needs and motivations toward different leisure experiences. They conduct research on various segments of the public, as consumers are often clustered together, according to distinct, observable characteristics. Although there are uniform attributes that guide mainstream leisure selections, recognizing segmented preferences and behaviors is also important; this recognition provides significant insights into how cultural consumers invest their leisure time, becoming connected in some way with various providers of leisure experiences. Cultural creators and consumers appear to attain an almost existential connection: Individuals consciously devote a significant portion of their life to cultural creations that acquire a special significance for them.

How much time do people spend on different cultural experiences? In terms of mainstream, popular media, the available descriptive evidence is quite overwhelming and published reports diverge on their findings, as they often focus on different aspects of the time people spend on different types of media activities. Prior to the internet/digital era, the average person watched more than six hours—and in certain segments, more than seven hours—of broadcast television every day; this figure has been significantly decreasing, to four hours daily. ZenithOptimedia (2015) reports an average daily overall media interaction of slightly more than eight hours, with half of it claimed by broadcast television. Internet in all its forms—mobile phones, tablets and personal computers—comes second, but with a strong tendency to significantly increase in the years to come. Indeed, internet use is expected to drive upward overall media use. Modern media users increasingly find that "half of our waking life is apparently not enough with global average consumption set to rise to 506 minutes."[1] In terms of sources and devices, emarketer (2015) reports that US adults consume 5.5 hours of video daily derived from broadcast, cable and internet, delivered to TV sets, mobile phones, personal computers and tablets.[2] These different reports converge in reporting an overall increase in average internet usage to more than 20 hours per week, while tablet usage around the world has been steadily increasing since 2010. Parallel to this, there is an overall increase in mobile and online entertainment, as people tend to watch television online, and the number of online gamers has doubled since 2005. Social media usage has tripled since 2007, with almost 70% of all internet users reporting that they have a social media profile. Social media use has shown the biggest expansion among 35–44-year-olds.[3] The average person spends approximately 1.7 hours on social media every day.[4] The use of mobile phones claims a significant portion of our time both in terms of digital content consumption as well as interpersonal communication, for example, instant messaging.

While time spent on digital media continues to increase, time spent on traditional broadcast and print media (printed newspapers and magazines) continues to diminish. Currently, conventional television claims approximately four hours of daily viewership, while digital media claim approximately 3.5 to 4 hours. If we take into account that digital media gained over 2 hours of daily usage over the past five years, a reversal of time allocation by modern media consumers seems imminent, while our overall media interaction is expected to exceed nine hours per day.

Observing children's media use is indicative of developing trends. After all, leisure habits are formed early on and follow individuals into adulthood. Reports show that children aged 8 to 18 spend roughly 44.5 hours every week in front of a screen, while parents become concerned that "screen time is robbing them of real world experiences."[5] Other reports raise this time allocation to up to nine hours every day,

as children engage in multiple media platform usage, including social media, music, games and online videos.[6]

If popular media claim an average of 8 to 9 hours every day, what do other less popular and highly segmented cultural activities, such as reading books or visiting museums, libraries and galleries claim from our time? Reading books, for example, is a segmented choice with a great deal of time differentiations across different groups. For example, students and older people read more than other age-related segments. But reading is segmented across different geographies, nationalities and cultural backgrounds. The highest interest in reading is displayed by people in China, Thailand and India, with an average of roughly 9 hours per week, while the lowest interest is reported in Taiwan, Japan and Korea, with less than 5 hours every week. Europeans read more than Americans—6.5 versus 5.5 hours on average, respectively. Eastern Europeans read more than western Europeans, while the same trend applies for people of the north in contrast to people of the European south.[7]

Museums claim only a small fraction of our overall leisure time, but this is less easily quantifiable than time spent on popular media. Similarly to books, there are differences in museum visitation patterns according to national origin, socioeconomic status and cultural background. For example, in the context of the European Union, people from countries of the north, such as Sweden, Denmark and the Netherlands, are more frequent museum visitors, whereas southern Europeans, from countries such as Greece, Cyprus and Portugal, are less frequent visitors.[8] Research shows that income level and education are significantly related to museum-related activities. Affluent and highly-educated people are more likely to seek museum- and gallery-related experiences, while people of lower socioeconomic status spend their time with popular entertainment media.

Our modern lives are connected with different types of cultural organizations and the products and services they disseminate for public consumption. If 8 or 9 hours per day is devoted to media-related leisure activities, this adds up to approximately 25 years of our human existence. To the extent that organizations and institutions of culture tell us what to think about their productions, their organizational agendas establish their image and brand value and in the process, they claim a significant portion of our existence. Furthermore, to the extent that organizations promote different cultural products in the form of leisure experiences available for public consumption, those agendas tell us which particular experiences are more valuable than others and more importantly, how to spend or invest our precious and scarce time on them and their creations, versus other available leisure choices. Although leisure time is not by definition comprised of mediated experiences, this is increasingly the experience of consumers today. Assessing those cultural agendas that are related to a significant portion of our time constitutes one of the main

themes of this book. And in the modern age, this portion is, without any type of hyperbole, the third third of our time.

Setting such cultural or leisure agendas can often be described as a zero-sum game. In other words, making a choice in terms of time invested on a leisure experience often excludes other cultural selections. Time is a finite asset, and in most cases, people can hardly be described as leisure multitaskers. As people make choices on how to spend their time, every choice displays traits of exclusivity. Deciding to read a book at home precludes other leisure possibilities, such as a visit in the museum, an athletic event, or attending a lecture. Although there are certain activities that can be combined to some extent, in most cases, cultural experiences are very exclusive. I can only watch one performance at a time, read one text, visit one exhibition. Although my smartphone allows me to look for information online or answer my email while attending an event, there are limitations to cultural multitasking. Sometimes, people listen to music in the background while doing something else simultaneously. However, usually we focus on one thing at a time. Therefore, by making a leisure choice, one cultural provider has set the agenda of my free time, precluding other possibilities.

This zero-sum game aspect of cultural agendas explains to some extent the intense competition among different cultural and leisure service providers as they attempt to influence consumer choices. Cultural providers recognize the complexity of cultural domains as they consider multitudes of individual traits and group attributes along with societal, economic, political, cultural and personality characteristics that influence leisure decisions. They have to take all of these into account as they establish their presence in the mediated environment of modern consumers.

Leisure Time, Creative Industries and Urban Transformations

Starting in the 1960s, the major urban centers of the planet underwent significant transformations, following new city planning initiatives and ambitious architectural designs. One of the main objectives set by policymakers was related to citizens' flexible management of their limited leisure time. This transformation of city centers followed a global investment trend leading to a tremendous growth of cultural and leisure infrastructures. As new investments were made in leisure services, city centers became attractive and competitive, aiming to persuade different urban segments to spend their leisure time in formerly neglected parts of metropolitan areas. According to Rogerson (2012), "localities which formerly were centers of production have been re-constructed and re-invented (or sought to be reinvented) as centres of consumption" (p. 189). Leisure time was recognized as a valuable asset, on which multiple

service providers and cultural industries depend for their sustainability and well-being. New markets emerged on the foundation of leisure activities and millions of new jobs were created worldwide. As a result of these initiatives, urban environments in city centers were restructured; entire house settlements with populations of low socioeconomic status and different marginal groups were forced to relocate. The new city centers became attractive for middle- and upper-class consumers; they provided an array of different experiences for public consumption and entertainment.

The Centre Pompidou, in Paris, became a major landmark of this urban transformation; this innovative cultural entity signified a global urban metamorphosis, recognizing cultural experiences as individual and public assets. Cities, in alliance with different cultural entities, became cultural providers of multiple experiences for visitors from all over the world (Van Aalst & Boogaarts, 2002). In the 1970s, new leisure service providers found their way to city centers, often housed together under one roof—department stores, galleries, museums, theaters, cinemas and bookstores. Museums found themselves at the center of these transformed cities. Indeed, city transformations progressed together with museum transformations. Along with old museums, new museums were designed, and their presence became a symbol of new urban visions captured in newly established cultural strategies. Most notably, city economies were transformed, expanding the existing cultural markets while investing in service and experience providers for different public appetites and aesthetic pursuits. Progressively, industrial manufacturing facilities with their imposing structures from previous centuries were either demolished in order to provide additional space for new cultural infrastructures or were restored to their original form to house the new cultural centers. The restoration of urban city centers brought investments in housing, providing up-scale apartments and condos for young professionals. Furthermore, these cultural and leisure initiatives encouraged the creation of new businesses appealing to new needs and aesthetics. This redefinition of urban centers created new employment opportunities, especially in the service sector. Creativity became the new buzzword. This trend did not just affect western metropolitan areas. Even the Chinese Communist Party has initiated an ambitious restructuring plan for the city of Beijing. The entire city witnessed a massive investment on new infrastructure as they cleared out old factories to replace them with new apartment buildings conveniently located around cultural complexes and creative production centers. "Meanwhile, city streets are congested by cars, residents suffer increasing instances of respiratory illness and traditional ways of living vanish amid the dust of bulldozers. This is progress Chinese style" (Keane, 2009, p. 77). Despite the peculiarities of this particular market system, the Chinese government recognizes that critical investments in creative industries

constitutes a strategic stepping-stone for catching up with the West. The city of Beijing is globally recognized as the ideological center of a significant regime; now it tries to reframe its space as a center of culture and creativity. People started being aware of this paradigm shift after the completion of the 2008 Olympics. This emphasis on creative industries has been embraced by Chinese policymakers and becomes manifested in Beijing as well as in other major cities. The opening of the Disney Resort in Shanghai in 2016 represents one more step toward this massive reframing endeavor.

The famous urbanist Richard Florida (2014) provides detailed evidence for what he describes as the creative class, a population of modern workers for whom creativity is an essential fiber as they carry out their professional tasks. Thirty percent of America's workforce belongs to the creative class, a unique group of professionals and creators whose values, everyday routines and desires influence major cultural shifts. Florida (2014) argues:

> because creativity is the driving force of economic growth, the Creative Class has become the dominant class in society in terms of its influence. Only by understanding the rise of this new class and its values can we begin to understand the sweeping and seemingly disjointed changes in our society and begin to shape our future more intelligently.
>
> (p. XXI)

Florida recognizes that, since the early 1950s, there has been a progressive shift in the way people value creativity. His seminal contributions around the concept of the creative class are unequivocally linked to the cultural domain. He calls our attention to various significant attributes that define those who become involved in cultural production, such as the human capacity to produce ideas, not just goods. Creative economies are information-based and knowledge-driven. The creative class creates new meanings, new forms and new designs. It values individuality, meritocracy, diversity and openness. Time limitations mean creative workers have to speed up what they do, substitute their leisure activities with others that take less time, and engage in multitasking and time planning. Furthermore, creative workers are described as experiential workers. Florida's research indicates that creative individuals "favor active participatory recreation over passive spectator sports. They like indigenous street level culture… They crave creative stimulation but not escape" (p. 135). Leisure is not something that happens but it serves the need for exposure to creative experiences and subsequently, inspiration. This creative clusters trend has had an impact on many industrial economies around the world. Florida traces urban transformations in relation to the advance of the creative class. After the 1960s,

when revolutions withered and the bohemian culture receded, "what happened instead was neither 1960s nor 1980s, neither bourgeois nor bohemian" (p. 169). Silicon Valley emerged in California. Arguably, different cultural industries were a part of the creative transformations that took place in western cities in the twentieth century and set dominant agendas for cities around the world. After all, claiming people's free time requires every creative capacity, including technological innovation and information-related experiences. Tolerance and talent need to coexist for the benefit of creative output. It seems that most cultural organizations have been affected both by the explosion in the creative sector as well as the urban transformation trend. Museums, for example, have evolved as popular international destinations. Research shows that half of the total number of tourists arriving in major cities will visit the local museums (Richards, 1999). As a result of this success story, museums have proliferated in cities around the world seeking to maximize their visitation, creative output and public attention. By engaging in strategic alliances with city authorities and other corporate entities and cultural institutions, they have achieved spectacular growth. Museum specialists recognize museum evolutions in different metropolitan areas of the world, along with media developments. Museum transformations can be assessed along with urban, creative, media and social regenerations throughout the twentieth century, and this is an ongoing story. However, it is not just about museums. Other cultural providers have contributed to cities' regeneration. Several case studies are indicative of cultural, urban and technological transformations. Gibson (2002), for example, describes a significant change of New South Wales's Far North Coast in Australia, which was redefined around the production and performance of popular music. He provides detailed evidence about the capacity of cultural industries to invigorate local economies, while capitalizing on the provision of cultural experiences.

In the context of urban transformations, there is one further element that deserves our consideration: the advent of the experience economy. So far we have explored urban and creative transformations. The gradual movement from goods and service economies toward experience economies adds another dimension to this discussion. In their book entitled *The Experience Economy*, Pine and Gilmore (2011) argue that modern economies should be transformed into experience economies. They defend a thesis that "goods and services are no longer enough to employ the masses" (p. XX), and they provide significant arguments about the need for such transformation; conceptualizing economic output as only goods and services renders an economy uncompetitive on a global scale. Transforming goods and services into experiences creates added value. People pay more for experiences. As they differentiate among different types of industrial provisions, they move forward with this thought-provoking statement: "whereas commodities are fungible, goods tangible and

services intangible, experiences are memorable" (p. 17). If transforming the entire economy into an experience economy constitutes a proposal of monumental proportions, skepticism is expected. However, culture by definition is inextricably linked to experiences. The entertainment business is by default an experience business.

Both cities and organizations seem affected by these realizations. Creative economies providing experiences display significant advantages. As we have seen so far, most metropolitan areas of the world became subject to cultural and urban transformations. Smaller cities followed these cultural trends and started investing in cultural centers and creative leisure activities. As a result, even away from urban centers, different types of organizations emerged, providing multitudes of different experiences. According to Van Aalst & Boogaarts (2002), cultural organizations were built in close proximity to one another, which allows visitors to seek different types of experiences either walking to them or using public transportation conveniently. In the twenty-first century, metropolitan centers of global significance continue to engage in ambitious planning for the restructuring of urban space, while modifying their overall missions and their sense of identity. Museums, for example, set new objectives that are compatible with renewed frameworks of identities and new understanding of heritage. In the past, museums were perceived as protectors and conservators of cultural heritage. Therefore, museum collections were protected and studied by specialists in confined environments. This notion of museums' research mission has become secondary to their role as entertainment and experience providers. Therefore, they actively seek out people's leisure time, invested in museum-oriented experiences. Researchers have borrowed old terminology to describe new museum missions; for example, in this book, I prefer the term "rational edutainment," implying that museum experiences carry a certain quality as they tout themselves not just as entertainment but also as education and information providers.

Although urban restructuring and cultural developments endowed museums with a privileged positioning in city centers, other cultural industries have become aggressive in claiming people's leisure time. Libraries have evolved as happening places. There are several examples of cities with significant libraries attracting visitors not just for the purpose of reading, but also socializing and relaxation. In addition, cinema, with more than a century of history, provides a popular experience that, depending on different genres and styles, appeals to mass audiences as well as to viewers with eclectic tastes and aesthetics. The cinema industry has benefited from urban transformations. In contrast to cinema theaters of the 1950s, which captured a certain atmosphere of reminiscence and romanticism, state of the art, modern movie theaters and multiplexes have been designed to provide an experience of flexible consumption. Not only the quality of digital audiovisual projection, but their strategic placement in large, shopping centers and theme parks

have become indicative of a holistic approach in claiming consumers' leisure time. In the same evening out in the town, modern consumers can combine shopping, dinner and cinema, all under the same roof, in state of the art facilities and with plenty of parking space.

The rebirth of cinema during the last two decades of the twentieth century, after its major crisis in the 1950s, can be attributed to its significant alliances, especially with the television industry, but also in its strategic repositioning in the urban environment along with a redesigned, totally upgraded cinematic experience. In these urban settings, where museums and movie theaters coexist, representing two distinct leisure choices, visitors also discover other cultural providers. All those who distribute cultural content strive to position themselves among the established cultural disseminators. In the large city centers, we discover new bookstores, providing a combination of experiences: a cafe, a reading area and a public space with plenty of opportunities for socialization. Traditional bookstores have tended to disappear or merge with media conglomerates or other publishing giants. In the old days, bookshops attracted readers and researchers. Modern bookstore chains attract not only readers in the traditional sense, but also people who seek an outing with relaxation and possibly some reading in a warm and well-designed environment. In the same city areas, people discover modern galleries with traders of different types of art, along with theaters and performance oriented providers, exhibitions, festivals and music performances. From stand-up comedians to street performers, no experience is insignificant in the leisure domain. The question is how a producer assigns value to various cultural offerings and different groups of potential consumers acknowledge those symbolic assets.

There is no doubt that cultural experiences and leisure have been redefined in line with Florida's creative assertions. City strategies for urban transformations, digital technologies, talent and tolerance have reformulated creative spaces. And cultural industries along with other experience providers can be found at the center of those developments. Although cultural experiences are produced, distributed and sold by sophisticated organizations with a great deal of highly specialized resources, the roles of individual creators have also been redefined. Somewhere in between, filling small market gaps, producers, authors, traders, artists, actors and directors, along with small business owners and other leisure entrepreneurs, attempt to find their niche group without getting in the way of the big players. Sometimes, they do, and often the big corporate players incorporate individual creations as they have the capacity to pay handsomely for them, or individual creators retain their independence in the smallness of their creative capacity.

In transformed urban environments, the highly creative and talented individual discovers new, flexible ways to claim the free time of potential consumers. Talent and a creative nature is a "must." But digital tools and platforms provide amazing opportunities for setting new agendas.

New musicians, film directors, artists, authors and actors find their niche through interpersonal and digital networks of relationships. In some cases, they form alliances with established industrial entities. After all, organizations have the capacity to utilize all kinds of human talents, multiple abilities and technologies in order to provide complex cultural products and services, although of ambivalent and uncertain value (Hesmondhalgh, 2013). This uncertainty factor demonstrates that consumers are very unpredictable in the ways they assign value to cultural experiences. This ambivalence of our postmodern culture signifies a radically differentiated reception of the same message by different groups of consumers. Furthermore, the constantly shrinking leisure time of the modern busy worker, who lives with a multitude of media technologies, leads to decisions for consumption of mediated experiences with fluid value. After all, leisure choices are not just available in open, urban settings where experiences are shared; there are plenty of options for individual exposure at home, such as television, video games and music. Depending on income and access, multitudes of experiences are available without the need to leave the comfort of one's home. Those popular choices provided at home claim the lion's share of time spent on leisure activities.

Time has been deemed an increasingly precious commodity that different cultural entities recognize as significant and try to claim for their benefit. These organizations exist because we all have some free time to spend and they strive to persuade us to spend our time in connection with them. Our time spending decisions direct their entire existence and their future well-being.

This small book focuses on cultural providers setting their agendas in order to claim some portion of our leisure time. Although occasionally the consumers' perspective is examined, the current investigation adopts primarily the lens of the providers: organizations and industries. In Chapter 1, the agenda-setting paradigm is explored. Since 1968, this dominant media theory has been developed through different phases, mostly in the political and civic domains, providing useful insights in regards to how different topics become prominent in the public conscience. In this book, I propose an expansion of agenda-setting applications as we examine the transfer of salience in various cultural markets. As we explore the nature of organizations, cultural products and creators, it is argued that the agenda-setting process is noteworthy because of a well-established public need that underlies all social and cultural domains: people's need for orientation. I revisit this notion with an expansive stand encompassing various types of orientations and motivations.

In Chapter 2, I explore the nature of cultural entities. I often use the term "cultural domain," describing a vast array of creative output with a primary connection to consumers' leisure choices. The term "culture," which ordinarily encompasses various social structures, identities and processes, in this book is narrowly focused on different kinds of cultural

producers and their creative output. However, the most popular terminology, "cultural industries," can be traced in the writings of sociologists and cultural theorists. I follow their lead as I explore the cultural domain with an expansive stand toward it. I often pose the question: How different are cultural industries in comparison with other corporate organizations? It becomes obvious that they form distinct types of industries, producing goods for particular tastes and appetites. The idiosyncratic nature of cultural markets is described as such because of commonly recognized organizational traits that render the so-called "cultural domain" different than other domains.

Chapter 3 provides a chart of cultural consumers as different segments and groups display various characteristics influencing their perceptions and behaviors. Geographic, demographic as well as certain lifestyle agendas are scrutinized, while cultural providers establish their promotion strategies in order to reach groups that display particular segmented interests. Studying segmented agendas of cultural entities can be revealing of their unique capacities to establish the symbolic value of leisure experiences that resonate with enhanced possibilities of acceptance among consumers that share common lifestyles, demographic or socio-geographic attributes. I don't provide an exhaustive matrix of segmented attributes. This chapter offers just representative examples demonstrating the influences that segmentation might have on the agenda-setting process. Furthermore, I recognize that cultural domains, by nature, are defined along the aforementioned criteria. In the same chapter, I explore the possibility of convergence among groups that, although they seem very different, can reach similar decisions in regards to their leisure choices.

Chapter 4 takes a look at the available digital media, platforms and technologies that virtually all cultural entities incorporate in their promotion strategies. Decisions about digital technologies are linked with cultural agendas both in terms of content dissemination as well as segmented behaviors. In this chapter, I explore "new" agendas linked with the proliferation of digital media across the various cultural domains. These "new" agendas pertain to promotion agendas, content agendas and technology agendas. The study of agenda setting in the modern world cannot be complete without understanding the nature and the functions of different digital media platforms as they are conveniently utilized by cultural providers, including social media and search engines. Virtually all cultural industries become immersed in discussions about adopting new digital tools and technologies to gain esteem and enhance their symbolic presence. Although digital technologies serve a primary purpose for the implementation of different tasks, at a secondary level, their mere presence offers opportunities for brand enhancement.

In this context, cultural providers create "new" content, ranging from personal blogs and personal random records to photographs and amateur short videos. Established cultural institutions promote different

categories of "new" content in the form of symbolic actions that generate additional attention. New technology agendas describe a variety of cultural initiatives with a core emphasis on attractive technologies—from virtual reality to sophisticated interactive audiovisual productions. Investing on such technological exhibits provides additional visibility and renders the organization known.

Finally, Chapter 5 examines the main influences of cultural agenda setting as a dominant mediated effect: the transfer of salience to different segments of the public. The concept of salience has evolved significantly since 1968. In this particular domain of digital culture, salience constitutes a multidimensional construct acquiring different characteristics in terms of perceptions as well as behaviors. This core concept acquires new meaning along the lines of horizontal and vertical media. Public salience is revisited in the forms of conventional public salience, word-of-mouth salience, mediated trends salience and various types of behavioral public salience. This enhanced discussion of cultural agenda setting provides a new set of tools as this historic paradigm expands its influence beyond its original theoretical boundaries. Both media theorists and cultural practitioners may find some of the ideas presented useful for scientific inquiries as well as strategic planning and media promotion. I hope that some of these ideas might be useful beyond just the cultural domain, as scholars pose new questions in different political, corporate and cultural aspects of public discourse.

Notes

1　Karaian J., We now spend more than eight hours a day consuming media. Retrieved from http://qz.com/416416/we-now-spend-more-than-eight-hours-a-day-consuming-media/ (Visited May 19, 2016).
2　US adults spend 5.5 hours with video content each day. http://www.emarketer.com/Article/US-Adults-Spend-55-Hours-with-Video-Content-Each-Day/1012362#sthash.w5OvjigS.dpuf (Visited May 19, 2016).
3　Ofcom Report (2015), Time spent online doubles in a decade. https://www.ofcom.org.uk/about-ofcom/latest/media/media-releases/2015/time-spent-online-doubles-in-a-decade (Visited May 19, 2016).
4　Mander, J. Globalwebindex report 2015, Daily time spent on social networks rises to 1.72 hours. http://www.globalwebindex.net/blog/daily-time-spent-on-social-networks-rises-to-1-72-hours (Visited May 19, 2016).
5　Keepsafe Report (2015), Parents' concern: Too much time online. http://ikeepsafe.org/be-a-pro/balance/too-much-time-online/ (Visited May 19, 2016).
6　Diebel, M. (2015, November 3). Teens spend more time on media each day than sleeping, survey finds. *USA Today*3. http://www.usatoday.com/story/news/nation/2015/11/03/teens-spend-more-time-media-each-day-than-sleeping-survey-finds/75088256/ (Visited May 19, 2016).
7　OneEurope Report (2014). How much time do your countrymen spend on books? http://one-europe.info/eurographics/how-much-time-do-your-countrymen-spend-on-books (Visited May 19, 2016).
8　Eurobarometer Report (2013). Cultural access and participation. http://ec.europa.eu/public_opinion/archives/ebs/ebs_399_en.pdf (Visited May 19, 2016).

1 Agenda-Setting Theory
A Brief History

The term "agenda setting" was coined by Maxwell McCombs and Donald Shaw in their seminal article in *Public Opinion Quarterly* (1972). The theory was met with wide acceptance by media scholars, initially in the United States and later in many other parts of the world. The two theorists established a foundation for agenda-setting explorations, explaining the notion of salience in today's mediated world. The ways people attribute significance to different issues has changed dramatically because of the advent of media industries and peoples' understanding of the world through them. Influenced by the work of Walter Lippmann, McCombs & Shaw (1972) reinforced the idea that the mass media build symbolic hierarchies of different issues and teach consumers to recognize only a handful of these as significant. Early agenda-setting studies stressed the notion that people can process and recognize only a few issues from a relatively short list of available selections during a given period of time. Of the multitudes of developments around the world, we only give attention to the small fraction ranked highly by the media in terms of positioning as well as attention. Events or issues that the media do not deem newsworthy may be viewed as less significant than prominently ranked issues, or they may go totally unnoticed.

Those initial agenda-setting studies indicated the special role of the media in providing hierarchies of significance. Because people cannot process a multitude of information in a given period of time, the media point to the most significant topics. From those early days, researchers began comprehending the ramifications of the agenda-setting function of the media. If the mass media attributed significance and defined what the public thought about, as we were reminded by Bernard Cohen's famous assertion, then symbolic, mediated notions of significance became more "salient" than any other non-mediated grasp of reality. Because of the media's capacity for agenda setting, individuals, groups, organizations, corporations, governments and even international bodies have historically engaged in competitive struggles to be a part of the media's hierarchies of salience. Arguably, the marketing and public relations industries, whose influence grew tremendously throughout the twentieth century, exist symbiotically with the media, as marketing and public

relations firms offer, among many other services, the capacity to establish agendas for interested corporate and political clients.

The agenda-setting theory was initially applied to the political or civic domain of human activity. The theory's founders have highlighted a grand array of agenda-setting applications in the context of journalism and political communication. Indeed, political parties and political personalities, by virtue of who they are and what they do, are dependent on various institutions, including the media, in order to establish their agendas, which eventually the public is expected to adopt, support and perhaps vote for. As the theory caught the attention of scholars worldwide, numerous studies started recognizing the multiplicity of applications related to mediated constructs of salience. Salience became a popular term among media theorists. Hundreds of studies were conducted worldwide, scrutinizing different aspects of the agenda-setting process and the supporting mechanisms that lead to salience (Carroll, 2010).

Agenda-Setting Influences at Different Levels

Agenda-setting theory has aroused the interest of researchers in different countries around the world. Apart from the United States, where the first studies were conducted, international teams of scholars from Germany, the Netherlands, Japan, Spain, Austria, Chile and even Greece—to name just a few—expressed interest in agenda-setting influences and effects. The success of agenda setting, which continues to sustain the interest of theorists, can be explained not only in terms of its original scientific inquiries, but its numerous applications in different fields: political communication, journalism, advertising, corporate and cultural communication. Communication professionals benefited from agenda-setting research as they acquired new understanding in regards to mediated notions of significance.

In the early 1990s, agenda-setting researchers coined the term "object" to deal with expanded possibilities for research on various symbolic structures that different stakeholders promote in media content. This theoretical evolution added to agendas of "issues," originally introduced by McCombs and Shaw in the 1970s. "Issues" dealt primarily with news stories and journalistic endeavors in general. "Objects" encompassed enlarged categories of symbolic structures: political figures, consumer products, social groups and corporate firms. In other words, any combination of recognizable and measurable symbols could be identified as an "object" or "issue," depending on the elements that comprised it. Empirical investigations of the salience of "objects" or "issues" revealed their mediated attention in relation to their public salience.

Of special importance for agenda-setting considerations is the hierarchy of "issues" or "objects." This hierarchy can be assessed through both quantitative and qualitative investigations. For example, the volume

of coverage constitutes a record of relative media attention, indicative of significance. A greater amount of coverage attributed to an issue is considered "more important" than less media attention attributed to a different issue. This record does not reveal anything about the essence of information or about its sense of value derived from other socially constructed perspectives. But there are also qualitative indicators of salience: a topic that is on the front page of a newspaper is considered "more important" than another that is on the last page of the newspaper, appearing in fine print. McCombs & Shaw (1972) examined the following seminal relationship: Is a hierarchy of issues in media content correlated with a corresponding hierarchy of those issues in the public mind? This seminal correlation in the original investigation—a parallel hierarchical relationship between media content and public perceptions—was scrutinized, while suggesting that one hierarchy influences the other. These initial, exploratory attempts led to the creation of new terminology. Specifically, the hypothesized relationship led to the concept that became known as "the transfer of salience."

Researchers concluded that the public prioritizes issues as people's perceptions are influenced by the media's attention to those issues. The Chapel Hill study provided researchers with the basic theoretical tools to study the transfer of salience as a process. Later on, other significant questions were answered, such as the question of time-order—which type of hierarchy preceded the other—the media or the public. Nowadays, the available literature, without significant disagreements, converges in terms of the mechanisms that lead to salience. Furthermore, the way media content is organized, in a specific hierarchical form, is indicative of its salience while it influences the relative significance of topics in the public mind. Progressively, numerous other factors have been scrutinized; for example, researchers discussed the nature of issues that are directly related to the daily experience of people. These issues were described as obtrusive, in contrast to issues that cannot be easily encountered in daily, ordinary settings by ordinary individuals; those issues were described as unobtrusive. This division of topics advanced the initial explorations, as researchers showed that certain issues are more easily elevated in the public agenda than others (Zucker, 1978). Furthermore, researchers reached a deeper understanding of intervening factors that explain the process of salience.

Although researchers agreed that the media play a domineering role in establishing salience and therefore various public players depend on the media in order to build their own agenda, this is more than simply a one-way relationship. As the years went by, researchers utilized various methodological tools to examine agenda-setting questions. They did not confine themselves to scholarly pursuits using only public opinion polls, but expanded their sphere of explorations through experimental designs. Different types of content—print, audio and television—became the

focus of these investigations that established the foundations of the theory (Iyengar, Peters & Kinder, 1982). Agenda-setting researchers went beyond the initial relationship that assessed media and public salience. They observed that often the media set agendas for other media within national or international media ecosystems. In many cases, regional media replicate the major headlines of national media for their own public. At the international level, certain media were globally recognized as elite gatekeepers, influencing content selections in different national markets and in different languages. CNN, *The New York Times*, the BBC and many other organizations of global appeal impact significantly the agendas of various media outlets around the globe. Reese and Danielian (1989) used the term "intermedia agenda setting" to describe how elite media with global recognition influence the agenda of local and regional media. For example, the content of *The New York Times* is often reprinted by major Greek newspapers, as some of its articles may have a regional or local appeal. In the late 1990s, a study of Greek newspaper editors in Athens demonstrated differentiated levels of gatekeeping practices, demonstrating explicitly their reliance on international media sources and therefore inter-media agenda-setting influences (Roberts & Bantimaroudis, 1997).

Initially in the 1970s, but with a renewed attention in the 1990s, McCombs and his colleagues turned their attention to what they described as the "second level" of the theory. To better understand the mechanisms of salience, they had to look deeper into the structure of different categories of content. Although they had already explored various facets of the transfer of salience, such as the obtrusivity factor, people's need for orientation, differences among media as well as time-frames necessary to reach salience, they realized that the question of salience can be explored further if media content is studied at the particle level. The way information is built—in other words, the particle structure of every message—could reveal some of the secrets of salience. Progressively, they moved away from "issues" and started discussing "objects," a term that encompasses a wider variety of information, not just confined within the sphere of news items. As we have already seen, "objects" represent different types of media messages that different stakeholders seek to advance in the public mind. Researchers became particularly interested in political personalities, as they often seek recognition to advance their symbolic significance. Naturally, they started wondering what symbolic elements of a personality would render him or her more likely to become salient. For example, what specific attributes of political personalities should be scrutinized in relation to their capacity to render the personality salient? The term "attribute," referring to specific semantic elements, of which "objects" are comprised, became a trademark terminology of second-level agenda setting. Ghanem (1997) outlined new typologies of attributes, both affective and cognitive. The affective category became synonymous

with valence or the tone of coverage toward political personalities, displaying a positive, negative or neutral stance toward politicians. The cognitive category encompassed multitudes of traits, such as the ideology adopted by politicians, their qualifications and personality characteristics (Kiousis, Bantimaroudis & Ban, 1999; Kiousis & McDevitt, 2008; McCombs, 2004). As researchers found numerous political communication applications investigating attributes of personalities and their capacity of salience, the entire field of political communication became richer both in scholarly as well as applied terminology. This literature on political personalities, mediated political discourse, public perceptions and voting behavior continues to expand at different levels, leading toward exciting discoveries in the context of the current digital media ecosystem (McCombs, 2014; Stroud, 2011).

Fragmentation of Agendas and Specialized Interests

As the twentieth century drew to a close, the vast proliferation of digital media platforms and social media changed the global media landscape and raised new questions about possible applications of agenda setting. The mass media, which had emerged as the premier gatekeepers and the dominant agenda setters of the twentieth century, faced unprecedented challenges. Newspapers' downward spiral intensified. Television started losing its mass appeal as the internet gained ground. Cinema and the music industry started facing new pressures from emerging industries such as the video game industry. Laptops, smartphones and tablets provided new relays for content reception in versatile ways and at a reasonable cost. But most importantly, mass audiences of the twentieth century were transformed from receivers to users. Today, individual consumers of digital content enjoy enhanced interaction with digital cultural content; among various possibilities, they can be communicators, searchers, visitors, gamers, readers, viewers, mobilizers, shoppers and creators.

According to Takeshita (2006), "the new media landscape affects the agenda-setting process because mainstream media have a weakened capacity for consensus-building, while losing their ability to establish a "common public agenda" (p. 286). Furthermore, different agendas are subject to audience group profiles and preferences. Although digital media technology enhanced the degree of fragmentation in terms of the availability of outlets linked to group or segment proliferation, certain thematic domains like the field of culture are subject to segmentation by virtue of their specialized interests (Weidman, 2016). In the news domain, Takeshita (2005) argues that "the mass audience is fragmenting, with fewer and fewer people dependent on traditional mass media such as terrestrial television networks or newspapers" (p. 286). In segmented domains, fragmentation is the norm. Takeshita's observations signify an environmental shift that affects the nature of agenda setting,

such as the concept of salience and the way the public satisfies its need for orientation. Naturally, as the environment changes, new discussions develop as to the nature of influences and effects. The central discussion is focused on the topic of salience. How is this process affected in the digital world? Although salience is recognized as a significant media influence, and in corporate settings as a mediated asset, there are questions related to its mechanisms as well as to the concept itself. Both can be affected when paradigms shift significantly. Initial evidence shows that the agenda-setting function remains a potent process with its basic influences unchanged in the digital world of the current century. Different types of media maintain a central role in this process and salience remains a valuable and sought-after asset. Nevertheless, the proposition for a process of agenda melding is indicative of the changing media terrain and new conditions that lead to salience (McCombs, Shaw & Weaver, 2014). As processes change, new research is expected to shed new light. Nevertheless, the quest for salience has not been diminished in the new media landscape, as more players see more opportunities in the digitally mediated global environment (McCombs, 2014).

Organizations and Agenda Setting

At the turn of the twenty-first century, agenda-setting research expanded toward different directions. Researchers often describe this trend with two terms: "a centrifugal trend, expanding to domains beyond the original focus on public affairs," and "a centripetal trend of research, further explicating agenda-setting theory's core concepts" (McCombs, Shaw & Weaver, 2014, p. 783). This small book is focused primarily on the centrifugal trend, but includes some suggestions or inferences regarding the centripetal one.

A focus on corporate firms and the business domain produced a variety of useful lessons with numerous applications. Corporate salience was scrutinized in various international settings and not just in relation to media and the various publics (Carroll, 2010). Scholars displayed a primary interest in corporate capacities to disseminate their content while influencing media content. This relationship resembles inter-media or, more accurately, inter-organizational agenda-setting influences. Several studies emphasize the capacity of corporate firms to establish and progressively build their own agendas, strategically influencing media content for their own benefit as well as the benefit of critical stakeholders. This inter-organizational transfer of salience clearly displays elements of marketing and public relations and therefore, this line of research draws from other disciplines such as management and strategy studies (Illia, Bantimaroudis & Meggiorin, 2016). The aim of corporate agendas is centered on key terminology derived from the aforementioned fields, such as brand, esteem, image and reputation.

Researchers started investigating new domains with multiple applications and the theory was adopted by different academic fields. Carroll and McCombs (2003) signaled this shift in interests. Focusing on corporations as "objects," they display an overall interest in the agenda-building capacity of corporate entities. Corporations collaborate with different stakeholders toward establishing their public presence at different levels. Marketing scholars discuss the differentiated levels of image, brand and reputation for different types of business organizations and, as the literature documents, agenda setting is considered, in this context, a significant paradigm (Rindova, et al., 2007). In several studies of corporate agenda setting, both substantive and evaluative attributes were scrutinized by scholars to assess agenda-setting effects. Overall scholars converge in their findings as "images transmitted by the media to the public prime the attitudes and opinions that various publics hold about a firm" (p. 45). Management scholars have explored the concept of corporate reputation, a multifaceted construct related to corporate perceptions by various stakeholders, including the media. Van Riel & Fombrun (2002) have argued that the reputation of corporate entities is very strongly related to media visibility. One core output of researchers who have consistently employed agenda setting in corporate reputation assessments was the design of useful measurement instruments, which empowers researchers to measure organizational salience in reliable ways, while revealing the complexity of this particular construct (Meijer & Kleinnijenhuis, 2006). Deephouse (2000) reached similar conclusions about corporate agenda-setting effects, focusing on the banking sector. In this study, he identifies media reputation, which constitutes one aspect of corporate reputation. This is a distinct reputation dimension drawn from the agenda-setting tradition, providing theoretical bridges between the different traditions of media and management (p. 1,108). Scholars notice an interdisciplinary link between media studies and impression management, encompassing agenda setting, priming and framing, a process acknowledged by management scholars as they study the evolving mediatization phenomenon (Illia, Sonpar & Bantimaroudis, 2014).

A Shift toward Culture

Recently, this list of organizational "objects" expanded further, as cultural organizations and cultural products became the focus of agenda-setting explorations. The cultural domain is different than any other domain explored thus far. It encompasses various manifestations of human expression, identity and leisure practices, all of them externalized through industrial production and leisure consumption. Agenda setting was chosen to explain the different dimensions of salience in leisure contexts. Cultural perceptions and leisure selections have been examined by theorists through various critical and cultural studies perspectives. However,

though scholars have discussed various motivations for leisure choices, the notion of salience, that guides various leisure perceptions and behaviors, is missing from the picture. Apart from Marxist, identity-related and cultural studies approaches that explain consumption of texts in this domain, different types of salience represent a missing link, derived from an empirical media studies perspective.

Researchers started testing these ideas in the context of museums. Greece became the initial testing ground for those ideas. In this small southern European country, culture and tourism represent two significant industries, due to the country's long history and geographic location. Every year, this country of 11 million people receives approximately 15 million visitors to its archaeological sites and beautiful beaches. Because museums are significant institutions of Greece's cultural inheritance, studying the agenda-setting process in this cultural market constituted a logical first step of empirical observations. A group of scholars started to investigate Greek museums in terms of the volume of media visibility in relation to their monthly public visitation (Bantimaroudis, et al., 2010; Zyglidopoulos, et al., 2012). The role of media attention, in conjunction with various other factors pertinent to this particular sector, was revealing of the capacity of museums in setting agendas while capitalizing on public salience. Furthermore, these initial agenda-setting studies of Greek museums confirmed the complex networks of relationships underpinning the museum market. The location of museums, their legal status for governance, their promotion tactics and seasonality were some of the factors that were observed in conjunction with media attention. In such complex cultural settings, although media attention constitutes a significant predictor of public salience, examining media salience in isolation could never yield interesting relationships and new knowledge. It is the entire network of influences that deserves our consideration.

Progressively, our attention shifted from organizations to cultural products and experiences. Art-house films represent a highly segmented cultural market. These cultural products become available through specialized channels of distribution in selected areas, through segmented forms of promotion. By definition, they appeal to consumers with selective appetites and, therefore, claim only a fraction of the general film market. We selected this particular market because it does not display the saturated characteristics of blockbuster advertising campaigns. Therefore, it presents itself as a promising testing ground for agenda-setting influences. One of the major challenges of this research is assessing the combined influence of numerous factors on movie attendance before identifying distinct influences of media agenda setting. Art-house films were investigated in terms of their media visibility in relation to subsequent movie attendance (Symeou, et al., 2015). Media visibility of art-house films, along with many contributing factors, predicts attendance and box office performance. This specialized sector reveals interesting

insights in regards to movies with a segmented appeal benefiting from different types of salience, including mainstream media and digital platforms such as YouTube.

These first agenda-setting research efforts in the museum and film markets demonstrated the special role of valence, which is particularly important in the cultural sector, as different cultural gatekeepers, art critics, specialized journalists and writers contribute to the process of agenda building. It seems that the mission of cultural gatekeepers is to offer significant direction to potential consumers in need of guidance. The role of critical valence—film critics evaluating art-house films—constitutes an additional influence, independent of media attention and visibility.

The museum and film studies offered some initial insights into the role of media agendas influencing different forms of public agendas. However, they raised some specific questions and opened a new round of debates in relation to behavior as an indicator of public salience. The underlying question in the context of leisure activities is this: To what extent do our selections of different cultural goods, in the form of leisure experiences, demonstrate an element of significance of chosen experiences? This sequence of studies advanced agenda-setting explorations at different levels. It expanded the list of "objects" toward a new domain of human activity and led to the current thoughts contained in the small book you are holding in your hands. We revisit those initial studies in Chapter 5, tracing in more detail some of the guiding principles that led progressively toward the concept of cultural agenda setting.

What Drives the Agenda Setting Process?

From the early days of agenda-setting theory, researchers wondered why agenda setting occurs. What primary public needs are satisfied through this process? As researchers took a step backwards trying to understand the "why" before grasping the "what" question, there was an early convergence in terms of what explains the agenda-setting phenomenon. The answer emerged relatively early in the 1970s, as scholars began discussing the public's need for orientation, a fundamental human desire and need that explains peoples' quest for information and knowledge. People of all ages always display a need for orientation as a fundamental aspect of human nature. Although manifested daily, the public's need for orientation is displayed in extreme situations, like a person who lacks access to useful information or a person who strives to navigate in a flood of information. People often wonder which of those conditions enhances more the public's need for orientation. Sometimes being surrounded by an abundance of information can render the navigation process disorienting for an individual who seeks content pertinent to one's particular needs. Therefore, the need of orientation in the current media landscape

might acquire very different forms in contrast to the conditions in which this concept was originally explored.

Scholars described the need for orientation as "the most prominent of the contingent conditions for agenda-setting effects" (McCombs, 2004, p. 67). In the 1970s, the work of Weaver (1977) had already identified the role of people's need for orientation in the agenda-setting process. All people display a need for orientation, especially in a disorienting, information saturated planet. Individuals often encounter situations in which they lack the informational capacity to comprehend their environment and make informed decisions.

In modern digital settings, they survey media content, search for content on the Google platform and talk with their friends on Facebook. As the media recognize this basic human need, they present the relevant information in a hierarchical form, outlining the significance of their content. Matthes (2005) defined people's need for orientation as "the tendency of an individual to seek information about an issue in the news media" (p. 423). It is understood that people's need for orientation is not satisfied exclusively by the media. Often, individuals go to their peers, friends and family to get the information they need. As researchers investigated further the driving mechanism of agenda setting, there was an overall agreement that the greater the need for orientation the public displays, the greater the applicability of agenda-setting theory in explaining audience surveillance and media use (Weaver, 1980). Some of the original studies provided additional evidence in regards to people's need for orientation. For example, in one of the seminal studies, Weaver (1977) concluded that voters with a higher need for orientation surveyed the media for political content significantly more than voters with lower need for orientation. Apart from the evidence generated in the early days of agenda-setting explorations, relatively recent evidence complements initial discoveries. Matthes (2008) conducted an extensive two-wave panel survey on the issue of unemployment, concluding that the need for orientation "fosters the agenda-setting function of the news media" (2008, p. 450). Therefore, the theoretical foundations of agenda setting were laid early in the history of this theory. Sometimes, understanding the "why" question is more important than the "what" question, as the former reveals hidden mechanisms that render the entire process more visible and thus more easily understood.

Relevance and Uncertainty

Researchers identified the need for orientation as one of the primary factors that drive the agenda-setting function of the media. While searching for sub-mechanisms that explain the dynamics of salience, they coined two lower order terms related to the need for orientation: "relevance" and "uncertainty." In a comprehensive presentation of agenda setting,

McCombs (2014) identifies the role of these two concepts. Individuals surveying available media content display different levels of their need for orientation.

"Relevance" describes how individuals or groups identify with certain issues or perceive certain issues as particularly appealing to them. "Relevance" captures the level of significance that individuals or groups of people attribute to a certain topic because they have a particular interest in it or are influenced by special circumstances in relation to it. This leads to the understanding that the more relevant an issue registers for certain people, the higher the need for orientation they display (Weaver, 1980; McCombs, 2014). McCombs & Stroud (2014), drawing on this early literature, identify three types of relevance at different levels: personal, social and emotional. As they differentiate between relevance and importance, they identify self-interest and avocation, described as personal relevance; civic duty and peer influence belong in the social relevance category; and emotional arousal is manifested through affective traits of relevance (Evatt & Ghanem, 2001; Bouza, 2004).

The other lower order term, "uncertainty," refers to the degree of available information about a topic and the level of accessibility to different types of content related to this topic. In some cases, individuals display a great demand for certain types of information as they have a specific need they try to satisfy. Depending on the availability of information, one might recognize a pronounced intensity of "uncertainty" pertaining to certain topics. Weaver (1980) argues that "uncertainty" is related to a "perceived existence of a problem" (p. 365). As the level of "uncertainty" rises, the greater is the need for orientation for information seekers. Although there is an overall agreement among scholars that "relevance" and "uncertainty" are determining factors that influence people's need for orientation, they do not always agree on how this occurs.

Furthermore, even from the early days of agenda-setting explorations, researchers differentiated among various types of issues in terms of their agenda-setting capacities. Issues are described as "obtrusive" or "unobtrusive" and differ in terms of the need for orientation (NFO) that people display toward them (Zucker, 1978; Weaver, Graber, McCombs & Eyal, 1981). Obtrusive issues such as unemployment, taxes and inflation are not strongly related to people's NFO because individuals experience them personally and can therefore form an opinion about them based on their own experience or that of their friends and relatives. On the other hand, for unobtrusive issues, on which individuals do not have personal experience, they are more likely to display a higher need for orientation and therefore survey media content for guidance and information. In short, as the agenda-setting literature documents, people display a lower need for orientation and therefore they tend to rely on media content less for issues they are very familiar with—because, for example, they have experienced what this issue means personally to them—whereas they

seem to display a higher need for orientation and therefore survey the media more intensely for issues in which they lack personal experience (Bantimaroudis & Zyglidopoulos, 2014).

Beyond the Need for Orientation

Although the need for orientation is described as the "central psychological concept" that explains why agenda setting occurs, scholars should consider additional explanations. McCombs and Stroud (2014) raise the following question in regards to the psychological explanations of agenda setting: "What else do people bring to the media experience that affects agenda setting?" (p. 70). Does the need for orientation adequately address the "why" question? The responses they provide from the realm of psychological explanations are certainly very relevant to this discussion. It seems that "casual exposure" to a variety of available information that comes to people's attention and, to a great extent, personal involvement with issues that resonate with personal interest, needs or objectives are sufficient to produce agenda-setting effects (p. 74). Personal involvement with issues or objects is described as automatic or deliberative (Bulkow, et al., 2013). Furthermore, the concept of "gatekeeping trust" merits additional attention. McCombs & Stroud (2014) define it as "the perception that journalists have done the 'heavy lifting' to determine the importance of issues and that their news judgments are useful cognitive shortcuts to use in determining the importance of an issue" (p. 78).

Finally, the authors discuss individual choices in the context of digital media. As mass media are in decline, individualized interaction with media content raises new questions about the agenda-setting process. We already know that individuals seek information from sources that provide views in agreement with their own individual beliefs. In other words, they seek confirmation and strengthening of what they already hold as valuable for them. McCombs and Stroud (2014) present different facets of individual media use as predictors of agenda setting. Unique interest, partisan beliefs, types of exposure and the role of niche audiences are scrutinized as different needs for orientations and forms of motivations for information seeking.

Cultural Agenda Setting: Motivations and Orientations

In the context of agenda-setting theory, the term "object" often refers to political personalities or corporate entities. Indeed, in the course of agenda-setting history, scholars have emphasized news and politics, while only recently has there been a significant exploration of corporate agenda setting. One of the objectives of this book is the expansion of the list of "objects." This initiative represents a "centrifugal" expansion,

including significant arrays of human activities such as cultural production and dissemination as well as cultural consumption and leisure selections. This is a vast domain of human activities, comprised of various subdomains and markets, pertaining to both mass and segmented communication processes. Among numerous possibilities, I propose three categories of cultural producers, often recognized as "objects" in agenda-setting explorations. The cultural domain includes cultural organizations, (museums, galleries, libraries, and so on), cultural products or experiences (movies, exhibitions, different types of performance, video games, books, and so on) and creators (artists, writers, directors).

A tentative definition of cultural agenda setting pertains to the nature of the "objects" it encompasses. New cultural "objects" are explored on the foundations of established symbolic structures, derived from the civic and corporate domains. Throughout the history of agenda setting, the so-called cultural domain did not receive significant attention. Virtually no interest was displayed about people's leisure knowledge, perceptions and behaviors as new forms of cultural salience. Furthermore, we need to understand the context in which cultural organizations, products and creators operate. The work of various cultural theorists is of historic value as it provides a significant framework of schools, perspectives and methods that render the cultural domain accessible. This body of literature is extremely useful as we attempt to recognize the nuances of the cultural domain and its observed differences with other domains. From the work of Theodore Adorno, to Stewart Hall and Pierre Bourdieu, if nothing else, we recognize the profound intensity through which the cultural sector has been approached by different schools of thought, documenting the significance of the cultural and leisure domains on the ways people live their lives. The examination of life and the pursuit of meaning itself are strongly related to the basic human motivations that drive cultural production worldwide. Throughout the history of humanity, people write and read influential stories in order to comprehend human nature and the meaning of our existence.

The famous European schools for the study of culture have been primarily concerned with structures of media systems, the production of meaning and, at the other end, differentiated decoding processes, allowing consumers to acquire from myriads of cultural experiences what they perceive as relevant to them. These historic cultural perspectives recognize, among other attributes, capitalist systemic structures producing meaning that sustains a class status-quo, or the significance of cultural capital that empowers members of certain classes and socio-economic status in their efforts to make sense of cultural experiences in such a way that other segments are not eager or interested consumers (Bourdieu, 1984). I further explore various motivations and gratifications that drive leisure choices in the context of a culturally defined, mediated world.

Based on this preliminary information, cultural agenda setting can be described as:

> a media agenda of organizations, products, experiences and creators influencing different public agendas, especially in regards to knowledge, perceptions and public behaviors pertaining primarily to people's leisure time.

This tentative definition emphasizes two specific traits of cultural agenda setting. Cultural objects are identified as distinct entities that merit specialized attention. To that end, the following chapters outline some of the characteristics of cultural industries and cultural markets. Second, cultural agenda setting is about leisure experiences. It is about something people identify, select and engage in during their free time. It is about public perceptions but also about public behaviors as forms of cultural salience displayed through choices during leisure activities.

What drives cultural agenda setting? Various motivations and needs for orientation merit our careful consideration. Apparently, the most important of the contingent conditions has been recognized as people's need for a "cultural" orientation. Although there is no record of specific empirical evidence that clearly explains this particular mechanism in the cultural domain, the vast literature of culture, leisure studies, marketing and public relations documents the peculiarities of the cultural sector and, therefore, a great demand for information in relation to leisure experiences. In other words, there is a great deal of "relevance" and "uncertainty" in relation to cultural content. The so-called "cultural domain" is comprised of a vast array of corporate entities as well as nonprofit cultural organizations and institutions. It is logical to assume that the growing variety and the volume of cultural output increase the need for information about the available cultural production. Furthermore, the sheer population of cultural entities has been steadily increasing over the past half century. This is an expanding market, a trend that can be documented through different indicators: number of employees, number of organizations, volume of available cultural goods and contribution in proportion to national gross domestic products. Consider, for example, the thousands of new museums that have been established worldwide since the middle of the twentieth century. Corporate cultural entities, along with nonprofit institutions and independent producers and creators, have proliferated around the world during the past fifty years. This is a testimony to perceived financial prospects as well as the growth dynamics displayed in the cultural domain. National governments have strategically invested in the cultural sector, capitalizing on market opportunities, tourism promotion as well as public mobilization around causes of national significance. "Cultural diplomacy" is another buzzword that became popular during the twentieth century signifying

the significance of culture in forging alliances and discovering a common ground for developing cooperation among states sharing common national or cultural traits. Different types of cultural institutions and museums in particular became instrumental in the establishment of cultural diplomacy initiatives.

People seem to be attracted by culture as this is a domain that allows for a great deal of freedom of expression and creativity along with corporate opportunities for growth. Culture by definition is very attractive. Along with national governments investing in new museums for the advancement of old or new identities, smaller groups and individuals find the cultural domain extremely appealing either for new business ventures or even for small nonprofit entities with local interest. Individual creativity, growth and entrepreneurship motivate many young businessmen who passionately seek new opportunities. From small galleries, bookstores or small, independent video production firms there are multiple opportunities for people who wish to be active in the sphere of creative economies. However, the greater the growth, the more complex and uncharted this sector becomes. The volume and diversity of cultural output keeps increasing over the years.

One of the elements that renders the cultural domain complex pertains to the nature of cultural experiences. Marketing scholars argue that cultural industries produce primarily, but not exclusively, services related to leisure experiences. Services usually refer to "activities, benefits or satisfactions offered for sale that are essentially intangible" (Kotler & Armstrong, 2010, p. 248). To describe such services as intangible means that "they cannot be seen, tasted, felt, heard or smelled before they are bought" (p. 269). Marketing scholars differentiate between experience and search goods. Experience goods are those for which consumers have difficulty acquiring reliable pre-purchase information. On the other hand, they can easily have access to pre-purchase information about search goods (Nelson, 1970; 1974). Services belong mostly in the experience goods category because of their intangible nature and because consumers cannot acquire easy access to pre-purchase information (Kotler & Armstrong, 2010). Essentially, most cultural goods belong in the experience goods category. Thereby, cultural consumers take risks when investing their leisure time on any cultural experience they select. Cultural experiences are quite different, as they are produced for consumers with individualized or segmented needs, aesthetics and preferences. We have to assume that there is a high need for orientation in regards to cultural products. Siegel & Vitaliano (2007) argue that experience goods have "a high degree of information asymmetry between sellers and buyers" (p. 780). In such complex cultural markets, providing a great variety of cultural experiences produced for every possible public segment, consumers often turn for guidance to friends and peers, but also they turn to the media in order to satisfy their need for orientation.

Scholars argue that people's need for orientation is more pronounced in the cultural sector than in other sectors because of the complexities of cultural markets and the unpredictability of cultural experiences—the fact that consumers cannot safely assess the value and the potential benefit of different experiences beforehand. As Hill, O'Sullivan & O'Sullivan (2003, p. 155) put it, "potential consumers cannot inspect an artistic performance before purchase in the same way as they may, for example, test-drive a car." Because of the observed difficulty, consumers experience an increased public need for orientation that is expected to drive cultural agenda setting (Bantimaroudis & Zyglidopoulos, 2014).

Are Cultural Experiences Relevant?

As we have already seen, "relevance" and "uncertainty" are two lower order concepts related to the need for orientation (Weaver, 1980; McCombs, 2014; Matthes, 2008). Are cultural goods relevant? It seems that they are, at the individual as well as at the societal level. Research originating in the so-called developed countries clearly demonstrates the relevance of cultural products for everyday life. Furthermore, at a societal level, the developed world invests significant sums of taxpayers' money on cultural production. Governments make it a priority to finance everything from national television content, to cinema, museums and theater. Although public subsidies for culture have been diminishing over the past few decades, due to different political pressures, nevertheless national governments continue to allocate significant sums of money, recognizing the value of the cultural sector. Apart from public expenditures, cultural organizations secure new sources of funding from other sectors, rendering culture an extremely relevant field of human endeavor.

Modern citizens in the Western world are quite accustomed spending a great deal of money and investing significant portions of time consuming various types of cultural experiences. Many of those experiences involve travelling in different places. As we have seen, people spend roughly one third of their existence with popular media and various other cultural outlets. Spending an average of eight hours daily renders consumption of cultural content extremely relevant. Furthermore, when they are on vacation, as travelers and tourists, they spend additional time on museums, landmarks, archeological sites, theme parks and numerous other destinations. People routinely make leisure decisions that determine the way they experience one third of their entire human existence. At the individual level, relevance may vary from consumer to consumer and from segment to segment. People seek different experiences in order to acquire information and knowledge and therefore satisfy their intellectual curiosities; or they try to relax, escape and generally tune out from the burdens of everyday life; or they try to understand

themselves. They interact with different categories of content, including various types of narratives, to know human characters and personalities while identifying with their needs, passions, curiosities and motivations. As a matter of fact, one of the basic reasons people write and read literature over the centuries is driven by this fundamental desire and need to understand ourselves. Furthermore, our leisure experiences deal with our understanding of our social world. In other words, these experiences give people something to talk about. They provide opportunities for socialization and interaction. Individuals display all of those motivations while the relevance of each varies from person to person.

The significance of cultural experiences was emphatically documented in a medical study by Konlaan, Bygren and Johansson (2000). As they gathered data from a fourteen-year cohort research of 10,609 individuals in Sweden, they assessed mortality risks between those who regularly go to movies, concerts, museums and art exhibitions in contrast to those who refrain from those cultural activities. Their findings "indicate that people who attend certain kinds of cultural events seem to live longer than those who rarely do" (p. 177). I don't think there could be more compelling evidence favoring the degree of relevance of cultural consumption. In this particular project, it seems to be a matter of life and death. In most cases, cultural consumers consider their cultural choices while trying to enrich their lives through improving the quality of free time.

One of the goals of leisure studies research is to assess the degree of relevance of certain experiences for specific public segments, while different experiences may be totally irrelevant for the same group. For example, a group investing a great deal of time on video games consider this experience to be extremely relevant for its leisure time, but may find another experience, such as reading a book, irrelevant and not worth allocating time to. Certain groups may find opera very important, whereas others may find it irrelevant and be completely indifferent towards it (Bantimaroudis & Zyglidopoulos, 2014). A recent study on the demand for opera in Finland is revealing of the segmented nature of this particular cultural experience, as well as its current resemblance to popular experiences. According to Laamanen (2013), "demand is found to be higher for premiere nights and for operas in their premiere season than for reprises. Finnish opera pieces are more popular than foreign. Non-classical pieces are more popular than classical, and modern pieces are less popular after their premiere season than others" (p. 431). Indeed, the segmented nature of this specialized cultural service acquires distinct characteristics for the Finnish people, while in other settings it may be experienced differently. As cultural industries invest in the production of an immense variety of cultural products and experiences, they are designed to provide experiences that appeal to different segments. Thereby, different groups have a variety of choices for their leisure activities.

As we investigate the agenda-setting process in different domains, it seems that the cultural domain is much more fragmented than other domains (Weidman, 2016). Researchers emphasize the segmented nature of cultural markets, as the relevance of cultural products and experiences varies significantly among individuals and groups of consumers. Politics appeals to mass audiences or large segments; political parties and their candidates promote policies that affect entire societies. The same principle may apply to popular entertainment, often attracting mass audiences at a global scale. The release of the movie *Star Wars: The Force Awakens* is an example of an international production of mass appeal, breaking box office records and meeting wide acclaim by viewers of different demographics. On the other hand, only small segments may be interested in opera, drama, literature, art-house films or classical music. Just a few individuals with specialized interests display a need for orientation about the latest production of *The Marriage of Figaro*, Mozart's most popular, comic opera, or *Fidelio*, the only opera composed by Beethoven. On the other hand, millions of people watch *Star Wars*, or listen to Mariah Carey's and Lady Gaga's music. Some market segments associated with popular entertainment are usually much larger than other segments, such as blockbuster movies, popular music and video games, but it is logical to assume that relevance to cultural products displays a greater degree of fragmentation than relevance to political issues. Therefore, we expect the agenda-setting process to apply in some cultural markets with a greater display of fragmentation.

Cultural Uncertainties

Uncertainty is the other lower order concept that is related to people's need for orientation. It refers to the availability of information that an individual needs in order to comprehend an issue and perhaps make informed decisions (Weaver, 1980). In the cultural domain, specialized information is needed in regards to particular products in which individuals consider investing their time, money and energy. Individuals often pose some of the following questions: Is this experience worth the money and time invested in it? Is it enjoyable? Does it offer new knowledge or information that is of value to me? What do other people think about it? Occasionally individuals are willing to risk a behavioral change, investing in a segmented experience that they have not previously had the chance to try out, such as going to the opera house or attending a symphony orchestra. For someone who is not well versed or lacking sometimes fundamental knowledge about certain cultural experiences, there is certainly an increased need for orientation. Under certain conditions, such pieces of information are often highly unreliable because cultural products are usually experience oriented, so the capacity of potential consumers to assess relevant information pre-purchase is usually limited

(Nelson, 1970, 1974; Siegel & Vitaliano, 2007; Kotler & Armstrong, 2010). Furthermore, the past performance of cultural producers does not guarantee a successful future performance (Mott & Saunders, 1986). Even the views of experts in the cultural domain, such as film critics and book reviewers, may be of particular appeal to certain groups of potential consumers, while leaving other groups totally indifferent or in direct disagreement. Even critics, despite their knowledge and expertise, are subjective receivers of cultural content and therefore express views that are not always helpful for certain segments of potential consumers. For example, many people openly express their distrust in film critics, relying instead on their own previous experiences, greatly enjoying a movie for which they read negative reviews, while having a totally negative experience with a movie that received rave reviews from professional critics. Cultural scholars have written extensively on selective reading and individualized retention (Ravid, 1999; Hirschman & Pieros, 1985).

Because of the high uncertainty that surrounds cultural products, the need for orientation in cultural markets is further enhanced. It is hard to convey to a potential consumer the meaning or value of a theatrical performance before the play. Although critics try to diminish the uncertainty factor, pre-show information or other people's opinions are not always a reliable indicator of the actual performance. One can rarely be certain before the show that the two hours will not be wasted. Of course, this uncertainty may be sometimes mitigated by the fact that the producer, individual or corporation has a reliable history of quality productions, but as Holbrook & Schindler (1994) point out, "reliance on creative intuition in the design of cultural offerings remains difficult, expensive, and prone to error" (1994, p. 412). There are many examples of producers of very successful cultural products who followed up their successes with spectacular failures. According to Holbrook & Schindler (1994, p. 412), cultural goods are "complex gestalts" whose evaluation beforehand is extremely difficult even by those who produce them. As Mott & Saunders (1986) point out, even famous producers like Steven Spielberg have, over the years, produced unsuccessful movies, which could be referred to as "expensive flops." Salganik & Watts (2009) present several examples such as the *Harry Potter* books, which were turned down by eight different publishers before selling millions of copies and becoming an international franchise phenomenon (p. 441). According to Hesmondhalgh (2013), eight out of nine music products fail, whereas just one out of fifty books reaches wide acceptance. Therefore, Holbrook & Schindler (1994) conclude, cultural goods are highly uncertain and there is an acute need for guidance.

Moreover, the uncertainty of cultural goods is further enhanced by the fact that the tastes of individuals evolve throughout their lives, and thus their experience with a given cultural product will fluctuate. Cultural experiences over time are formulated as individuals grow up in

the context of environmental and societal alterations that influence the ways these individuals consume different cultural products. So the experience a consumer acquired from a cultural good at a certain point in their lifetime may be different from what this person will experience from the same product at another point in time. We have all had the experience of rereading a book after many years, and finding that the second reading provided a completely different experience than the first (Bantimaroudis & Zyglidopoulos, 2014). Because our experience depends on a dynamic interaction between the consumer and the cultural good, the uncertainty factor increases over the years. Scholars have commented extensively on this cultivated relationship between cultural consumers and their texts. For example, DiMaggio (1987) argues that "those with less finely developed schemas will view Beethoven and Puccini, or country music and rock and roll as substitutes for one another" (1987, p. 196). Those cultivated stands toward different types of texts develop in individuals during the course of a lifetime but they differ significantly across different groups of consumers. Furthermore, accessibility is an issue when seeking people's perceptions about different experiences. It is certainly easier to find individuals across different demographic groups who have watched the latest *Star Wars* movie, than finding individuals, for example, who have attended *The Marriage of Figaro* in the Seattle Opera house. There are great differences in those experiences both in terms of distribution as well as access. Certainly, the famous sociologist Pierre Bourdieu would have been very vocal about the cultural capital necessary for accessing as well as understanding and appreciating certain texts. The audience for blockbuster films such as George Lucas's productions is by definition much larger than opera productions. Finally, the degree of media coverage and visibility of the *Star War* movies by far exceeds other popular films, let alone opera productions or museum exhibitions. Opera-goers by definition constitute a small segment in the global cultural market.

Although there is limited empirical evidence of cultural agenda setting, secondary testimonies acquired from different academic fields provide enough insights to build a case for the transfer of salience in the cultural domain. If the need for orientation has been recognized as a driving mechanism that determines agenda-setting influences in the civic domain, the same compelling need must be prevalent in the cultural domain. Both cultural relevance and uncertainty seem to be defining attributes of the cultural domain. However, because the cultural domain is so fragmented and diverse, with some public segments being more dominant than others, there is a varying degree of relevance and uncertainty displayed toward cultural experiences. Both relevance and uncertainty depend on the available information that the public can access conveniently and before investing time and money on cultural content. Some people argue that agenda-setting phenomena are mitigated in popular

culture markets because of the emphasis on promotional campaigns undertaken by global conglomerates. On the other hand, the transfer of salience may be more visible in the realm of nonprofit organizations, whose market power is smaller and where every promotion effort can be easily accounted for, measuring small-scale effects. These hypothesized relationships offer opportunities for future research as different cultural markets represent a significant domain of human activity.

Consumer Motivations in the Cultural Domain

McCombs & Stroud (2014) cite significant additional evidence as to why agenda setting occurs. These psychological motivations go beyond the established need for orientation. I would like to revisit their work while offering some additional thoughts in regards to the "why" question. We have already seen that one of the central questions that McCombs & Stroud (2014) pose is the following: "What else do people bring to the media experience that affects agenda setting?" (p. 70). Their responses provide significant insights for future explorations, with potential applications in the field of leisure and cultural activities. If for example, "casual exposure" to a variety of information produces agenda-setting effects, it is likely that "casual exposure" to digital cultural content may produce similar effects. Casual exposure to a particular kind of political content may be linked to various factors, including ideology and partisanship. Furthermore, digital media platforms render their content easily accessible to casual seekers of leisure experiences. Casual exposure in the cultural domain may be linked to a type of identity, personality or group need. This notion seems relative to the concept of "personal involvement," either automatic or deliberate. If it provides significant explanations for civic or political engagement, it also raises significant questions in the context of leisure perceptions and selections.

Furthermore, the concept of "gatekeeping trust," the idea that journalists do the "'heavy lifting' to determine the importance of issues" (p. 78), may be extremely useful in the diverse cultural and leisure domains. In a study on art-house films, we extensively explored the concept of critical valence, the idea that film critics, specialized media writers and columnists lead the way in establishing salience (Symeou, et al., 2015). Trusting the gatekeepers as mediators who can provide accurate, useful and reliable information may be revealing of moderating effects that lead to salience. The mere availability of content provided by critics may not produce significant agenda-setting effects, if critics are not perceived as trustworthy. Because so little empirical research has been conducted in this area, there is significant space for new explorations. Stroud (2011) has emphasized the role of individualized interaction with digital media content. She has already established in the civic domain that digital platforms empower news consumers to seek information

from digital sources that strengthen and confirm what they already hold as valuable for them. McCombs & Stroud (2014) explore the roles of partisan beliefs and types of exposure catering for the needs of individuals as intervening factors in agenda-setting processes, the role of niche audiences as moderating influences among orientations and motivations for information seeking.

Adding to this evidence from the civic domain, I would propose considering some sociological evidence from the cultural domain. What motivates people to interact with cultural content when agendas are set in both mass and segmented contexts? Cultural scholars, media theorists and sociologists enrich this discussion by adding the constructs of identity, cultural capital and the uses and gratifications approach. Falk (2011) differentiates between "Identity" with a capital "I", encompassing stable identities such as race, ethnicity, religion and national origin; and "identity" with a lowercase "i," which "may include one's sense of being a member of a family, a good friend, or even a valued employee" (p. 144). He has consistently argued that these fluid descriptions of identity play a significant role in how people spend their free time. The lowercase "i" descriptions of identity provide useful insights into daily leisure decisions. They may explain motivations for interaction and consumption while moderating agenda-setting influences. I am convinced that interdisciplinary research endeavors often provide new understandings as different literatures are merged under commonly explored questions. Falk (2011) applies his identity typologies to museum visitation, but these may also be applicable in different cultural settings, or even other domains beyond culture. According to Falk & Dierking (2013), museum visitors can be classified into seven groups, driven by identity defined orientations: explorers, facilitators, professionals/hobbyists, experience seekers, rechargers, respectful pilgrims and affinity seekers (p. 49). The role of identity as a motivation has been acknowledged by Abercrombie & Longhurst (1998), arguing that audiences assume different roles in a world of spectacle and performance. Audiences construct their identities as they actively select from endless messages about what to accept and modify to fit their sense of identity. Furthermore, the notion of cultural capital is significant in this context, as members of certain groups, usually of higher socioeconomic status, have the decoding capacity to make sense of certain messages. This is why museums appeal more to certain demographics of more affluent and educated consumers. Bourdieu's work demonstrates that certain segments are more motivated to interact with specialized content (for example, museum exhibits) because of their background, knowledge and their capacity to decode information not always accessible to the general public.

The pioneers of the uses and gratifications theory, media theorists Katz, Gurevitch & Haas (1973), examined 35 different needs satisfied by the media, which they classified into five distinct categories: (1) cognitive needs,

(2) affective needs, (3) personal integrative needs, (4) social integrative needs and (5) tension release needs (pp. 166–167). The uses and gratification theory views audiences as goal-oriented and free to use the media in order to satisfy certain wants and needs. These gratification-based motivations for interaction with media content provide a descriptive map of consumers' motivations. The literature interconnects different pathways of wants and needs with other significant paradigms such as the incorporation/resistance and the spectacle/performance paradigms. Collective evidence derived from different schools, disciplines and approaches is quite revealing in regards to the motivations that drive content selection and consumption.

This evidence emerging from different fields and scholarly interests presents a diverse set of explanations of what people bring to the agenda-setting processes. They elaborate on needs for orientation in a media-saturated digital ecosystem. Relevance and uncertainty become key factors related to individuals' need for orientation as they become motivated to seek certain types of information. Furthermore, trusting specialized gatekeepers and the type of exposure have been identified as moderating factors. However, what other factors enhance people's need for orientation? How relevance and uncertainty as individual needs interact with one's sense of identity? Although this is a complex question, the literature confirms that identity constitutes a key driver for various forms of visitation. Falk and Bourdieu enrich our media-oriented quest with valuable sociological perspectives. Both the concept of identity and cultural capital need additional scrutiny in media studies not only in terms of what individuals search for consumption but what, by definition, they become discouraged to seek, because they lack the skills and the codes in order to interact with certain texts.

Finally, goal-oriented, behavioral motivations such as the uses and gratifications tradition provide a descriptive map of consumers' wants

Table 1.1 Orientations and motivations for cultural consumption

Forms of Cultural Consumption	Motivations	Orientations
Visitation	Identity	Personal Relevance
Attendance	Cultural Capital	Social Relevance
Searching	Performance	Emotional Relevance
Sharing	Uses and Gratifications	Uncertainty
Gaming		Gatekeeping Trust
Viewing		Personal Interest
Listening		
Reading		
Participating		

Sources: McCombs & Stroud, 2014; Weaver, 1980; Falk & Dierking, 2013; Bourdieu, 1984.

and needs. However, uses and gratifications should be examined in conjunction with the paradigms that explain why people display the identified needs. In other words, how identity-related motivations, along with the psychology of selections and interactions, guide how individuals perform their wants and needs in spectacle-defined contexts. Combined evidence of orientations and motivations may shed additional light on agenda-setting influences. Along with evidence accumulated within the field of journalism and media studies, focusing on relative knowledge gathered from other areas of social sciences and humanities might make us more suspicious about hypothesized influences and hopefully more eager to look over scientific fences as many of the answers we seek might be already there. Certainly the agenda-setting paradigm will benefit from such collaborations as its already expansive literature will provide richer and convincing answers for the lingering questions about salience.

2 Cultural Markets, Organizations and Experiences

In Chapter 1, I discussed people's need for orientation and their various social and psychological motivations for interaction with cultural content in a global, complex, asymmetrical and segmented cultural domain. Various needs for a cultural orientation in combination with social and psychological motivations are the primary drivers of cultural agenda setting. Reviewing secondary evidence suggests that cultural experiences are very relevant for most people as culture is linked to individuals' searching for meaning, the construction of identities and the strengthening of personal values. Furthermore, the average person displays needs for information, entertainment, escape and diversion. As the nature of modern urban life burdens people with various physical and psychological loads—working, raising a family, financial insecurity, political and social instability, health issues—it is reasonable for people to seek different routes of escape. Leisure activities provide consumers with those exit points from everyday burdens.

I argued that the vast supply of cultural goods takes place in a highly uncertain global environment, especially in terms of the perceived value of each experience. It is difficult to assess the value of cultural goods before their consumption and therefore there is significant evidence of a high need for orientation in this very exciting as well as complex and unpredictable cultural domain. In this chapter, I attempt to describe the cultural domain in terms of its market structure, the different types of organizations and corporate entities and the variety of cultural output that becomes available for consumption. The cultural domain generates a great deal of interest and excitement worldwide. I have described a trend toward cultural, leisure, creative and experiential transformations that involve corporations, cities and different types of producers and creators. Those collaborations have redefined metropolitan areas in the world with a current, continuing effect in non-western cities and even in the most unlikely cultural markets. Consider, for example, the recent developments of the Louvre and Guggenheim Museum projects in the United Arab Emirates. By tradition, museums represent the conservative players in the cultural domain. This huge investment in museums in the United Arab Emirates is indicative of significant changes

in museum markets. The numbers are quite staggering: Approximately $27 billion will be invested in the cultural and tourism center of Saadiyat Island. "The construction of the Guggenheim was originally said to cost $800 million and the Louvre $500 million."[1] According to *The Guardian*, "The Louvre branding itself is worth over half the value of the total: £344 million for a period of 30 years," while "a similarly gargantuan sum was promised to the Guggenheim."[2] Built on Saadiyat Island near the center of Abu Dhabi, this extravagant cultural complex will not just be the home of the Louvre and Guggenheim, Abu Dhabi; it signifies a huge shift in the cultural policy and strategy of the Persian Gulf region, an example of a global investment in a cultural market that is expected to provide strategic advantages to a region strongly associated with the oil economy.

The cultural center on Saadiyat Island is an excellent example of cultural agenda setting. It was established as a dominant organizational image: those who envisioned it relied on established museum brands before the construction of the complex had even begun. Naturally, they made a global mediated impression, securing major headlines and glamorous coverage even before there was any new infrastructure in Abu Dhabi. Its long-term objectives involve influencing global perceptions about an innovative, creative, experience-oriented global hub that subsequently will attract visitors, investors and innovators. Culture is a significant business that relies on agendas of images in order to capture the attention of potential viewers, visitors, readers and even players. But it goes beyond the expected relationship between producers and consumers of culture. National governments utilize cultural investments to convey messages beyond their domestic public for the promotion of international policies, diplomatic agendas and national branding. It is common knowledge that national museums are not just producers of cultural experiences, though they increasingly tout themselves as entertainment providers; however, they are so much more than that. They serve as bridges among cultures carrying out different missions involving cultural diplomacy, strengthening different conceptualizations of identities and providing international forums for different ideologies. In many cases, taxpayers and wealthy patrons provide funding for those enlarged missions that surpass the mundane objectives of ordinary corporations—attracting visitors, customers and participants. Bringing attention to national causes or even constructed identities along with strengthening cultural alliances while improving bilateral international initiatives is often deemed worthy of the political effort and the taxpayers' money.

Overall, museums, galleries and libraries receive more attention than in the past. According to Kawashima (1998), who cites the Museums and Galleries Commission in the United Kingdom (UK), annual museum visitation exceeds attendance at football matches. Although there is a significant difference between the number of visits and the number of

visitors, a record of more than 100 million visits every year is indicative of the attention attributed to modern museums. However, culture should be examined not only in regards to market structures and revenues, but in terms of its broader role of exporting the collective psyche of human history: love, suffering, identity and conflict. These are elements that often become commodified, though there are significant exceptions that go beyond economics and finance. Critics would point out that commodifying culture has profound effects on the way people experience the world. And though a great variety of experiences are produced with diverging attributes and values, various critics would be quick to point out that all information somehow assumes a form of entertainment. In this sense, even the most painful and heartbreaking messages can easily be twisted to become mass infotainment products desensitizing global consumers toward apathy and carelessness. At the same time, the reality of the world tells a very different story of devastation and despair calling for political action, empathy and individual participation. I will return to those thoughts at the end while discussing Neil Postman's seminal thoughts about amusement in relation to modern media.

In the current chapter, I focus on the structure of cultural industries aiming primarily at those distinct characteristics that might render cultural entities visible, symbolically valuable and reputable. Therefore, this discussion of the available literature has a particular aim that revolves around the greater issue of salience. As we revisit the structure of the cultural domain, several questions should be considered: Which are the dominant characteristics of the cultural domain? Why do cultural entities strive to establish their mediated presence? Which cultural traits render cultural producers visible in this distinct domain? Furthermore, which types of cultural attributes are more likely than others to aid the establishment of mediated agendas? This literature review draws from different subfields with the aim of creating a holistic picture of an entire domain in terms of its agenda building capacity.

Developments in the Cultural Domain

The study of cultural organizations is complex; specialists present a multilayered web of relationships, creating a framework of cultural economics, politics, social structures and leisure practices. Furthermore, the cultural domain is very dynamic as it absorbs creative assets, economic forces, technological developments and policy initiatives. Because most countries set national priorities recognizing its strategic significance, culture gathers political, economic, technological and social forces that converge in the sphere of cultural production. Furthermore, the degree of competition has intensified as various political and social stakeholders pursue different interests in this dynamic domain. The ways those markets are approached by different observers vary significantly. Some

adopt an optimistic view toward those cultural transformations. They argued that investing on creative, experience-based economies will lead to significant progress and market upgrades; new terminology emerged such as "creative clusters" (Porter, 1990) or "creative class" (Florida, 2014). They present significant arguments that global demand for cultural experiences—which by nature are interconnected with the creative class and experience-oriented industrial provisions—will lead toward the generation of new opportunities, economic expansion and added value. Florida (2014) converges with Pine and Gilmore (2011) as they adopt a pro-creativity stand that will initiate additional transformations in different cities, markets and even entire societies. On the other hand, critics adopt a radically different standpoint. The notion of creative industries encompassing not just a narrowly defined concept of cultural industries but an enlarged notion of information-related industries, along with cultural providers is seen as problematic; it encourages class structures while prolonging societal inequalities (Garnham, 2005).

Scholars recognize that during the past four decades, there have been massive observable changes leading to significant transformations of cultural markets. Hesmondhalgh (2013) identifies key economic and political factors that progressively applied pressure to major western cultural producers, leading to profit shrinking and intense competition. Western cultural markets encouraged deregulation while curtailing labor rights, cutting spending and pursuing mergers and organizational alliances. Industrial producers of cultural goods "attempted to restore higher profits by investing abroad in order to spread fixed costs and make the most of cheaper labor markets, as real levels of pay rose in advanced industrial countries" (p. 105). Furthermore, the internationalization of cultural production has forced major corporate players to pursue innovation and digitalization. Rapid and extensive changes left no one unaffected at a global level. The cultural domain is highly interconnected, with changing trends in one type of cultural entity affecting most of the others. Occasionally one type of industry may compete with another, while on different occasions they both benefit from strategic alliances. Bustamante (2004) follows a similar conceptualization of cultural industries. In a matrix of cultural entities, he includes cinema, music, books, the press, television, radio and video games. He converges with other cultural theorists in recognizing a common thread of developments in cultural markets: deregulation, concentration and globalization. Although he recognizes transformational trends that cut across different industries and cultural markets, he is hesitant to talk about a communication revolution. "The most evident finding of a sector-by-sector study is that there is a consistent line of continuity and that digital change does not engender a revolution, an abrupt rupture with past history, because the new technologies cannot erase the core nature of the media within modern capitalist society" (p. 805).

There is no doubt that the twentieth century has seen a marked industrialization of culture. Not only intellectuals but also consumers of cultural experiences recognize a mass, standardized production and dissemination of cultural goods. As this has intensified not only due to cultural industrialization but also because of a massive merging of cultural industries, the result was the establishment of mega cultural entities producing a wide diversity of products for global markets. Global conglomerates brought cultural output to a new level with diversified fields of production, with different internal rules, market structures and segment behaviors.

Not all scholars conceptualize cultural industries in the same way. For example, Hesmondhalgh's (2013) valuable presentation of cultural industries remains focused on popular entertainment providers. It largely ignores the nonprofit cultural sector, which, however, represents a significant branch of cultural goods and accompanying experiences. Since the 1980s, when major corporate conglomerates expanded internationally, extending their sphere of influence in different geographic areas around the world, the nonprofit sector was equally affected by market developments and socioeconomic policies. Different conservative governments decided that subsidized culture was expensive, burdensome and unproductive. Furthermore, the massive proliferation of cultural entities rendered cultural funding from state sources inadequate. Museum executives witnessed continually diminishing public funding from year to year. Therefore, as cultural organizations were multiplying, state subsidies for cultural causes were shrinking. In the UK, according to Twitchell (2004), "Thatcherism 'cut loose English museums from what was sometimes 90 percent funding' (p. 197). The same happened in France, a country with a long tradition of cultural subsidies and state endowments. Despite the fact that France still preserves policies for state cultural support more than other industrial western countries, this new trend forced internationally known cultural organizations to seek financial support from the private sector, in order to retain some momentum and pursue future viability. Twitchell (2004) says that "until 1993, the Louvre was [still] entirely state funded," whereas in 2004 it had to find "30 percent of its yearly operating costs on its own" (p. 197). This significant market change, initiated by conservative governments in the 1980s, has had a profound impact on the museum sector. Jaffry and Apostolakis (2011) report similar findings. In their case study on the British Museum, they point out that cultural institutions in Britain have been very active in fundraising, drawing money from private sponsors and encouraging individuals to make donations. American museums are subject to similar pressures. Skinner, et al. (2009) observe several problems in museum finances, some of them dealing with the countercyclical nature of museum attendance. This plainly means that often museum visitors increase when public funding is not available while the

number of visitors decrease when there is available funding for museums. Museums go against business cycles, which are described as procyclical. Among many other factors, these peculiarities of the museum market increases the level of financial uncertainty. According to Skinner, et al. (2009), "the state of the economy, the political make-up of Congress, tax incentives, and the charitable nature of museum supporters, along with many other factors, affect donation and contribution levels. In 1998, according to the American Association of Museums (1999), these institutions used private sources (32.3 percent), earned income (28 percent), investment income (11 percent), and governmental sources (27.9 percent) to fund their operations" (p. 492).

The fact that museum managers seek the advice and in many cases the services of marketing and public relations specialists is indicative of the aforementioned difficulties. Kotler, et al. (2008) have persuasively argued that modern museums, without significant exceptions, execute long-term strategies knowing that their survival depends on their own marketing initiatives. Since government support is no longer guaranteed, one of the core strategies of modern museums is maximizing the numbers of their potential visitors, drawing people from different public segments, even from those who traditionally are not seekers of museum experiences. In this context, marketing terminology, such as brand, image and reputation, progressively became standard terminology and practice (Smith, et al., 2005; McNichol, 2005; Olkkonen & Tuominen, 2006).

Therefore, I contend that the nonprofit sector is quite sufficiently industrialized to merit our attention and even be included in the same map of cultural activity worldwide. However, despite the fact that museums and galleries are engaging in business tactics to increase their visibility, brand value and eventually revenues, their market size represents only a fraction of the main market of popular cultural industries. The same principle applies in time invested in them by consumers of culture. Only a small portion of leisure time is devoted to museums, galleries and libraries, whereas almost one third of people's entire existence is claimed by popular entertainment providers. Even the largest cultural institutions of the world, like the Louvre, the Smithsonian and Guggenheim, in terms of size, are dwarfs of the global cultural activity.

Cultural Industries and Cultural Theorists

Studying cultural industries and the various products they produce allows researchers to assess consumption patterns and the specific needs they satisfy. Early in the twentieth century and especially in the 1930s, the famous thinkers of the Frankfurt School discussed the notion of a cultural industry, while the French sociologists of the 1970s referred to the cultural industries (in the plural). Cultural theorists have written extensively about the nature of cultural production. The entire field

comprises various subfields such as political economy, cultural studies and the sociology of culture. Collectively, they display commonly recognized traits: As they are primarily associated with the ideology of the left, they are highly critical of the liberal economies of the west, they engage in sophisticated discussions on the nature of mass production of culture and they present varying modalities for textual interpretation and reception. This vast critical discourse generated from multiple perspectives is primarily academic in nature. Critics of industrialized cultural productions focus on cultural markets in capitalist settings, characterized by intense inequality and class distinctions. The element of class is strongly related to cultural consumption tendencies, as segments of different socioeconomic status are linked with different selections and leisure trends. Furthermore, the relationship between cultural producers and various institutions and agents of social power is well established and documented. The question of representation—whose voice is heard and what does it mean—has been of particular importance in the cultural studies tradition. Scholars have consistently identified the significance of people's leisure time and recognized that cultural productions emanate from different types of experiences that people seek and from which they receive a sense of identity, orientation, guidance, as well as various types of gratifications. The terms "product" and "experience" are often used interchangeably to describe the output of cultural industries, though certain scholars differentiate between the two, arguing that cultural organizations produce both "products" of a material nature, along with experiences, intangible services manifested in time spent to satisfy leisure needs. Although there are differences between products and experiences, I adopt the view that consumers of culture are primarily experience seekers. Even tangible cultural creations carry symbolism, as significant narratives evoke a sense of significance. Therefore, I have used the term "experience" as a common denominator for all cultural output.

Despite the vast available literature on culture, representatives of cultural industries and distributors of cultural goods are in most cases indifferent about extensive essays of Marxist orientation, confined and codified within academic ivory towers. The worlds of cultural producers, consumers and critics rarely converge with one another. Industrial producers of culture as well as the average lay consumer of leisure experiences are in most cases oblivious to academic criticism reiterated in language and style far too technical and abstract to be comprehensible by larger segments of society. Ironically, though criticism of cultural production aims at awakening the average consumer to a more informed and critical stance against industrialized cultural production, representing the interests of established class segments, the nature of many texts renders them accessible to readers defined by high socioeconomic status and refined reading and analytical skills.

In this chapter, my goal is not to repeat well known descriptions of the cultural domain or to recite established cultural and critical perspectives. For a holistic presentation on cultural industries, David Hesmondhalgh's book *The Cultural Industries* (2013) provides a detailed account of the field. Furthermore, *Cultural Theory: An Introduction* by Philip Smith and Alexander Riley (2008) offers a comprehensive, well presented overview of the most significant theoretical perspectives in this vast domain. Rather, I draw from the cultural literature with the aim of highlighting some of the sector's more recognizable traits, especially those that render cultural entities salient in media content and arguably in the public conscience. As we have already seen, "attributes" are significant building blocks of "objects" that are profoundly related to salience. Thereby, there is an agenda-setting perspective that guides the basic arguments presented here.

So, what is culture? The term has encompassed various different elements. However, for the purpose of the current book, I focus primarily on markets and leisure activities. In a traditional definition, DiMaggio (1987) refers to the "symbolic works produced in formally organized sectors of the economy—that is, materials produced for an audience, widely recognized as 'cultural artifacts,' and distributed through established channels" (1987, p. 195). Although cultural production involves material things—museums are full of them—cultural specialists recognize that culture is mostly about symbols. It is about intangible elements, primarily "texts" that people read in various ways. Those who appreciate the varied nature of cultural production, appreciate the value of symbols. The widely differing value of these symbols is primarily determined by their potential for consumption by different groups of people, in different locations and in different time periods. As texts are consumed, they are experienced in different ways. This selective reading/decoding of texts by different audiences has generated significant attention, especially in the context of the British cultural studies tradition (Williams, 1975).

The industrial production of symbols has attracted significant scholarly attention throughout the twentieth century. In the 1930s, the Frankfurt School theorists wrote extensively about the value of symbolic production. They were the first to differentiate between "high" and "low" culture. Drawing from a Marxist theoretical toolbox, they argued in defense of this dichotomy of cultural production, associating the former with class, domination and socioeconomic status and the latter with subordination, poverty and the masses' inability to distinguish between valuable and less valuable symbols, while displaying any subversive mobility against those who maintain control over the means of production. This dichotomy of high/low culture later met with significant resistance and refutation at different levels. However, the Frankfurt School definitions prevailed in scholarly discourse until the middle of the twentieth century. People tended to associate "High" culture with certain cultural experiences such as classical music, museums, art galleries and operas,

whereas "low" culture included popular goods such as films, music, radio and later television. Since the 1950s, scholars have moved away from the Frankfurt dichotomy. Lash & Lury (2007) argue that "culture no longer works—in regard to resistance or domination" but it is displayed primarily as a "superstructure" (p. 4). Furthermore, Campbell (1988, p. 16) critiques this artificial distinction between high and low culture:

> 'High culture,' standing for good 'taste' and often supported by wealthy patrons and corporate donors, has become associated with 'fine art' which is available primarily in libraries, theatres, or museums. In contrast, low or popular culture has become aligned with the questionable tastes of the 'masses' who enjoy the commercial 'junk' circulated by the mass media. Whether or not we agree with this cultural ladder, the high-low hierarchy has become entrenched, often determining or limiting the ways culture is discussed today.

Segmented preferences in consumption habits attract the attention of cultural analysts as various groups are divided by complex and highly unpredictable distinctions. Cultural producers also display significant differences. Usually, museums, opera houses and galleries tend to be nonprofit or state controlled organizations, catering to the needs and aesthetics of upper-class, more affluent and better educated segments of society (DiMaggio, 1987, p. 201). Why this is the case is a question tackled by different theorists, but most notably, by the French sociologist Pierre Bourdieu. Bourdieu developed some key concepts explaining why certain groups are more equipped to process specialized cultural experiences, which leave most low class groups largely indifferent. Furthermore, those segments that favor interactions with museum content, for example, benefit from their cultural choices or perceive their cultural selections as valuable, advantageous and conveyors of an additional sense of worthiness.

On the other hand, popular culture providers vary a great deal, including large conglomerates or established business entities catering to the needs of very large segments of the general public. Occasionally they aim at global markets with products of mass appeal. There are, however, small or medium size producers catering to the needs and aesthetics of niche audiences, often defined by national, regional, linguistic or other elements. Popular goods are consumed by everyone, both rich and poor, educated or less educated, upper-, middle- or lower-class. The literature documents an overall versatility of upper-class consumers navigating easily along multiple types of experiences, regardless of classifications and descriptions, while lower-class consumers remain at large loyal to popular cultural goods. Therefore popular culture providers engage in commercial, large-scale productions with greater potential for profitability, whereas other producers of specialized products are usually nonprofit organizations catering for the needs of smaller segments with

fine tastes. Sometimes, nonprofit entities rely almost exclusively on rich donors or state grants while those entities' recent transformations render them accessible to middle-class consumers.

As I explore the differences among cultural organizations distributing a wide array of cultural goods, it is important to examine their promotion capacities and strategies. Usually, popular entertainment providers engage in aggressive and extensive promotion campaigns, having the vast resources to flood cultural markets with intense advertising. On the other hand, nonprofit institutions usually operate with smaller budgets and personnel, being by definition subject to various strategic limitations. Often, nonprofit entities do not aim at maximizing the distribution of specific cultural experiences but at attracting donations from wealthy patrons or subsidies from governmental cultural resources (Bantimaroudis & Zyglidopoulos, 2014). For example, symphony orchestras in the United States reportedly earn approximately 35% of their income from selling concert tickets, while the rest of their revenues are derived from endowments and other forms of private donations and public subsidies.[3] However, things are changing. Many nonprofit organizations realize that the available public funding for cultural causes is not only diminishing, but is claimed by an increasing number of cultural producers. The number of museums, galleries and libraries has been steadily increasing during the past fifty years. Because of the rapid proliferation of cultural organizations and institutions, public subsidies have to be divided among more recipients. In trying to survive these budget cuts, cultural organizations have been undergoing significant transformations. As Lampel, et al. (2000) put it, "to survive, organizations in cultural industries must reconcile the demands of artistic production with those of the marketplace" (2000, p. 265). For example, museums have been forced to recognize the necessity of maximizing their potential visitors (Kotler, et al., 2008, p. 154) and have started utilizing all the available communication and marketing tools for the establishment of their brands, while promoting new, diversified forms of cultural goods. But even if many of the organizations populating the cultural domain have started to use marketing and promotional techniques to increase their revenues and promote their goods and services, they are still far behind the corporations of the popular culture domain, which possess vast resources and experience (Bantimaroudis & Zyglidopoulos, 2014).

Cultural Attributes

Drawing from the literature on culture, I trace what I consider the most recognizable traits of cultural entities that render them salient in media content as well as in public perceptions and behaviors. These traits or attributes are significant thematic areas that scholars as well as practitioners recognize as important.

Cultural Economics

Cultural scholars increasingly scrutinize cultural organizations, which function at the center of economic activity and whose turnover has become of major significance for the gross domestic product of many countries. Cultural output is increasingly viewed as an indicator of an advanced economy, technological innovation, job growth, creativity and urban development. Economics is a big part of culture. Even producers of blockbuster films tend to release details of the cost of their production as an indicator of the significance of the film, information which is readily available to prospective viewers. As a matter of fact, a film's budget constitutes a visible attribute that researchers take into account while assessing, visibility, symbolic value and marketing practice.[4]

Cultural investments are traced at different levels—at the individual creator/producer level, small businesses, medium-size corporations and global conglomerates. Naturally, global firms attract most of the attention. Major media conglomerates, such as Time Warner, Fox and Disney distribute an immense variety of cultural products worldwide, their total annual revenues in some cases surpassing the combined GDP of national economies (Noam, 2009). The United States dominates globally as the leader in cultural exports. Audiovisual productions maintain significant global advantages both in the United States and in different national markets worldwide. The numbers are indicative

Table 2.1 The most expensive films of all times

Pirates of the Caribbean at World's End
John Carter
Tangled
Spiderman 3
Pirates of the Caribbean on Stranger Tides
Avengers: Age of Ultron
Harry Potter and the Half Blood Prince
Batman vs Superman: Dawn of Justice
The Hobbit: Battle of the Five Armies
The Dark Knight Rises
Spectre
Avatar
The Amazing Spiderman
Pirates of the Caribbean: Dead Man's Chest
Men in Black 3
Man of Steel
The Chronicles of Narnia: Prince Caspian
The Avengers
Oz: The Great and Powerful
The Lone Ranger

Source: Forbes, 2016.

of the significance attributed to cultural goods in people's daily lives. Cultural economic activity, large investments, commodification, market size and segmentation constitute cultural traits for the establishment of mediated agendas. Therefore, cultural industries are under scrutiny by researchers worldwide because of their economic output, the number of people they employ, their product diversification, their level of flexibility in different economic environments and their overall contribution to GDP growth in different national settings. Hesmondhalgh's (2013) analysis provides a comprehensive map of industrial cultural output. Naturally, his analysis focuses primarily on popular entertainment providers. However, small-scale producers deserve more careful research attention. What about museums, cultural institutions, libraries and national galleries? What about archaeological sites with significant monuments? There is a widespread discussion that museums, galleries and cultural institutions are increasingly becoming entertainment providers, in many respects imitating their popular counterparts. For example, the Smithsonian Institution, one of the global leaders of "rational edutainment" providers, manages a yearly, nonnegligible budget of more than $800 million.[5]

In certain countries, culture and tourism constitute their "heavy" industries, such as Italy and Greece, which in their totality are described by visitors as national archeological parks. These countries are popular destinations for millions of tourists because of their weather, a natural environment combining both mountainous areas and incredible coastlines, along with an extraordinary cultural heritage spanning 4,000 years. In Greece, the culture and tourism industry contributes more than 10% to the annual GDP of the country. However, despite the advantages of cultural economies, there also are noticeable weaknesses. Visitation is subject to seasonality, particularly during the summer months when people are on vacation. Furthermore, cultural economies can be sensitive to extreme market fluctuations, especially when national economies experience recession and households lose a portion of their disposable income, cutting down on entertainment and leisure spending.

Despite the recognized risks, there is a global interest about investments in leisure experiences, and as I have already argued, this trend has had a profound effect on the development of urban space, providing redesigned infrastructures in city centers, while offering multiple opportunities for people who wish to engage in different activities in close distance. Policymakers have turned their attention toward culture; in certain countries, shifting strategies toward creative, experience-oriented economies have moved forward swiftly through decisive initiatives, while in other areas developments have been slow. In Athens, the unification of archeological areas in the city center and the completion of the new Acropolis museums became indicative of the cultural shift. In the 1990s, the underground train network provided easy access to the

city's archeological sites and the most significant museums. However, if such developments in Athens can be described as slow, policymakers in the United Arab Emirates have been very effective in their reframing investment initiatives. As I have already argued, their efforts are indicative of a cultural strategy to reframe a worldwide perception of a region relying primarily on its oil economy, while promoting a significant shift toward a creative, cultural economy. To achieve that, the United Arab Emirates invested a great deal of money to initiate their reframing project. Furthermore, they utilized established cultural brands with a long history and experience—the Louvre and Guggenheim. Apparently, this gargantuan investment is expected to keep bringing a return when the oil economy will be subject to downward fluctuations, diversifying the long-term investment portfolio of this particular region that many would consider one-dimensional.

Although cultural industries are very different from one another, overall, scholars agree that they are considered high-risk ventures (Hesmondhalgh, 2013). Large initial investments are required for those who wish to enter the cultural sector, and the rate of return is usually much slower compared to other business sectors. Furthermore, consumer tendencies and behaviors are hard to predict and even those who think they understand consumer choices will often fail to reach out to their perceived segments of consumers. There is widespread agreement that the cultural sector is unpredictable and therefore there are greater risks involved than in other business sectors. Certain industries are costlier than others. For example, television is considered an expensive market sector, requiring special licenses from government bodies, whereas investments in technology and specialized personnel raise the stakes even higher. The same observation applies in the cinema industry. Although costs vary, blockbuster movies usually require extravagant initial investments while producers expect a return from the domestic market and from international exports. Competition among industries is often described as intense; different organizations compete with one another for people's leisure time, striving to analyze tendencies and trends along with short-lived aesthetics and audience preferences. Many entrepreneurs invest in cultural products in highly volatile, unpredictable and competitive cultural markets.

In the 1990s, deregulation allowed for multiple media ownership, a trend that progressively led to increased media concentration and conglomeration. This vertical and horizontal integration led to the formation of global corporate giants, employing hundreds of thousands of workers worldwide and managing complex corporate sub-entities. In the United States, in 2004, the total revenue of mass media—television stations, radio, cable and satellite—surpassed $111 billion in revenues, a huge rise from just $50 billion in 1984 (Noam, 2009).

Cultural industries expanded their sphere of influence through vertical and horizontal integrations. The term "vertical integration" implies

a certain mode of control over different branches of a cultural market. For example, an audiovisual corporation controlling not just production mechanisms but also distribution chains, along with movie theaters, exercises a vertical control in this particular market. This approach secures better corporate control within a market as it minimizes risks and assesses any unknown elements that might harm the business. A production company that also controls movie theaters makes sure that its films will maintain unhindered access to the market, allowing for easy distribution and consumption, without being dependent on corporate mediators, which, in pursuing different interests, might hinder certain films from being widely accessible.

The term "horizontal integration" describes a corporate structure controlling only one level of the industrial production or consumption chain. For example, consider an organization owning only production facilities but no distribution companies or movie theaters. This corporate entity will exercise significant control of the supply of films in a given market, but the business is dependent on other corporate stakeholders and financial interests for distribution and dissemination. Modern markets, especially in the developed world, display traits of both vertical and horizontal integration, which implies a total control of media markets exercised by mega corporations at a global level.

On the other hand, vertical and horizontal controls in certain cultural markets might imply less competition among cultural providers, a lack of diversity in cultural content and barriers to entry for new providers in a relatively closed market system. During the period 1994–2000, there have been a significant number of mergers among large corporations. Viacom bought Paramount for $8 billion and the merger provided this new corporation significant control over an array of media products, including film, television, cable and thematic parks. In 2006, six global conglomerates divided the lion's share of the American media market: Time Warner, Disney, Sony, News Corp., Viacom and General Electric. These organizations control approximately 80% of the American market (Noam, 2009, p. 107). In 1995, Time Warner, a global leader among media corporations, bought Ted Turner's empire for $7.5 billion, retaining, among other outlets, control of CNN. During the same year, Disney bought Capital Cities/ABC, penetrating the market of established news media; Seagram bought MCA (Universal), thereby controlling a variety of audiovisual products; Westinghouse bought the CBS network. In 2000, two significant corporate alliances were formed: Vivendi merged with Seagram/Universal, while America Online (AOL) allied with Time Warner. Continuous merging trends and formations of corporate alliances during the 1990s changed the global corporate media map. The resulting concentration of capital in specified centers continues to control investments in new media technologies, production of cultural content and global consumption trends, while maximizing cash flow.

Hesmondhalgh (2013) describes the "magnificent seven," the most dominant international conglomerates: Vivendi, Walt Disney, Comcast, News Corporation, Time Warner, Sony and Bertelsmann (p. 195). Ownership reshuffling pertains primarily to popular entertainment industries rather than non-for-profit entities. Recent developments between Time Warner and AT&T, a dominant content provider and a telecommunications giant, produce varied reactions. If the merger becomes final, it signifies a consolidation of power by seemingly different industries which in fact converge unifying different communication sectors. The effects of this gigantic alliance cannot be foreseen in terms of long-term repercussions. Because popular cultural industries constitute the lion's share of global markets, they receive most of the attention by entrepreneurs and scholars alike. However, as "rational edutainment" providers increasingly imitate the strategies of their popular counterparts, observing shifts in economic activity, organizational alliances and product convergence can easily lead to observable changes in the future. For example, a *Star Wars* exhibition at the Smithsonian Institution is only a sign of the things to come.[6]

A Digital Culture

Cultural products are not confined within national boundaries and regional economies, but receive international attention, often related to what scholars describe as a global cultural heritage. In the twenty-first century, more than in any previous era, cultural producers actively seek to extend their sphere of influence internationally. A cultural experience that transcends the confines of nationality, geography or local economy may eventually transcend time itself. It becomes globally recognizable and perhaps globally shared. Cultural producers strive to set agendas beyond their locality and occasionally they achieve a level of salience that transcends time and geography.

In the twenty-first century, culture has become dependent on digital communication technologies. Different types of digital media play a decisive role in all cultural industries, both in terms of production as well as dissemination and consumption of cultural products. Although digital agenda setting will be examined in subsequent chapters, it is worth pointing out here that digital communication has had a profound impact on cultural markets. Most cultural producers attempt to make their mark through their web presence, designing sophisticated websites with enhanced capabilities. Elaborate investments on web technologies convey a symbolism of significance as they allow for multiple content-related interactions among producers and consumers. This web presence often entails an ontological essence, encouraging consumer visitation, community building, content downloading, data exchanges, personal communications, customized interactions, online games and various other forms of leisure activity derived from the consumption of

cultural content. When cultural organizations encourage sophisticated interactions with different groups, they receive feedback but also become aware of new ideas, human talent, innovations and new content that materialize into meaningful creations. Sophisticated web presence constitutes a significant step for digital agenda setting. Many organizations rely on their web capacity to influence media content and other stakeholders about issues they consider important and they try to establish them as a part of the public agenda. Digital news subsidies delivered through websites, blogs and social media platforms either set the agenda or establish the scene for future agenda building.

Cultural organizations still rely on other organizations and digital platforms in order to bring attention to their websites and encourage enhanced digital traffic through digital gatekeeping interventions. Their reliance on different platforms, like Google for example, is expected to enhance their web presence, visibility and visitation of their website. Google has evolved as a digital gatekeeper managing searching requests, digital advertising and searchers' attention. Cultural and corporate entities rely on digital gatekeeping services as they strive to convert web attention to behavioral attention. Any cultural entity with a sophisticated web presence is expected to benefit from enhanced attention and valence. Subsequently, cultural executives strive to convert web attention to different forms of visitation in their actual premises, attendance, participation and purchasing. Digital gatekeepers in the form of organizations, platforms and software provide crucial interventions and strategic enhancements when cultural producers need to improve their web salience. There are new complex relationships among different gatekeepers that determine new flows of information, and new filters that affect the mobility of information in the most unlikely places. Scholars recognize that the relationship between an organization and their public has become increasingly complex, involving different specialists from public relations, strategy, marketing and journalism. Because of the role of different mediators, public preferences and aesthetics continually evolve, influenced by different audiovisual industries. Different cultural centers set the tone for themes followed subsequently by different cultural producers around the globe. Most cultural organizations follow similar marketing rules and promotion strategies. Also, content management and thematic choices are influenced by established trends. Hesmondhalgh (2013) highlights a convergence trend between audiovisual cultural industries and IT companies, arguing that "the most significant intervention by IT companies into the cultural industries so far has been the purchase of YouTube by Google in 2006" (p. 198).

The digitalization phenomenon represents a paradigm shift in all sorts of media communications because it allows for more independence, control, creative autonomy and access for non-professional creators—especially those who are not affiliated with organized institutions and

industrial producers. Furthermore, digital media gain attention in the cultural domain because of the digital transformation they bring to interpersonal communication, interactive games, information searching and social media. New media use has been linked both to organizational transformations as well as digital innovations that have changed the nature of media altogether. For example, the capacity of ordinary individuals to create broadcast-quality digital video has revolutionized the entire field. In the old days, the need for professional equipment and know-how rendered the production process inaccessible by ordinary individuals. Nowadays, individuals and small groups can easily create quality audiovisual productions. Small museums, galleries and rural cultural centers incorporate audiovisual productions into their exhibitions. Video is accessible everywhere through different hardware—smartphones, tablets, laptops or large screens installed indoors and outdoors. Cultural organizations have been transformed while changing the world. Now we live in a world of visuals. We share pictures, we exchange video content and we cherish our ability to conveniently record our daily lives through digital media.

Different types of digital games relying on virtual reality technologies have become available, creating new generations of available products that were unknown before the advent of the internet. And those products, associated with virtual experiences, have known unprecedented demand by players around the world. Understandably, cultural organizations have been affected by the developments in the gaming industry. Popular entertainment providers were the most versatile encouraging new forms of convergence—film and game content. However, museums followed that lead, investing on virtual reality applications and encouraging visitors to explore new experiences. Museum games usually assume an educational role.

Other new trends pertain to long-distance interaction. Accessibility from far away, allowing for visitation, shopping, education, gaming and social interactions were elevated in the priorities of cultural entities, signifying their commitment to modernization and their continuous dissemination of innovative offerings. Lagging behind in any of those areas signified an organizational inability to follow the rhythm of the planet. Most organizations followed this digital tempo, which sets the tone for cultural developments around the world. Understandably, this field of culture and new media is in constant flux. Because of media's capacity for interactivity, new theories are expected to scrutinize the degree of interactivity, social presence, the freedom to play and the extent to which private life is protected. Privacy lies at the core of modern discussions in the cultural sector (McQuail, 2010).

Sometimes, even those cultural organizations who were not avid followers of digital developments chose to follow the example of their competition for the purpose of conveying to the public agendas related to

innovation. Everyone wants to be perceived as innovative, and they discovered that innovative agendas produce salience (Zakakis, et al., 2015). Therefore, those new agendas pertained to significant alterations in production of digital content, the transformations of cultural organizations and the creation of totally new products/experiences that were largely unknown before the advent of the digital world.

Culture and Competition

The cultural sector is characterized by extreme competition. Producers of culture compete for people's leisure time, knowing that a person's choice precludes other possible leisure activities. Reading a book or watching television claims a person's attention and thereby other activities are not possible during that particular cultural selection. The book experience is radically different from the movie experience. So when a person devotes his leisure time to reading, this choice leads away from other potential experiences. Furthermore, competition becomes more intense when museums compete with popular entertainment industries, including malls, thematic parks and movie theaters (Andreasen & Kotler, 2008). However, competition takes other forms as well. Earl & Potts (2013) adopt a creative instability hypothesis, "a mechanism by which creative producers end up destroying demand for their works by the very process of trying to stop their sales from decaying as the attention of their fans is attracted elsewhere by new products from rival creative producers" (p. 154).

Although organizations offering different types of experiences compete against each other, producers of similar experiences are also in a competitive mode. In this environment, certain organizations, mostly of the popular domain, enjoy certain advantages, as they generally have larger market shares and attract mass attention. On the other hand, museums, galleries and libraries strive to compete against each other for segmented attention as well as against the more established industries of sound and spectacle. Despite the imposing presence of international conglomerates dominating various markets through prolific and varied products of different kinds, small players keep proliferating, further increasing competition. According to Hesmondhalgh (2013), small firms and independent producers play a significant role as "the conception stage of texts remains small scale and relatively inexpensive and still takes place in relatively autonomous conditions" (p. 209). Organizations use marketing and public relations techniques to persuade different segments of their audience to invest their leisure time in their own cultural products and experiences.

Apart from competing for prospective consumers and their free time, cultural entities compete for funding and attention. There is certainly a relationship between the two. Popular entertainment providers face intense competition from other similar industries trying to outperform

them in terms of profits, primarily to get a return on initial investments. The degree of competition in popular media like television and blockbuster movies is systematically recorded through ratings measures that subsequently influence profits from advertising and box office results, demonstrating, for example, the most successful films in relative ranking against their competition. In the realm of nonprofit organizations, there is also significant competition for attracting donations, private investments and government subsidies. In the nonprofit domain, an increasing number of cultural organizations and creators compete for limited resources. Most organizations make it their priority to engage in aggressive fundraising from private donors while at the same time claiming a portion from diminishing public subsidies. Despite the intense competition, this rapid growth of the cultural sector globally produces different types of experiences while further expanding the cultural market. This dynamic is recorded by different researchers. For example, Smith, Discenza & Baker (2005) argue that small galleries increasingly function as small businesses employing management strategies and marketing tactics to promote works of art. McNichol (2005) discusses the significance of branding for small museums as they strive to become recognizable and marketable. Olkkonen & Tuominen (2006) consider the pursuit of sponsorship as emerging museums design their strategy for sustainable growth and future viability. Cultural organizations discover new ways of redefining their relationships with their potential consumers. Drawing from the agenda-setting literature, it is safe to conclude that cultural competition is intense because people can only devote their attention to a small number of leisure activities at a given time, excluding other possible leisure choices. In agenda-setting terminology, this can be described as a zero-sum game principle (McCombs, 2014).

Culture in the Form of Texts

All cultural products are consumed as forms of texts, whose perceived value is neither fixed nor defined. People read texts differently, they perceive their value in unpredictable ways and they go through different levels of reception and retention. Cultural output is described as a complex gestalt of tedious production processes, whereas reception is subject to individualized or segmented consumption tendencies.

As cultural texts keep multiplying, several theses have emerged in regards to the direction of influences. Do the established players impose their culture on the newer and smaller entrants? Most scholars agree that the old cultural imperialism model seems obsolete, replaced by different terminology, such as "internationalization." It seems that the advent of digital technologies provides various opportunities to aspiring cultural producers. Hesmondhalgh (2013) offers several examples of this trend. For example, Latin American countries remain for years active

producers of cultural products, challenging cultural imperialism perspectives. And many peripheral producers that are not associated with the dominant cultural players remain successful exporters of audiovisual products, finding niche audiences around the world. Despite the dominance of the major conglomerates in global markets, today more than ever, smaller creators find more opportunities to penetrate the realm of cultural production. Indeed, many developing markets from Latin America to southeastern Asia discover new opportunities for cultural dissemination worldwide. Similar observations can be made with Arabic television exporting its journalism. The case of Al-Jazeera is indicative of a flow reversal as it exports its content to various interested segments internationally. In the film industry, India and China are not negligible international exporters of audiovisual products, while often engaging in co-productions and joint ventures with their western counterparts.

Evaluating a cultural experience is rarely a commonly ascertainable and predictable process. What are the traits that render a movie, a song or a book accepted by the masses, whereas other similar products remain largely unnoticed or unwanted? Furthermore, how do different consumers receive, process, retain and interpret different messages? The British cultural studies tradition offers a prolific and well-established literature to answer these questions. In the words of Burgess (2006), "cultural studies was shaped around a concern with both understanding and dignifying 'ordinary' people's lived experiences and cultural practices, and that mass-mediated popular culture was seen as a site of negotiation and political potential" (p. 202). However, negotiations among ordinary lived experiences and mediated experiences are not always ascertainable. Despite this common knowledge, cultural creators cannot always recognize the various ways in which their experiences are received by different groups. If such cultural attributes that lead to acceptance were readily definable and ascertainable, producers, authors and designers would be preemptively in the advantageous position of knowing with a significant degree of safety which cultural experiences should be promoted. However, rarely are such decisions so clear-cut. Texts are read differently by interested, niche groups or by large, heterogeneous audiences. In some cases, they are neglected or they receive minimal attention. Predicting the volume of their acceptance and the ways they will be read by different groups is basically impossible.

Consider, for example, that eight different publishers rejected the *Harry Potter* project submitted to them by J.K. Rowling, before it became a global subcultural phenomenon selling millions of books around the world and before being established as one of the most successful franchises of all time (Salganik & Watts, 2009, p. 441). The success of *Harry Potter* surpassed any expectations, becoming a book and movie series, while the Harry Potter theme park, built in Florida, opened its doors to the public in 2010. Most of the blockbuster types of cultural

products that have become globally accepted icons faced similar difficulties when their creators tried to sell them for the first time. For example, the television series *Friends* and *American Idol*, and even the band the Beatles faced hard times as they strove to sign their first contracts. Sometimes, the process is reversed. In other words, producers with high expectations for revenues derived from cultural products or artists, in which they have invested significant sums of money, are gravely disappointed. For example, MCA Records invested $2.2 million in a very promising young artist, Carly Hennessy, whose record, *Ultimate High,* sold 378 copies in three months (Salganik & Watts, 2009, p. 442).

If indeed producers had a clear formula predicting accurately the level of acceptance of a cultural product, they would be able to consistently discern between promising and not-so-promising texts. However, it is common knowledge among producers that this foreknowledge remains in the realm of wishful thinking. What defines broad acceptance of a cultural product seems to be related, among other things, to widely disseminated word-of-mouth recommendations and aggressive advertising, along with a complex array of other social and psychological factors, and, in some cases, a vortex of coincidences related to ideology and the collective psyche of cultural consumers. By the same token, the fact that many creations that go unnoticed and rarely get adopted by an audience does not necessarily imply lack of creativity or value. There are many examples of artists and creators whose work was discovered long after they had died and their creations acquired a life of their own, separated from their creator forever. How many painters, for example, were "discovered" long after their death? During their lifetime, their work was ignored, despised or even ridiculed. Stories like these are widely available in the cultural domain. And even popular reality shows, like *American Idol*, despite their often populist orientation, reveal hidden talents that otherwise would have remained unnoticed. And even if a certain text receives wide acceptance, there is no way of knowing how various groups will interpret it. Hesmondhalgh (2013) discusses how rock and roll music was received in eastern Europe during the Cold War as people in these states distanced themselves from local musical production. The internationalization of music spreads the use of the English language and familiarizes listeners with western cultures, but at the same time western sounds are assimilated in unique ways into national cultural contexts.

Indeed, the cultural domain is characterized by unpredictability, seasonality and random occurrences. For example, one would expect that economic cycles would always be predictive of cultural consumption. After all, economic indicators should be considered as a significant factor determining leisure activities. However, research has not been able to provide consistent evidence about that. According to von Rimscha (2013), who surveyed data from the movie industry, "the demand for cinema entertainment as a whole is unrelated to economic indicators

such as GDP, consumer confidence, and consumer prices. Only the disposable household income has some effect on the overall demand" (p. 451). This is not what one would have expected. It seems that culture satisfies deeper human needs that go beyond economic cycles and recessions. Similar observations are recorded by Symeou, et al. (2015). After surveying a large volume of art-house films in the Greek market during a period of a severe financial crisis, they concluded "that the financial crisis had a marginally positive relationship with box office performance" (p. 748). This is an unexpected finding contrary to what analysts would have predicted. Such findings are indicative of the unpredictability of the cultural domain. To eliminate this uncertainty factor, cultural organizations produce a lot of different products, hoping that a few of them will come to mass acceptance and thereby minimize the loss caused by many other products that were doomed to begin with.

According to Hesmondhalgh (2013), cultural products are considered "semi-public" goods. Rarely is a cultural product completely destroyed after usage. Because cultural goods do not reduce their value after their initial consumption, corporate producers try to artificially limit access to content through various means such as copyright controls to prevent consumers from accessing texts without any limitations and by applying controls on reproduction of content: that is, making copying illegal.

Cultural products are shared in many ways and for long periods of time. The fact that they have been used does not diminish their prospects for future consumption. In some cases, they are possessed by different owners, while cultural content is often commonly shared and appreciated by different segments of the public across time as well as in different geographic areas and time periods. Consider Homer's *Iliad*, for instance. This famous narrative constitutes a part of the global cultural heritage that has been shared by the peoples of the world for roughly 28 centuries. It has been written, adapted, sung, acted out and read by different global audiences who appreciate this ancient story in various forms, from books read by university students in literature classes, to movie goers enjoying watching Brad Pitt in the role of Achilles (Bantimaroudis, 2011). Cultural artifacts, such as the famous Gutenberg Bibles, have been owned by different individuals and preserved as forms of material cultural heritage while changing hands across history, from wealthy patrons to university libraries and archives. (I remember as a student in Austin standing in front of one of the original Gutenberg bibles, in the University of Texas library.)

This semi-public nature of cultural products attributes a special "life" to them. It is almost metaphysical in a sense, as cultural experiences acquire another dimension of existence, clearly escaping from the environment and the control of the original creator. Because of this, cultural creations separate themselves from their creator and increasingly

become adopted by readers and consumers. This separation between creators and creations takes different forms; certain creations acquire different textual manifestations in different groups of readers, producing multiple meanings while different groups attribute differentiated values and sense of worth. Other creations are discovered long after the creator died, evolving almost independently since readers cannot safely assess what the author's intensions were in the first place. The more they are read and consumed, the more they evolve as texts encompassing a wider sense of existence, interacting with various peoples and acquiring different meanings and symbolic extensions that no author could ever have initially conceived.

Cultural Convergence

Cultural organizations produce a tremendous variety of very different products that are designed to appeal to the diverse needs of individuals. Museums visitors invest their time in a very different experience than movie-goers (though cinema has been influencing the museum experience). This variety in cultural experiences can be observed in different aspects of production, dissemination and consumption. However, cultural products converge in the digital world. In terms of content, we often observe different types of narratives becoming available in different forms: text, audiovisual, digital games, and so on. Certain books are published under the premise that the narrative is promising for movie-making or game development. This convergence in content allows for different readings and audience reception, as it also maximizes the profit potential. It enhances the diversified spectrum of cultural output. Convergence in content has been enhanced by digital developments. For example, *The Lord of the Rings* book trilogy, published by J. R. R. Tolkien initially in 1954, though it was received enthusiastically by various segments of readers around the world, became the popular film trilogy, directed by Peter Jackson in 2001. This time-lag between the publication of the books and the creation of the films is casually attributed to lacking the technological means for such a visually demanding narrative. The film trilogy offered a new life to the book narrative, reintroducing Tolkien and his stories to the masses, and the producers maximized their profits from this extraordinary tail. Content convergence seems to follow parallel developments in the realm of digital technologies.

However, content convergence can be manifested in various ways. Buchmann (2010) examines the relationship between popular film narratives and film oriented tourism while focusing on the Lord of the Rings movies and their impact on visitation in New Zealand. Because the trilogy was filmed in New Zealand, the film tourism phenomenon became a noteworthy form of content convergence in different market sectors.

Several aspects of this relationship were investigated, like the challenges, expectations, experiences and the lessons learned from film tourism. This convergence in content is documented by Buchmann (2010) when she points out that the "Lord of the Rings-film tourists successfully experience both the 'real' world of New Zealand and the 'reel' world of Middle-earth" (p. 83).

Convergence affects different types of cultural experiences. For example, performance oriented productions are totally intangible in nature, which presents significant challenges in terms of promoting something which, after its consumption, leaves nothing behind but a pleasant (or not so pleasant) memory. Those who attend a stand-up comedy act, or a theatrical performance, or a symphony orchestra, experience a real-time event without the capacity of replaying it or reliving it. They live out an once-in-a-lifetime experience. Those types of live events or performances present some unique attributes. Audiences have a difficult time assessing beforehand the value of these experiences. They have to take larger risks. They try to minimize their need for orientation by consulting with friends, critics or advertisements, but the risk of being disappointed is certainly higher than with other types of experiences. In the end, consumers decide whether the experience was worth the time and money. In some cases, people retain a copy of the ticket, a reminder of time spent in a worthwhile cultural venue.

However, convergence affects performance-oriented experiences. Even once-in-lifetime events are currently offered on multiple digital platforms, often recorded by people's smartphones or other portable devices. On YouTube, audiences can see a glimpse of what they might experience and thereby minimize their potential risk. Though there is not a comparison between recorded and live experiences, the recorded convergence satisfies a consumer's need for orientation. While most cultural experiences are produced and consumed at different points in time, for performing arts, it is not always possible to separate production from consumption. Usually the two processes take place concurrently. For example, there is no separation in time between production and consumption of a musical performance, a lecture or a theatrical presentation (Hill, O'Sullivan & O'Sullivan, 2003, p. 115). However, things have changed. Despite the fact that these are real-time experiences, multiple offerings through different digital media alter the nature of such experiences. Although production and consumption of a music performance is inseparable while the performance takes place, it can be rendered separable, to some extent, because of digital media platforms that allow consumption of such experiences at different points in time. In real-time settings, consumers in such experiences are described as partakers of the production process. Performances are unique, live experiences. No such experience is exactly the same. For example, the

same song can be performed by different artists; the same part in a theatrical production is played by different actors. The uniqueness of relatively similar experiences can be a marketing advantage as it can be touted strategically to new segments. Cultural products or experiences are primarily lived out. They become an integral element of living itself. So, promoting them becomes a real challenge in uncertain conditions where experiences cannot be easily rated and nothing is left behind but a memory.

Convergence is an expansive phenomenon. Scholars talk about convergence in content, in technologies and even in ownership. Although the latter is subject to a different discussion involving integration in ownership and international conglomerates controlling popular media, digital platforms and product dissemination, different forms of convergence have become interrelated at different levels. Certainly, content and technological convergences represent two sides of the same coin as media and messages are inextricably connected to one another jointly influencing the nature of people's leisure perceptions. As we have drawn from the works of Hesmondhalgh (2013), Kotler, et al., 2008 and Hill, O'Sullivan & O'Sullivan (2003), the following table presents a matrix of cultural attributes that have become indicative of the complex and unpredictable nature of the cultural domain.

However, there is one more distinction that merits our attention. It has been recognized by numerous scholars as it pertains to critical distinctions in cultural production and the ways people process cultural content. For almost a century, sociologists, cultural scholars and media critics have toyed with these ideas, while producing a vast literature employing various perspectives and observations.

Table 2.2 Attributes of the cultural sector

- Cultural Economics
- High Risk Industries
- Products of Uncertain Value
- Semi-public Goods
- Diverse Products
- International Culture
- Digital Culture
- Competition
- Cultural Texts
- Convergence
- Intangible Nature of Arts
- Mergers and Conglomerates
- "Rational Edutainment"
- Popular Entertainment
- Distinct Lifestyles

Sources: Hesmondhalgh, 2013; Hill, O'Sullivan & O'Sullivan, 2003; Kotler et al., 2008.

"Rational Edutainment" and Popular Entertainment

Cultural scholars have attempted to create different typologies of cultural products. Throughout the twentieth century, scholars with different ideological outlooks engaged in typological exercises, recognizing some pronounced differences in cultural productions. The Marxist theorists of the Frankfurt school in the 1930s wrote extensively on what constitutes "high" and "low" culture, focusing on class distinctions and socioeconomic differences. They argued that popular entertainment in the form of low culture provides the means for controlling the masses, preventing the possibility for achieving social justice. Popular entertainment becomes the opium of the nonprivileged, preventing them from accessing useful information with a life-changing, meaningful potential.

As the distinction between "high" and "low" culture by the Frankfurt School theorists signifies a foundational typological structure, many thinkers have built on this tradition, providing additional useful differentiations of cultural experiences, testifying to the varied nature of such productions. Campbell's (1988) cultural ladder, as a typology among cultural experiences, represents one of many scholarly observations of cultural providers that address fundamentally different consumer needs and preferences. In the nineteenth century, the American museum pioneer Charles Willson Peale openly endorsed the notion of public museums as providers of "rational amusement." He promoted an organization of edifying diversion, instead of passive escape and entertainment. Kotler & Kotler (2004) argue that today's concept of "edutainment" captures the same idea: attractive and entertaining presentation, designed to facilitate education goals. Peale envisioned his museum as a cultural environment for edifying diversion. He openly encouraged forms of "rational" entertainment in contrast to idle entertainment (Miller, 1991 in Lowry, 2004). Although the concept of entertainment has evolved since those times, the modern concept of "edutainment" is based on Peale's notion of "rational amusement": attractive but informative, entertaining but also educating. Peale attempted to incorporate entertainment tools but with a core objective to facilitate educational goals. He pioneered an approach that touted education and information-seeking as worthy pursuits that incorporate creativity, the joy of learning along with designed experiences that could put these elements together. Many modern organizations present themselves as "rational edutainment" providers, in contrast to "popular entertainment" entities.

From my perspective, this notion of "rational edutainment" should be revisited, not exclusively as a museum experience but as a holistic construct that describes the nature of various cultural provisions. A primary "rational" or educational dimension enhanced by secondary entertainment traits provides a basic outline of this construct. "Rational edutainment"

experiences seem to be related to modern museums going through extreme makeovers in order to compete against other cultural industries, attracting people's attention, maximizing visitation and advancing their redefined missions. In this context, I argue that "rational edutainment" displays certain distinct attributes. First, it is particularly appealing for organizations that historically were associated with preservation related missions and objectives. Certain cultural institutions were entrusted with the study, preservation and protection of cultural heritage. Nowadays, these narrow missions have been enlarged to encompass communication, information and education (Hooper-Greenhill, 1992; 1995). They strive to attract visitors from different public segments, representing various demographic and psychographic backgrounds. As they compete with popular entertainment providers, they strategically include entertainment components in the experiences they provide, while retaining their core objectives of education and information. According to Falk & Dierking (2013), "whether through adventure tourism such as whitewater rafting or mountain climbing, or more intellectual pursuits such as visits to historic or natural settings or museums, increasing numbers of people view leisure as an opportunity to expand their understanding of themselves and their world" (p. 40). Education- and information-oriented goals encompass various layers of pursuits, including understanding oneself as well as social and environmental conceptualizations. Falk & Dierking (2013) cite a Canadian Tourism Council assessment of American leisure choices, demonstrating that the most popular destination for Americans is the beach (54%) followed by culture (51%). It seems that "rational" leisure choices compete intensely against more popular selections. Despite the expected popularity of the beach as a leisure destination, culture follows closely as a significant choice.

Second, combining education and entertainment constitutes a challenging task, as cultural institutions need to develop special creative skills, possessed primarily by popular entertainment producers, such as cinema, television, popular music and the game industry. According to Pine & Gilmore (2011), "these include, but are not limited to, the multisensory nature of experiences, their level of personal meaningfulness, the way the experience is shared with others (if at all), the intensity and duration of various experiential elements, complexity (or simplicity), and untold other characteristics of how people spend time" (p. XXI). Therefore, it is not uncommon for modern museums to form alliances with other cultural industries as they strive to develop "edutainment" experiences for larger segments of potential visitors.

Third, "rational" experiences often require some sort of preparation on the part of the consumer. By definition, information-based experiences demand previous involvement. For example, a visit to a museum can be more enlightening and interesting if prospective visitors have some previous exposure to information about particular exhibitions,

allowing them to understand the context, the history and the narratives of what they will encounter. Attending an opera (especially for the first time) can be disorienting for some people, unless they have done some homework ahead of time: knowing the story, the characters, and perhaps the context of its creation. The same principles could apply to a visit to an art gallery. DiMaggio and Useem (1978) argue that the appreciation of artistic work is learned. It requires a systematic preparation offered by families in the course of entire lifetimes. Parents with artistic training, who cultivate such interests, are more likely to train their children to appreciate fine art. As a matter of fact, such preparation takes place throughout childhood and people keep cultivating specific forms of aesthetics throughout their lives. Therefore, parents and teachers provide reading and appreciation skills that render such experiences valuable. Having some prior preparation about artists, histories, narratives and special circumstances allows visitors to derive more from an art experience that seems otherwise nebulous or disorienting. In other words, "rational edutainment" experiences are not only about museums. Although the origin of the concept can be traced in Peale's museum initiatives in the nineteenth century, numerous organizations are capable of designing and offering cultural goods of mixed nature satisfying different needs of potential consumers.

If prior preparation for information-based experiences is not possible, a tour guide assumes the role of a teacher. Both in formal educational settings as well as in various cultural environments, the role of the teacher or guide is significant as it adds substantive information and value to the overall experience. After all, the role of the teacher is irreplaceable in any context. Anyone who visits museums consistently can appreciate the role of those who help visitors understand what they experience by providing contextual information and narrative structures, thereby taking the museum visit to a different level. By its very nature, "rational edutainment" involves experiences that are associated with substantive information of different kinds, requiring more active engagement on the part of the consumer while, sometimes, prior preparation or a guide must be involved.

Certain theorists have discussed the notion of "serious leisure" to describe, for example, museum and gallery offerings. This notion is related to opportunities provided by organizations that their visitors can utilize for career or personal advancement (Rojek, 2000). Understandably, this conceptualization of museums should entail the element of social inclusion. Perceived opportunities should be offered to as many people as possible empowering the less privileged and encouraging social cohesion. This particular perspective is not alien to the notion of "rational edutainment."

Apparently, these elements are not contingent in popular cultural experiences, which are more passive, with no prior engagement or preparation necessary to fully interact with different texts. "Rational edutainment" providers cater for the segmented needs of groups that seek "valuable"

experiences with an educational dimension, or sometimes they attract consumers who wish to have both: popular entertainment with "rational" or information-related components. Therefore they are also touted as entertainment centers, whose visitors value their unique capacity to offer educational and information-oriented experiences with a secondary entertainment dimension. According to Kotler (2001),

> small and medium-sized museums face the greatest hurdles. The idea of experience which in recent years has captivated the museum world and other formal cultural institutions, is seen as an elixir. Many years ago, a museum visit was prized for aesthetics, visualization and education. Today, the concept, experience, has several meanings: involving intense, sense-perception as well as emotion and intellect; direct, immediate happening; participatory and social happenings; situations that evoke strong responses rather than passivity and spectatorship; intense, visceral excitement; one-of-a-kind, memorable happenings. Whatever the implications, tourists and a large number of infrequent visitors expect a "wow" experience. (p. 418)

The multidimensional nature of "rational edutainment" renders the entire strategy challenging. Museums have had no difficulty attracting segments of a higher socioeconomic status. Consistent information and education seekers find their way toward "rational" experience providers. However, cultural organizations set objectives that involve the design and development of "rational edutainment" experiences that cater to the needs of segments which, for different reasons, are not considered consistent consumers of museum experiences. We could expand this observation to other "rational" experience providers, such as art galleries and libraries, facing similar challenges. Finding the right balance is a real challenge for "rational edutainment" providers in times of socioeconomic pressures, when public funding is not enough to sustain such ambitious objectives (Lowry, 2004). This transformation of museums, libraries and galleries from cultural institutions to cultural industries affects the types of experiences provided by those organizations, along with their positioning in cultural markets.

Understandably, "rational edutainment" does not imply uniformity. Producers of such experiences might vary in the way they design them, while consumers will translate and use them differently. Table 2.3 divides organizations according to the types of experiences they provide. This division is not meant as an absolute typological map of cultural provisions, as no experience can be one or the other exclusively. In fact, no experience can be described exclusively as "rational" or popular in nature. However, these two groups of cultural industries tend to cater to the needs of groups primarily seeking information or education, in contrast to entertainment, release or diversion seekers.

Table 2.3 "Rational edutainment" and popular entertainment

"Rational Edutainment"	*Popular Entertainment*
• Museums • Cultural Institutions • Art Galleries • Libraries • Books • News • Educational Multimedia	• Television • Cinema • Games • Popular Music • Social Media • Recreation Parks • Radio

As a side note, this distinction between "rational" and popular experiences is not defined by emotional or affective attributes versus cognitive traits. Both types of experiences might entail an emotional or affective dimension of attributes. Knowledge- and information-related quests often include emotional traits, as is the case with diversion and escape-related experiences. Sometimes, experiences with a significant impact on people's lives involve personal discoveries and charismatic personalities. In other cases, a simple exposure to something new, an experience that a person never had the opportunity to be exposed to, can touch people's hearts and produce both emotional as well as cognitive reactions.

Concluding Remarks about Prominent Attributes in the Cultural Domain

In the modern world, diversified experiences are produced by different types of organizations. In contrast to the outdated high/low perspective of the Frankfurt School, in which social class is the differentiating factor, or the profit/nonprofit component that interests organizational scholars, managers and leaders, the "rational edutainment"/popular entertainment typology adopts a consumer experience perspective. This division might display preferences across different groups consistently seeking similar experiences, as well as within the same group that occasionally seeks different experiences in different points in time.

The modern consumer is subject to various influences discussed by cultural theorists and political economists, but people are capable of surprising us if the right opportunities are present. Apart from the well-established popular entertainment industries, which produce a great variety of cultural products with the intent of maximizing their profits, there is a significant number of organizations for which profit is not their primary objective. In many cases, there is no private ownership involved. Usually they are run by boards of trustees overseeing their overall mission. Many of these organizations are state entities, and thereby the government has the primary responsibility for providing funding, personnel and other necessary resources. Although there is a varying degree of autonomy

in nonprofit cultural organizations and institutions, what is at stake is their mission. These organizations are often subsidized because their mission is linked to collective experiences, histories, and identities. Protecting and preserving one's heritage, for example, is often entrusted to public or semi-autonomous institutions for which taxpayers and private donors are willing to offer their own resources. A common public objective that brings people together deems such nonprofit organizations worthy of support. Adopting a consumer perspective enhances organizational conceptualizations of missions and objectives. Sometimes, what is important is not structure, organizational status and form, but who the organization serves. The current proposition entails the reuse of an old tool. Sometimes, the past can be recycled effectively in the cultural sector, terminology included. In this case, Peale's concept of "rational" culture merits our attention again. Many scholarly presentations remain focused on popular culture: the film, television and popular music industries. Because of the magnitude of commodification and the vast global market size, other organizations have been neglected. However, in the twenty-first century, most cultural experiences are products of industrialized processes. As we have seen, modern museums have undergone significant transformations in order to commodify their experiences, in the same way as popular experiences have become pervasive in global markets. People often differentiate between infotainment, edutainment and entertainment. Those terms entail the degree of information and knowledge seeking as a fundamental human need. Learning is related to entertainment as people seek to acquire information and knowledge outside the educational system. These are active endeavors seeking an experience that satisfies the mind, while refraining from totally passive entertainment choices. Revisiting those old concepts allow us to recognize the consumer, the visitor, the participator, the user as the focus of our observations. We do know that cultural consumers display aesthetics and preferences that are not easily accessible, and they demonstrate infinite interpretation possibilities. Understanding their complex wants and needs empowers cultural providers not just as traders of cultural goods but also as gatekeepers, teachers, guides and interpreters. Sometimes, providers of "rational" experiences serve as significant leaders diminishing knowledge gaps while offering alternative education possibilities for segments of the public that cannot always afford or do not know how to access valuable sources of information. Because of those distinct missions they carry out, their agendas deserve attention and promotion.

Furthermore, there is a wide range of popular entertainment choices involving escape, relaxation, diversion and passive entertainment. These are legitimate and significant needs. In this book, I argue that when they monopolize our leisure attention, there is an element of simplistic focus on how we deal with time itself. The most significant industry in this domain is television, which up to recently, monopolized people's interest while targeting the majority of audiences' leisure time. This trend is

changing as the internet and digital games compete against television for people's leisure. Recognizing some of the traits that render the cultural domain accessible and therefore salient offers organizations as well as consumers certain distinct opportunities. At the same time, similar attributes or framing choices might produce unsuccessful corporate strategies and discourage potential consumers from making certain leisure choices. In many cases, cultural differentiations of experiences can be the product of media agendas, framing various types of experiences according to previously established sociological typologies. The media can influence public perceptions of cultural output, producing to some extent uniform reactions either on a mass scale or at the level of segmented perceptions and behaviors. To what extent do salient attributes of cultural organizations, goods and creators influence public perceptions and behaviors? In this book, I support the idea that apart from individualized readings of texts, a mass audience or a group of consumers agree on the perceived significance of a cultural good. The transfer of salience in the cultural domain establishes organizations, products and creators hierarchically as more or less significant than others. Salience is also manifested at a behavioral level: different types of visitation, attendance, and purchase behavior become indicative of significance. Therefore, this discussion on attributes or traits, in the context of agenda setting, traces salience influences in relatively uniform fashions. The fact that people recognize a text as significant does not preclude multiple decoding processes and individual readings. Significance is at stake, not interpretation. Therefore this presentation of the cultural domain draws from its vast literature with the aim of establishing its distinct characteristics. As we begin to understand cultural industries at their particle level, future work will unravel their potential for salience. Agenda setting constitutes yet another mechanism that explains cultural perceptions and consumer choices.

Notes

1 Shadid, A. (2012, January 24). An ambitious Arab capital reaffirms its grand cultural vision. *The New York Times.* Retrieved from www.nytimes.com/2012/01/25/world/middleeast/abu-dhabi-reaffirms-its-grand-plan-for-museums.html?_r=0, May 23, 2016.

2 Tharoor, K. (2015, December 2). The Louvre comes to Abu Dhabi. *The Guardian.* Retrieved from www.theguardian.com/news/2015/dec/02/louvre-abu-dhabi-guggenheim-art, May 23, 2016.

3 League of American Orchestras. (2011). Quick orchestra facts. Retrieved from www.americanorchestras.org/, June 21, 2016.

4 Berg, M. (2016, April 27). The Most Expensive Movies Ever Made. *Forbes.* Retrieved from www.forbes.com/sites/maddieberg/2016/04/27/the-most-expensive-movies-ever-made/#4d6e956e6639, June 24, 2016.

5 Smithsonian Institution. (Fiscal Year 2016). *Budget Justification to Congress.* Retrieved from www.si.edu/content/pdf/about/fy2016-budgetrequest.pdf, June 24, 2016.

6 Seattle's EMP Museum, exhibit opened January 31, 2015, www.sites.si.edu/starwarsandthepowerofcostume/.

3 Cultural Segmentation and Media Agendas

Today's producers of cultural experiences recognize the need to understand their public both as a mass audience and as distinct groups of potential consumers and experience-seekers. Marketing scholars explain the necessity of studying the cultural profile of different segments of society in order to understand group attributes in relation to leisure choices. This process of understanding general audiences as well as group-specific needs and sought-after gratifications is a necessary prerequisite for setting cultural agendas. Cultural executives routinely collect and analyze information that subsequently provides them with interesting insights into how they should promote different cultural experiences. Information about consumers' knowledge, attitudes, preferences, loyalties, perceived benefits and readiness to adopt can become a strong foundation upon which cultural executives can implement their future promotional strategies (Kotler, et al., 2008).

Furthermore, the cultural domain is characterized by segmentation. Divided perceptions and behaviors across various groups are consistently observed as consumers develop leisure appetites that they loyally retain throughout their lives. The degree of mobility between different leisure activities represents uncharted territory, but it can also be segment-specific. Certain groups routinely navigate between various choices, showing a remarkable variety of leisure aesthetics, whereas others remain connected to a more restricted range of leisure selections. However, in contrast to the civic domain, where political content is of interest to mass audiences or large, heterogeneous groups, the cultural domain is subject to fragmentation, certain selections being sought by tiny groups of interested consumers. Discovering that niche group constitutes a strategic marketing priority for cultural executives. Many cultural providers focus their marketing strategy around a core group of people as the primary segment with which they aim to forge a mutually beneficial bond. Cultural entities also identify their key stakeholders for the purpose of advancing their agendas. For example, many museums establish associations of friends, groups of people who value the organization and its mission and therefore offer significant support for the promotion of the museums' agendas. In return, the museum's friends

receive numerous benefits in terms of networking, access, advancement and a sense of belonging.

Identifying and mobilizing those groups of central importance for the evolution of cultural objectives constitutes a foundational step in expanding toward other segments, including those who are peripherally engaged, such as one-time visitors, tourists and occasional consumers. Identifying niche segments, moderately engaged groups and those one-time participators are all part of the segment analyses pursued by cultural managers. Segmentation studies are of interest to cultural industries of different sizes and economic power. Small museums consistently seek niche audiences to become affiliated with the organization as a mutual investment in a long-term relationship, but even global conglomerates producing a tremendous variety of cultural products seek those segments that will be the most responsive to each product and experience.

The aim of this chapter is not to describe this process of collecting and analyzing such information, but to discuss the implications of such findings in agenda formation. McKercher, et al. (2002) point out that the concept of segmentation can be of value when organizations have well defined strategic plans to meet market needs. The authors outline the following criteria that describe segmented profiles:

- Sharing common values and interests that are sufficiently different and distinct from other segments.
- Being sufficiently large to give the organization return for its effort.
- Being easy to reach through promotional media and other marketing activities, at an affordable cost.
- Having their needs satisfied by the products being offered.

(McKercher, et al., 2002, pp. 25–26)

Understanding what motivates people to make specific leisure choices is not new in the cultural domain, where scholars have explored different paradigms in regards to public needs, preferences and aesthetics, expressed through an extremely complex array of personality and lifestyle characteristics. Most studies about segmented cultural choices are layered around standard socio-demographic, geographic and behavioral characteristics (O'Brien, 1996). Despite the available evidence, addressing the profiled needs of specialized groups is not an easy task. We have already explored the unpredictable nature of cultural products. Despite successful recipes and previous successful choices, cultural producers experience a great deal of uncertainty. For example, film producers are notorious for recognizing that nobody knows anything in the film industry (Debenedetti, 2006). They openly admit that a successful recipe in terms of genre, narrative, cast or style does not guarantee future success. However, despite the complexity of the task, collecting such information is

absolutely essential for the establishment of segmented agendas. Understanding profile characteristics of different groups provides interesting insights into their attitudes and leisure choices. Furthermore, cultural executives acquire useful information about consumers' friends and peers. One of the most significant influences in the leisure domain comes from word-of-mouth (Lam, Lee & Mizerski, 2009; Murphy, Mascardo & Benckendorff, 2007). Numerous studies testify to the significance of assessing such influences. People constantly survey available information as well as the opinions of their family, colleagues and friends and make choices as to when, how and where they should spend their leisure time. They depend on friends, peers and family members as well as the views of experts, critics, creators and the media in general to satisfy their need for orientation.

Segmented Agendas

Popular media claim most of our leisure time, as well as the greatest proportion of the global cultural market. Only a fraction of this time is spent on "rational edutainment" providers, such as museums, galleries and libraries, so there is a particular need for these cultural providers to gain a better understanding of various groups, to establish segmented agendas. We will focus our attention on the weaker players of this domain, while also identifying popular trends and dominant practices. Smaller organizations, by nature appealing to smaller segments and specialized needs, depend on crucial information that reveals segmented profiles of leisure choices. However, figures can vary significantly among different groups. Even popular entertainment providers, which often appeal to mass, international audiences, can benefit from a better understanding of certain groups that are closely related to their experiences and identify with their products.

There are certain groups that invest heavily in "rational" leisure choices, from books to museums, while others remain primarily consumers of popular experiences. Furthermore, there are people who can navigate across different types and genres with remarkable versatility in terms of consumption tastes and habits. Scholars point out that people from higher socioeconomic segments move through various selections, both "rational" and popular, while consumers from lower socioeconomic segments remain primarily loyal to popular entertainment choices (Hesmondhalgh, 2013).

Some of the most noteworthy agendas deal with museums trying to attract to their premises people who would not under ordinary circumstances choose to visit their exhibitions. Promoting "rational" experiences to groups of low socioeconomic status is an empowering service, allowing individuals to experience information-rich cultural goods. Offering people high-quality information opens new educational horizons, new

understandings and new opportunities. Having access to quality information empowers people as they begin to understand the difference between information-rich products versus just entertainment, to shift their perceptions of the world, to build networks with other people who also seek alternative educational routes, and ultimately to identify significant, life-changing opportunities.

For the same reasons, many museums, galleries and libraries around the world invest in educational programs for children from low-income families. This cultural agenda has significant implications for organizations and their young visitors alike. Children benefit from those participations, because, from an early age, they begin to recognize the value of alternative education, while discerning between various experiences in terms of the quality of information they carry. Furthermore, "rational edutainment" providers invest in their future publics. Marketing scholars argue that when museums invest in their relationships with children, their young consumers continue to explore those experiences as they become adults. The particular agendas promoted to low socioeconomic segments are intended to overcome class entrenchment and demographic walls.

These are just a few examples of cultural agendas with significant implications for entire societies and their practices. One of the key questions, at least from an organizational perspective, is this: What segmented characteristics should be taken into account in order to set cultural agendas that have a particular appeal in a specific group? What other factors might affect the process?

Different streams of research have identified several types of orientations and motivations that guide people's leisure selections. Recognizing those distinct attributes of cultural agenda setting across different groups of consumers directs our thinking in regards to the leisure motivations of different groups. People survey multitudes of cultural experiences, and in the process, they recognize some of them as more important than others, and they make decisions on how to spend their free time. The rest of the chapter, while not providing an exhaustive list of segmented needs, motivations and gratifications, revisits some of the most noteworthy types of segmented agendas with future research potential.

Geographic Agendas

Geography plays a pivotal role in segment selections. The meaning of geography varies as multiple cultural experiences become available in a given area. Although cultural creators cater primarily to the needs of those close to them geographically, there are many cultural producers that attract consumers from further afield. Furthermore, there are large differentiations among many popular entertainment providers, such as television, movies and video games enjoyed at home, and "rational edutainment" providers that, in many cases, strive to attract visitors to

their premises. Van Loon, Gosens & Rouwendal (2014) present significant evidence that cities are perceived as more attractive if they are promoted as cultural heritage destinations. Geography plays a crucial role, especially in connection with the city or the country in which the organization operates. Many museums, art galleries and cultural institutions promote themselves in alliance with the city to which they belong, as both the city and the museum will benefit if visitors choose to spend their leisure time there. It is no surprise that some of the greatest museums of the world are located in famous cities that exude an image of cosmopolitanism and multiculturalism. As already explained, major urban transformations were directly linked with the establishment of prominent cultural organizations, like the Centre Pompidou in Paris. Since the 1960s, virtually all European capitals have promoted cultural policies involving urban rearrangements in conjunction with cultural experiences. Southern European countries followed this trend, with notable delays. For example, Barcelona underwent its urban change in relation to a major athletic event: The city received a face-lift in preparation for the Olympic Games of 1992. However, not all cities used similar tactics. In Athens, major infrastructure built for the Olympic Games of 2004 was not strategically utilized for city promotion. On the other hand, the unification of archaeological parks in the city center and the new Acropolis Museum have set a new tone in relation to classical antiquity and the historic Athenian monuments that renders the center of the city a recognizable destination for tourists. A longitudinal study of Greek museums and agenda setting (Bantimaroudis, et al., 2010) demonstrated a significant difference in terms of visitation among museums located in Athens in contrast to other museums located in rural areas of Greece. This research confirmed what was widely assumed: that a popular metropolitan area brings additional visitation to museums. After an organization has established its public image, this process reverses, as famous organizations might render the city attractive to visitors. Organizations and cities form symbiotic relationships to establish a joint sense of salience for the benefit of both. Therefore geographic agendas entail various attributes that link the attractiveness of cities and organizations together. City transformations entail an "informational" element (Castells, 1989). Citizens, consumers and experience seekers converge in a pursuit of aesthetic constructs offered by multiplying leisure outlets. Cities and organizations strategically utilize their cultural assets, upgraded through technological investments that blend the real and the virtual. As those alliances are formed, more leisure providers strive to find their niche audiences.

However, not all geographic agendas follow established cultural and urban trends. Although most known cultural organizations are located in established geographical locations in terms of city brands, there are occasionally some very interesting investments that take place in

geographical areas that are not widely known and lack well-established brands. In some cases, rural areas of the world have attracted attention because of significant cultural investments and industrial activity. When Disney Corporation decided to invest huge sums of money in a relatively unknown part of Florida, it single-handedly established this rural area as a global destination. Pine & Gilmore (2011) directly link experience provisions with added value: "Before his death in 1966, Disney had also envisioned Walt Disney World, which opened in Florida in 1971. Rather than create another amusement park, Disney created the world's first theme park" (p. 3). Disney World was envisioned and designed as a world-class investment in an area that had not enjoyed significant attention prior to Disney's arrival. This family-oriented, popular entertainment provider brought added value and esteem to the greater Orlando area. Its huge investment in a regional setting boosted the local economy, while the entire region benefited, building an internationally known brand, maximizing the inflow of domestic as well as international visitors. Commenting on the relative attraction of theme parks versus museums to Canadian visitors, Macdonald and Alsford (1995) observe that "there are more Canadian visits to Orlando's theme parks each year than there are to all Canadian museums combined" (p. 132).

Location is a significant determinant of image and visitation. In Europe, as the venue for its entertainment park, Disney chose Paris, arguably the most established cultural center of the world, the home of the Louvre, Eiffel Tower, Centre Pompidou and many other cultural assets. Similar thinking guided their international investments in Hong Kong, Tokyo and more recently Shanghai. Despite the cultural obstacles that the conglomerate had to deal with in places where the "Disneyification" of local cultures might be viewed with skepticism, Disney executives chose to expand their services in international metropolitan areas with recognizable assets. In Paris, for example, initial skepticism was overcome as this popular entertainment provider receives more than 10 million visitors every year, having been embraced by the French market.[1]

A case of cultural agenda setting with a dominant element of geography is conveyed through the huge investment on the Saadiyat Island near the center of Abu Dhabi in the United Arab Emirates. As we have already seen, it demonstrates a policy shift toward the establishment of a new cultural market in a place identified as an oil economy. Although cultural executives aim at potential visitors and consumers from the Persian Gulf region, their strategy is to promote it as an international attraction for world class investors, researchers, leaders and consumers. When such decisions are made, investors and cultural executives need specialized information about cultural markets. What types of products should be selected? What kinds of symbolism should be conveyed? What kinds of hindrances should be considered?

When media giant Star TV started distributing television content to Asian markets in 1991, targeting the richest 5%, its executives thought their investment was risk-free. They ended up losing millions of dollars. Cultural distance between the west and Asia involving religion, race and language can cause major failures in reaching audiences in different geographic settings (Ghemawat, 2001), and many geographic agendas fail if cultural attributes are not considered carefully. Tracing niche audiences in geocultural environments is by definition a challenging task. Cultural analysts and audience researchers have to consider various parameters of what is generally described as cultural diversity. According to Athique (2014), "human differences operate at the level of language, spiritual belief systems, socializing rituals, kinship structures, moral regulation, cultural performance and formal political organization" (p. 7). These elements contribute to conceptualizations of collective identities. Hesmondhalgh (2013) discusses the notion of "geocultural markets," a construct related to geography but that entails much more than location attributes. In many cases, cultural characteristics describe distinct segments of potential cultural consumers or seekers of particular cultural experiences. Hesmondhalgh (2013) offers a relevant example: "The countries of Eastern Europe and the European nations of the former USSR, for example, form a particular geocultural region, with shared histories of Soviet oppression and longer Christian traditions, but there is no shared language" (p. 279). Any of these countries form related segments of potential cultural consumers that belong to more than one market, with varying degrees of cultural identification. Individuals in these geocultural markets might identify with a common heritage, history, religion and conceptualization of the world. In Europe, there are significant differences in regard to how often Europeans visit their museums. More Swedes and Danes seek museum experiences than any other European nation, a trend recorded in visitation numbers. On the other hand, the Greeks and the Portuguese visit their museums less than anybody else in Europe.[2] Geographic agendas entail a variety of attributes. In fact, the term "geographic" might be misleading, as it includes geocultural traits, such as histories, identities, behaviors and ideologies as well as market characteristics and resources.

Other geographic considerations pertain to proximity of certain segments to the organization and the kind of investment necessary to sustain an audience from the nearby area in contrast to attracting people from far away. Promoting the value of a specific location and its potential attractiveness constitutes a significant cultural agenda for virtually all types of organizations, institutions and creators. Many smaller organizations have been envisioned as local entities. Their viability depends on local consumers, though attracting people from afar is an added bonus. Local libraries belong in this category, serving community members of different ages. One of my favorite examples pertains to a local library

in Veria, a medium-sized city in Greece. Its executives managed to attract funding from the Bill and Melinda Gates Foundation, expanding its scope of services considerably, and rendering Veria's library recognizable around the country. Despite its remarkable success, the library's primary mission is confined to its limited geographic area and the local people that it serves, and its viability depends on the relationships it sustains with residents and nearby inhabitants of northern Greece.

Rogerson (2012) identifies several investments that rejuvenate cultural economies at a local level. He argues that physical attractions in the form of new infrastructure and cultural attractions such as museum exhibitions, art collections and performances are recognized as foundational investments that might attract attention to a particular locality. Furthermore, the transformation of a city to an "eventful city," a place with a lot of festivals, games, music, lectures and other types of performance-oriented offerings, demonstrates an event-oriented strategy pursued by different stakeholders. Shopping opportunities constitute another layer of local promotion; while improving the city's night life it offers additional venues for entertainment. Local investments provide leisure outlets for residents but the city might benefit from additional attention, attracting visitors from other regions and countries. There are numerous examples of case studies, each displaying interesting lessons on cultural agendas, and geography has become a recognized segmented characteristic that guides people's choices at different levels. For example, a study jointly pursued by the Canadian and American travel and tourism administrations catalogued the most significant activities for international travelers: taking pictures, visiting places, restaurants/dining out, shopping, observing wildlife, contacting local inhabitants, attending festivals/events, visiting friends/relatives, and various athletic outdoor activities (Hsieh, O' Leary & Morrison, 1992). Cultural heritage, along with other popular choices, provides a useful description of visitors' perceptions and valued behaviors. A geographic agenda incorporates multiple capacities for outdoor and indoor activities that prospective consumers recognize and select. Managers and executives undertake business initiatives, calculating geographic advantages and the potential to build marketable cultural experiences. In the end, consumers make choices in regards to certain locations, as they weigh the geographic advantages along with their own needs, identities and decoding capacities.

Demographic Agendas

Demographic agendas can be built on characteristics that separate different social groups based on their socioeconomic status, gender, age, ethnic background, religious beliefs and race. Along with products and experiences of mass consumption, cultural providers set demographic agendas, recognizing segmented differences in leisure selections.

Therefore, identifying key differences among various groups with the intention to provide services that are focused on their specific needs, aesthetics and preferences contributes toward agenda building. Indeed, there is a great deal of evidence generated from different disciplines and areas of study, sometimes with conflicting findings in regards to group leisure selections. Researchers are expected to evaluate this huge volume of research with caution and a critical eye.

Scholars agree that males and females differ in the ways they perceive "value" in the cultural domain, as they differ in their leisure choices. Those differences can be attributed to the manner in which they interact with media content and the various ways they process information in general. Though research shows that information processing is influenced by several factors (social class, culture, and education, to name a few), men and women display fundamental differences in the way they approach information and therefore they "arrive at different judgments" (Okazaki & Hirose, 2009, p. 796). Understandably, collecting information about gender differences is a standard parameter in most audience analysis endeavors. In a comprehensive presentation about gender differences and the media, Greenwood and Lippman (2010) identify four types of media that have been linked to different consumption patterns between males and females: new media and the internet, video games and certain types of movies. As they survey the available evidence, they present a map of gender differences especially in relation to video games, touted primarily as male activities. However, there is certainly a mixed picture about internet and digital media usage, not necessarily pointing toward pronounced gender differences. Since the early days of the internet and as different digital media and platforms have become widely available, scholars have observed a slow convergence in terms of digital media usage, progressively lessening initial diverging observations. Research on video games shows that males spend more time on this activity than females, as designers of video games cater primarily to male consumers, from children to adults. Different researchers point out that marketing video games to female consumers has not been successful, despite the overall interest expressed by manufacturers. The video game market provides a wide array of products clearly appealing to young males in contrast to fewer available products geared toward women of all ages. Lucas & Sherry (2004) conclude that instead of "making cosmetic changes or reducing the complexity of games, redesign efforts should focus on playing into female players' natural cognitive abilities" (p. 519).

Along with gender, social class differences are recognized as significant predictors of cultural consumption. Although this sounds a cliché statement acknowledged by different schools of thought, it is worth pointing out that "rational edutainment" experiences are primarily sought by affluent, highly educated people who display refined appetites for opera, theater, ballet, classical music and fine arts. According

to Dimaggio and Useem (1978), class structures represented by level of income, education and specific professions are associated with leisure selections involving certain art forms such as classical music, ballet, and the opera. Dimaggio and Useem (1978) point out that "appreciation of and familiarity with the high arts is a trained capacity, with access to this training unequally distributed among social classes ... Individuals must learn to 'read' a painting or a piece of music just as they must learn to read the printed word" (p. 149). Although appreciation of the arts constitutes an acquired capacity that people learn, it is also a contextual experience in the sense that it is learned in upper- or middle-class environments. Class structures provide the context in which reading, understanding and appreciating art becomes possible. Consumption and appreciation of fine arts provide class cohesion and solidarity. People identify with those who appreciate art in similar ways and therefore a special bond is forged among members of similar class structures. The authors draw from Pierre Bourdieu, reminding us that art appreciation is a form of cultural capital: "The possession of refined cultural tastes can serve as an alternative to the possession of wealth and corporate power for asserting high status within the elite" (Dimaggio & Useem, 1978, p. 154).

Level of education and income are two especially significant predictors of many consuming tendencies. According to Yucelt (2001), "to increase the number of visitors, some museums have established dollar nights to reach lower-income groups. The Children Museum in Boston uses group rates and corporate sponsorship to keep admission costs down. However, getting people in the museum door is only half the battle, museums need to keep their visitors connected to the institution" (p. 6).

According to Falk (2013), visitors of history museums, art galleries and science museums come mostly from high socio-economic status segments of society and have had more education than the average citizen. The same goes for those who attend symphony orchestras, opera performances and theater. Highly educated individuals present similar behaviors in terms of cultural preferences and consumption trends.

Along the same lines, Kabanoff (1982) examines a different demographic consideration in relation to leisure choices, using different professions as predictors of cultural consumption. He provides evidence that "people with jobs that provide autonomy, variety, skill utilization and so on should seek leisure activities with similar characteristics, while persons in jobs that are routine, restrictive and undemanding will also have similarly routine leisure activities" (p. 233). Demographic agendas entail many initiatives undertaken by cultural producers aiming to appeal to particular groups.

Van Eijck and Mommaas (2004) avoid conventional observations of class structures in outlining the elaborate and diverging appetite of the new middle class, as representatives of different professional groups that

display different cultural appetites and preferences. Sometimes the middle or upper-middle class are treated as monolithic entities. They present detailed evidence of an evolving and highly complex group of professionals recognized in the literature for their mobility within their cultural domain. Among various theorists, they draw from the work of Savage, et al. (1992), dividing the middle class into three categories of lifestyles: the ascetic, postmodern and indistinctive. "The ascetic lifestyle is dominant among public sector welfare professionals. The postmodern occurs among private sector professionals and specialists, while the undistinctive lifestyle is most prevalent among managers and government bureaucrats" (p. 375).

The literature documents that people of lower socioeconomic status watch more television and have a pronounced preference toward different types of popular entertainment, while they rarely seek information or education-rich cultural experiences. Low income and education are related to passive entertainment choices, with television being one of the core leisure choices (Huston, et al., 1992). Occasionally, low income and low quality of education blend in with ethnic and racial characteristics, forming a demographic multi-trait map of preferences. Although there are cultural demographic trends that merit attention, in most cases, national/cultural characteristics become intertwined with low income and a poor educational system, which influence these consumers in terms of the information-poor cultural experiences they select.

Encouraging people from disadvantaged environments toward information-rich experiences has become a significant priority for various organizations. Many museums, art galleries and libraries design experiences for children of different socioeconomic backgrounds with a primary attention on disadvantaged segments. These cultural agendas initiated by museum educators and curators have multiple benefits for organizations and experience-seekers alike.

Age is another significant demographic parameter that deserves our attention. One standard strategy choice made by most organizations and institutions involves attracting young people, from early childhood to early adulthood. Increasingly, museums develop agenda-setting strategies for children as they realize that they are investing in future visitors. Indeed, children and teens constitute strategic segmented choices for various organizations, not only as current consumers but because they establish relationships with groups of strategic value and with a long-term potential. Organizations set agendas now to ensure that they will have a future audience many years later. Children from low socioeconomic environments benefit particularly from these agendas because they cultivate an appetite for more "valuable" cultural experiences. Some policymakers view such initiatives positively in their ongoing efforts to minimize class distinctions and allow children from different social groups to come together.

Museums complement the school experience by providing alternative routes to knowledge, information rich experiences that do not necessarily resemble formal education provisions. Rather, children are exposed to different types of "rational edutainment" empowered with new knowledge, active information seeking and alternative learning capacities. Especially in the realm of "rational edutainment," children benefit from educational experiences in contrast to other more passive forms of entertainment from the popular domain. If children learn to appreciate "rational" forms of leisure from an early age, there is a higher probability that upon reaching adulthood, they will continue to be active consumers of such experiences. Through continuous exposure to the arts, they acquire a familiarity with cultural offerings outside of the mainstream popular domain. The goal is to empower children with reading skills and decoding capacities of various types of products and experiences.

Most modern cultural organizations strive to reach out to children, which constitutes a strategic choice because: (a) consumption habits and cultural choices formed in early life tend to follow people into adulthood; (b) children process information and adopt values with much greater ease than adults, giving organizations a unique opportunity to shape children's attitudes and beliefs; (c) children are linked with the future viability of an organization and so constitute a long-term investment (Strasburger, Wilson & Jordan, 2009).

Therefore, designing and producing cultural goods specifically for children is essential for the future well-being of an organization. Recognizing children as a public segment of great significance for the future of an organization offers strategic advantages because children are consumers with a great deal of independence in their purchasing decisions, a trend that affects the function of global markets. Their interaction with adults in terms of their spending behaviors and overall development as future consumers should leave no organization indifferent. All of the above constitute dominant cultural agendas that deserve the attention of modern cultural providers. Kotler (2001) stresses this notion as he discusses the future of museums. He argues that

> a successful future museum will not be an entertainment center although it will have entertaining elements. It will not be "a cabinet of curiosities," although art and artifacts will be important elements. A future museum will not be exclusively a place supported by collectors, cultural leaders, and elites, although their presence and support will be vital. Nor will it be a place, which caters mainly to adults who can afford membership fees. A future museum will be a place that attracts young people who want to learn and enjoy recreational activities. (p. 423)

Sometimes, entire generations are influenced by developments that take place during their lifetimes. Scholars focus on the Net generation as a distinct group of people, also known as millennials, or generation Y. The Net generation refers to people born between 1977 and 1997. They display unique traits that differentiate them from previous generations. They have unprecedented access to digital technologies, different types of media and information. They grew up with different media platforms and came into adulthood along with Facebook and other social media. They are described as more tolerant than previous generations. They are savvy in content management and understanding of media. They understand what advertising is all about and are thus more suspicious and less impressed by it. At the same time, they circulate among themselves relatively superficial and frivolous lay digital productions. Since this is the generation of the internet, they deserve special attention (Napoli & Ewing, 2000).

Young people in the twenty-first century represent cultural consumers with unprecedented access to technology, more than in any other period in human history. They have grown up surrounded by technology and become adults knowing the internet from the first years of their lives. Arthur, et al. (2006) identify some key preferences of teenagers and young adults related to interactive technologies. Young people look for opportunities to express their identities and to engage in social interactions. Furthermore, they want to discover the world while constantly seeking entertainment. As digital technologies become the primary media for youthful interactions, cultural providers must recognize those habits and preferences if they wish to keep modern teenagers culturally interactive.

These findings on demographic agendas prompt many questions: Which kinds of cultural experiences would be primarily appealing to an educated person? How can people of low socioeconomic status be enticed to diversify their cultural consumption habits? Why are certain leisure choices unappealing to certain demographics? Why would certain experiences be primarily appealing to women, whereas men might be indifferent toward them? Which products cater to a particular ethnic group, whereas other ethnic groups might not display a significant interest? Which products or experiences might be geared exclusively toward rich people because middle- or lower-class individuals cannot afford such selections? Some of the questions can generate cultural agendas that are appropriately designed for certain demographic groups while generating attention for groups that show a minimal interest. Finally, there is a general question that cultural creators strive to answer in modern, culturally diverse markets: How can an organization attract segments that traditionally are not interested in the types of experiences it provides?

Lifestyle and Personality Agendas

In the previous chapter, I attempted to differentiate between different types of organizations based on the kinds of 'experiences they provide. Cultural marketing specialists scrutinize the relationship between types of lifestyles and the experiences sought by different consumers. This area of study is also known as psychographic research. According to Chaney (1996), studying lifestyles helps "to make sense of what people do, and why they do it, and what doing it means to them and others" (p. 4). The concept of lifestyle encompasses, among other things, personal interests, preferences and models of behavior. As leisure choices seem to be related to individual lifestyles, cultural organizations need to understand better the relationship between types of lifestyle and personality-driven selections. Peter and Olson (1994) approach the construct of lifestyle around three main dimensions: interests, activities and opinions. Researchers from various backgrounds and disciplines have considered the area of "interests," enhancing both the measurement and operational conceptualization of the lifestyle construct. Measurements of "values," "life visions," "aesthetic styles," and media "preferences" have provided further insights into the scope of lifestyles. Vyncke (2002) argues that mere demographic descriptions are often not enough in capturing consumers' motivations. Closer examination of people's psychological profiles explains their choices through enhanced matrices of motivations, preferences and aesthetics. Cultural managers are aware of the role of personality types in connection with different forms of leisure and therefore cultural strategists incorporate appropriate research as they try to influence people's leisure choices and attract cultural consumers from different groups. Researchers have observed that lifestyles mirror the character and the personality of individuals.

Some people display an "educational" lifestyle, investing in distance learning courses, traveling, attending performances and conferences, visiting museums and buying a lot of books. Learning in the form of acquiring information or seeking different opportunities for education represents a significant personality category, which corresponds to a particular lifestyle. In this group belong lifelong learners and different types of researchers who exploit every possible opportunity to acquire new information and seek understanding.

Some are social types, prioritizing time with other people, including family and friends. It is expected then that their leisure choices will reflect their personality type, as they choose to spend their free time with other people. Other people display an inclination toward an indoor, passive entertainment lifestyle. Staying at home and watching television, playing video games, or listening to music expresses a set of preferences displaying less social and more passive entertainment priorities. Socially conscious lifestyles displaying a philanthropic agenda characterize different

personalities who care about making a difference, providing for the less privileged or solving social problems and injustices. Adventure constitutes a choice of interest, attracting many different personalities that occasionally share common interests. People in this group seek traveling experiences, exciting trips and generally anything that stimulates their imagination.

Drawing from empirical evidence, González & Bello (2002) identify five groups of lifestyles along the aforementioned descriptions: (a) the home-loving group, conservative by nature, inflexible in their views, focusing on family and raising children, who enjoy a wide spectrum of cultural activities from popular entertainment to museums and natural parks; (b) the idealistic group, focusing on personal success in relation to social causes, flexible and tolerant, who are readers of books and magazines and also enjoy classical music, theater and news; (c) the autonomous group, who are ambitious and value individual freedom and independence, favoring primarily a popular entertainment lifestyle; (d) the hedonistic group, who value human relationships and work, and enjoy a wide range of experiences with a primary emphasis on news and popular entertainment; (e) the conservative group, defined by family relationships, not necessarily career-oriented, typically religious, law-abiding citizens who hate disruptions and abrupt changes. They are not fans of popular entertainment and seek primarily "valuable" experiences. In their descriptions of the most typical lifestyles, González & Bello (2002) converge with most researchers who study market segments in relation to consumption tendencies (pp. 73–79).

Lee, Lee & Wicks (2004) studied segment characteristics in the festival market and identified four clusters: culture and family seekers, emphasizing "family togetherness" as a core attribute, multipurpose seekers with generic and varied characteristics, escape seekers, with a primary emphasis on "escape" and "novelty," and event seekers, with "socialization" being the most recognized attribute. Along the same lines, a study on cinema segmentation in Spain provides evidence for three distinct groups of movie viewers: the "social," the "apathetic" and the "cinema buff." The social cinema viewers recorded the value of social experiences such as being with friends or being with a partner, the apathetic types registered primarily emotional motivations, and the "cinema buffs" described more esoteric motivations such as to "see the work of a director" or "cultivate my interest" (Cuadrado & Frasquet, 1999, p. 262).

Hood (1983) identifies six categories of leisure choices that encompass the core descriptions already provided: socially oriented people who constantly seek social interactions and being with others, those who seek valuable experiences, those who value the environment and are at ease with it, seekers of new challenges and new experiences, those who seek learning opportunities, and finally those who seek different forms of

active participation. Kotler, et al. (2008) cluster Hood's typology of lifestyles into three general categories of lifestyles: the emotional, the rational and the sensory (p. 164).

Popular and "Rational" Agendas

It is not paradoxical to examine many organizations both as "rational edutainers" as well as popular entertainers through common perspectives. The key word is convergence. All types of organizations converge technologically and most consumers navigate along multiple experiences. According to Jenkins (2004), "media convergence is more than simply a technological shift. Convergence alters the relationship between existing technologies, industries, markets, genres and audiences" (p. 34). Convergence is shaped through myriad different processes originating both from the producers as well as through participatory initiatives of citizens and consumers. It forces us all to rethink global flows of information and the ways they shape our understanding. Jenkins (2004) insists that mainstream media will retain their agenda-setting capacity; however, alternative media of a grassroots nature reframe the main agendas, altering meanings and values while offering a voice to those who find themselves on the periphery of the public sphere. Convergence certainly empowers the already powerful, offering further expansive opportunities. For them, providing something for everyone sometimes constitutes a strategic choice. Capitalizing on particular experiences while assigning a secondary role to others constitutes a key difference among cultural providers. To use the terminology of Pine & Gilmore (2011), certain organizations invest heavily in their educational experiences. That does not mean that their cultural provisions are deprived of entertainment, aesthetic or escape-related experiences. In some cases, convergence is manifested between cultural providers that share "rational" attributes. For example, there is a high correlation between people who consistently listen to classical music and those who visit museums and art galleries (Kotler, et al., 2008). Though symphony orchestras and museums represent two different types of cultural entities, there are some noticeable similarities. The experiences they offer are targeted at consumers with prior exposure to art and music. As we have already discussed, they have learned to "read" and appreciate those cultural offerings and it is very likely that they share common socioeconomic characteristics. Therefore, though the experiences vary, there is a common lifestyle foundation among consumers.

Various combinations of experiences can be offered as managers take into account consumers' lifestyles: for example, more of an education and escape agenda in contrast to entertainment and aesthetic choices. On the other hand, popular entertainment providers might downplay the educational aspect while promoting entertainment, escape and aesthetic

experiences. Again, the mix of choices might vary a great deal. In terms of an organizational strategy for agenda building, this common perspective could apply to television, cinema and popular music as well as to museums, libraries and galleries. Treating the different paradigms as an all-encompassing platform for understanding leisure motivations empowers us in our effort to understand cultural segmentation and leisure practices. From a marketing point of view, I adopt a differentiating typology between "rational edutainment" and popular entertainment providers, recognizing them as industries that produce experiences with specific characteristics. However, there are rarely cultural providers that can be described exclusively as "rational" or "popular" in nature; researchers recognize types of consumers that belong more in one category and less in the other. Many organizations are mixed types, as they can offer a balance of both "rational" and "popular" experiences. To stress this point even further, a cultural provider described as "rational" in nature might invest in popular experiences. A technology museum, despite its education and informational products, might have a lot in common with cinema in the sense that it relies on audiovisual content and narratives to shape its experiences. Although organizations differ greatly both in terms of the quality of the experiences they provide as well as the types of audiences to which they primarily appeal, they increasingly adopt audiovisual media and multimedia applications in museum exhibitions, art collections and library activities. On the other hand, television is described as a media industry that provides "popular" entertainment, as the vast proportion of its programming is industrialized, passive entertainment. However, public television in many countries has been historically connected with several educational initiatives. Television was subsidized as a mass medium accessed by impoverished parts of societies, targeting disadvantaged children with the aim of complementing formal education.

According to Prentice, Guerin & McGugan (1998), learning and entertainment represent two significant needs that become leisure choices. Indeed, leisure and media studies converge in the sense that leisure experts describe different types of lifestyles, whereas media and cultural theorists identify the primary needs of each group. Katz, Gurevitch & Haas (1973), who coined the term "uses and gratifications," described five general categories of needs that drive media consumption but can incorporate various leisure choices. While focusing on audience uses of the media, they identified: (1) cognitive needs, (2) affective needs, (3) personal integrative needs, (4) social integrative needs and (5) tension release needs (pp. 166–167):

Cognitive needs: People satisfy their need for surveillance, information and news seeking with a wider appetite for education. Certain segments of the public display a life-long need for knowledge as they are intellectually curious about different topics.

Affective needs: People satisfy a wide range of emotional needs. They become exposed to different types of content in order to gain emotional satisfaction.

Personal integrative needs: This category of needs is linked to self-understanding and self-reassurance. People use media content in order to confirm their well-being, to seek self-improvement and self-validation.

Social integrative needs: People are by nature social beings. Their socialization at different levels is extremely important for the well-being of individuals. Understanding different roles in various social settings, such as family, work environment and society often satisfies a socialization process.

Tension-release needs: Very often, individuals need just to relax and escape from daily routines and burdens accumulated from their daily responsibilities. They use media to relax and relieve tension.

(Severin & Tankard, 2000, pp. 296–297)

Both the work of González & Bello (2002) on lifestyles and the work of Katz, Gurevitch & Haas (1973) on the uses and gratifications of the media shed additional light in terms of recognizing a primary emphasis on certain uses and gratifications sought by groups that favor a particular lifestyle. For example, the home-loving group, which focuses on family and raising children, enjoys a wide array of leisure activities from popular entertainment to museums and natural parks; arguably their primary uses and gratifications are centered on education and popular entertainment. The idealistic group, focusing on personal success in relation to social causes, might emphasize "rational edutainment" with a lot of cognitive stimulation. However, their social-integrative needs are expected to be of primary importance also. The autonomous group, who are ambitious and value individual freedom and independence, are expected to display a primary appetite for popular entertainment; because of their lifestyle, they are also expected to satisfy their tension release needs, while downplaying other leisure choices. The hedonistic group, which values human relationships and work, might enjoy a wide range of experiences with a primary emphasis on news and popular entertainment; furthermore they are expected to value social integration, striving to be included in social circles while understanding different social roles. Finally, the conservative group, defined by family relationships, and strong religious beliefs, might value certain forms of popular entertainment but also seek "valuable" experiences.

The degree of satisfaction of different gratifications in the context of certain segments and types of lifestyles is open to debate. Different groups might prioritize exposure to different experiences because of lifestyle and personality traits. Also they might choose the same type of experience,

Table 3.1 A typology of lifestyles, uses and gratifications

Lifestyle Group	Uses and Gratifications
The Home Loving Group	Cognitive Needs, Affective Needs, Tension Release Needs
The Idealistic Group	Cognitive Needs, Social Integrative Needs
The Autonomous Group	Affective Needs, Tension Release Needs
The Hedonistic Group	Affective Needs, Social Integrative Needs
The Conservative Group	Affective Needs, Cognitive Needs

Sources: González & Bello (2002); Katz, Gurevitch & Haas (1973).

while acquiring different gratifications from it. Lifestyle and personality research in combination with media research offer many opportunities for exploration in the realm of leisure. There are many gaps in the available literature, matching segmented lifestyles with media usage and cultural choices. Certain scholars shed some light on these relationships. For example, Nolan and Patterson (1990) explored the connection between personality types and viewers' television selections and concluded that highly emotional people recorded a preference toward daytime reality television. Finn and Gorr (1988) present a relationship between shy and lonely people and television usage for the purpose of companionship, passing time and escape. Creating accurate matrices that match lifestyles and personalities with prioritized leisure experiences can become a powerful tool for marketing strategy and cultural promotion.

As researchers and marketers consider personality characteristics and different lifestyles, they set priorities for gratification agendas. Pine & Gilmore (2011) propose four experience-related realms that satisfy different needs and are perhaps connected with specialized profiles of different consumer segments. The entertainment, educational, aesthetic and escapist realms of experiences represent four basic types of experiences, from passive to active, from immersion- to absorption-oriented choices. Immersion is defined as "becoming physically (or virtually) a part of the experience," while absorption is described as "occupying a person's attention" (p. 46). The four realms of experiences described by Pine & Gilmore (2011) seem in partial correspondence with the uses and gratifications theory, coined by Katz, Gurevitch & Haas (1973). However, there are some marked differences. Pine & Gilmore (2011) differentiate between entertainment and escape. Escapist activities are described as artificial as well as active: virtual reality, theme parks, casinos, and so on. There is a participatory aspect for players and participators in general. Entertainment is described as much more passive than escape. For example, watching a movie is a passive entertainment activity. Finally, aesthetic experiences are all about the environment, the surroundings, or the location. People enjoy visiting the Eiffel Tower, or "standing on the rim of the Grand Canyon" (p. 53). Pine & Gilmore (2011) define

education and escape as active experiences, entertainment and aesthetic experiences as passive.

In such a fiercely competitive environment for people's leisure time, popular entertainment providers possess some observable advantages as they approach their audiences. For example, for those individuals who value friendships, social experiences and generally spend their time socializing, popular entertainment providers offer a rich array of products and services which often incorporate physical activities. Furthermore, the need for escape and for diversion are satisfied through various media and leisure choices. Theme parks and entertainment centers have a clear advantage among those who seek social experiences. Although opportunities for social experiences are not offered exclusively by popular entertainment providers, the variety of products and experiences in this sector is extremely diverse. Enjoying an experience with friends can be amply satisfied by very different types of organizations.

Those who pay particular attention to the environment and the quality of cultural infrastructure, where they draw inspiration and feel at home, can be approached equally by both "rational" and popular entertainment providers. These segments of society attribute their visitation choices to both natural and artificial environmental factors. Beautiful architecture or recognizable landscapes might attract visitors simply for the value of the location. Those who constantly seek new experiences and challenges can be approached by different types of organizations, depending on the type of challenge they seek on different occasions. Such experiences might include anything from parachuting and bungee jumping to knowledge seeking and personal enrichment. Those who are active, athletic and passionate, in contrast to those who are passive and loners, can be targeted by different types of organizations depending on their personalities and characters. Thus, active individuals who are knowledge seekers usually end up in museum type experiences, while active, athletic types might be drawn to athletic events, sports, traveling, hiking, and so on.

Depending on people's lifestyles, certain groups are attracted to popular, passive entertainment and therefore are heavy television viewers or gamers. Generally, people who watch television, listen to music, read books, spend time on computers, play games or spend time with friends are groups who by nature prefer more passive types of leisure activities, which are not too expensive, do not require a great deal of preparation and do not require them to travel far from home. These groups are targeted by different cultural industries offering a great variety of products for leisure choices at home. Naturally, television claims a significant portion of people's free time, while in the digital era there has been a steady increase in the amount of time we spend on computers, tablets, game consoles and mobile phones. Multimedia are a part of the leisure agenda. Only a small portion of people's time is allocated to "rational edutainment" products, such as books. Away from home, people are

divided into multiple segments, as individuals go shopping in malls, eat in restaurants, go to the cinema, attend athletic events or do sports and occasionally visit theme parks, museums and theaters.

Popular entertainment providers are closely related to a culture of spectacle, with their content strongly based on audiovisual products. In contrast to that of "rational edutainment," their audience does not go to them to satisfy a primary need for information or education. I am not arguing that popular entertainment does not entail any information-related content at all. On the contrary, there are popular experiences that are relatively rich in information provision. However, consumers of popular content do not recognize education as their core reason for consumption. Furthermore, no prior experience or preparation is necessary as individuals are exposed to popular entertainment. Furthermore, popular cultural products do not demand any effort on the part of consumers. Consumers are more passive and satisfy their entertainment and aesthetic needs. These products are easily "digestible," as historically they have been designed to appeal to mass audiences. Their core characteristics provide vast advantages to popular entertainment organizations in terms of attracting large groups of consumers. Apart from the core objectives that basically pertain to all cultural organizations and institutions, there are organizational differences that deserve further consideration.

Museums, galleries, libraries and publishers are some of the "rational edutainment" providers. The experiences they offer incorporate significant information and education components. Prior preparation on the part of the visitors empowers them to make the best of extracting information and engaging in knowledge seeking. Seeking "rational edutainment" constitutes a distinct behavioral agenda of leisure choices. Museums are the primary representatives of "rational edutainment" providers. Over the past few decades, they have turned their disadvantages into strategic advantages, expanding their primary publics significantly and drawing crowds from all over the world. It is noticeable that they have managed to draw visitors who traditionally were not attracted by museum experiences. The museums of western metropolitan areas have become major attraction centers for different publics: children, adults, minorities, tourists, researchers, and so on. By offering a variety of services and products for all imaginable appetites, from gift shops to restaurants, museums have managed to be transformed into cultural industries. For example, American museums encourage young adults to invest in their need for meeting people and socialization (Kotler, et al., 2008, p. 172). Thyne (2001) describes museums as nonprofit organizations that fulfill certain societal needs: "they have a preservation obligation to society, they also have an education and entertainment obligation to their visitors" (p. 116). Kotler & Kotler (2000) ask the following provocative question: "Can museums be all things to all people?"

Outlining the struggles and the challenges of modern museums to adapt to market demands, they propose three strategies for expanding museum visitation. They propose an overall improvement of museum experiences, expanding museums' involvement with their communities and a strategic market repositioning. Many researchers converge on the value of experiences and the meaning attributed to experiential provisions. "Rational edutainment" providers are well placed to appeal to those who seek a "valuable" experience—usually educational in some form—who want their time allocation to offer worthy knowledge or some type of "cultural capital." Apart from knowledge and information seeking, "worthy" experiences are often related to identity formation, group orientation, humanism and relief endeavors.

Despite a primary emphasis on education and informational provisions, "rational edutainment" providers do not refrain from entering other experiential realms. On the contrary, appealing to a wider spectrum of lifestyles and personalities mandates the design and promotion of diverse types of experiences. Merritt (2006) identifies several categories of "rational edutainment" providers such as zoological parks, science and technology museums, botanical gardens, organizations related to children and young people, natural history museums and art museums. In these organizations, there is an inherent recognition of seeking learning, keeping in touch with technological developments and forms of innovation as well as engaging in social interactions. However, in many "rational edutainment" providers, there are also significant investments in escapist and aesthetic choices. "It must be admitted that the introduction of entertainment forms has been equally prompted by pragmatic motives of revenue generation, audience development, and audience retention for longer stays. Imax films or the Smithsonian World television program provide examples of entertainment media adapted to museum purposes" (Macdonald & Alsford, 1995, p. 139). The mere availability of all types of experiences manifests that cultural providers refrain from one-dimensional provisions, as they attempt to satisfy the needs of different personalities and lifestyles.

Even from the distant past, researchers have acknowledged that performance oriented motivations often explain museum visitation. Veblen (1899) discusses "displaying one's wealth and power" as a social motivating factor for traveling and visitation (p. 64). Social position and status and the tendency to display both provide a motivational background for behavioral choices in this domain. Furthermore, the concept of cultural capital constitutes a key element for understanding what skills and capacities are acquired by certain segments to make sense of and enjoy certain experiences, such as museums (Bourdieu & Darbel, 1991; Hummon, 1988).

As we scrutinize information- and education-seeking closely, what particular mechanisms explain the curiosity and the mobilization of

visitors? Various answers emerge from the work of museum specialists. Certain scholars argue that it is primarily perceptions of identity that explain certain forms of cultural consumption. If personal identity is the key notion that explains "rational" leisure choices and motivations, there have been numerous perspectives on how individuals negotiate their identities in the leisure domain. Sometimes, these questions are intimately related to personal life stories expressed with unique answers. In other cases, there have been observed practices that characterize group or segment mobility. For example, Falk (2009) undervalues the usage of marketing tools such as demographic research, noting that conceptualizing one's personal identity constitutes the most important explanation of leisure choices and, more specifically, museum visitation. Individual perceptions of identity explain better than segmented indicators how individuals seek information and reach decisions on museum experiences. Falk's construct of personal identity is explained through a multidimensional typology of experience seekers that encompasses explorers, professional/hobbyists, facilitators, spiritual pilgrims, experience seekers, as well as affinity seekers and respectful pilgrims (Falk, 2009, Bond & Falk, 2012; Falk & Dierking, 2013). Falk & Dierking (2013) describe primarily museum visitors and their segmented identities. However, additional research might shed light on the applicability of their typology to other organizations in the "rational edutainment" domain providing information-rich experiences, such as galleries, libraries and cultural research centers. Although more analysis is necessary, it seems very likely that Falk's research applies to these types of edutainment as well. Following the typology of Falk & Dierking (2013),

"Explorers" are described as curiosity driven visitors, seeking different kinds of content to satisfy personal curiosities as they display a primary need for learning.

"Facilitators" are primarily social beings. They enjoy social gatherings and group activities. They are motivated to organize learning experiences for family members and friends and they derive pleasure from facilitating such social learning opportunities.

"Professional/Hobbyists" are those who identify with special types of content because of personal or professional interest manifested during visitation. For this group, a visit is motivated because they identify a link between organizational content and their personal lives.

"Experience Seekers" are motivated by the perceived value of the place they set out to visit. They perceive the organization or the geographic location as very special and thereby they enjoy just being there.

"Rechargers" seek restorative experiences. They might seek a "spiritual" escape from the burdens of everyday lives. In this sense visitors

derive from content a recharging value, something that will keep them going after they return to their ordinary lives.

"Respectful Pilgrims" visit museums and presumably other organizations because they feel obligated. There is a sense of duty involved in the visitation.

"Affinity Seekers" seek an experience that enhances their sense of heritage or identity. Special exhibitions and heritage collections might speak to one's heritage, cultural background and sense of belonging.
(Falk & Dierking, 2013, pp. 48–49)

Smaller studies converge along the findings of identity related literature. McKercher & du Cros (2003) recognize the purposeful, sightseeing, casual, incidental and serendipitous cultural tourist categories (p. 49). Todd & Lawson (2001) identify the following categories of museum and gallery visitors according to their segmented characteristics: "active 'family values' people," "conservative quiet lifers," "educated liberals," "accepting mid-lifers," "success-driven extroverts," "pragmatic strugglers" and "social strivers" (p. 271). Their work also converges with the identity paradigm.

Although Falk's identity typology for museum visitation has been criticized as lacking "a contextually sensitive framework" (Dawson & Jensen, 2011), it provides an interesting taxonomy not necessarily of different segments but of visitors' motivations. It arguably has numerous applications to different cultural sites, organizations and experiences, as scholars strive to understand what motivates people to travel and visit different places. Responding to different reviews of his work, Falk (2011) acknowledges the vast literature on identity and the various definitions of a multifaceted concept. He differentiates between an 'Identity' with a capital 'I', encompassing core attributes acknowledged widely in the available literature, such as race, ethnicity, religion and national origin. These are described as stable identities. On the other hand, 'identity' with a lower 'i' "may include one's sense of being a member of a family, a good friend, or even a valued employee" (p. 144). Falk has consistently argued that these fluid descriptions of identity play a significant role in how people spend their free time. The lower 'i' descriptions of identity provide explanatory power of day-to-day leisure decisions not for the purpose of building a new segmentation model of museum visitors but with the intent "to understand the ways visitors use and make meaning from museum experiences" (p. 146).

As "rational edutainment" has attracted a lot of research attention, Goulding (2000) argues that museums need to recognize their cultural provisions as services and therefore survey systematically the satisfaction of their visitors. In her effort to provide "a holistic approach to service marketing," she identifies four determinants of service experiences

in the museum environment: socio-cultural factors (related to identities, themes, conversations and interactions), cognitive factors (related to activities, engagement, reflection, imagination and perceived authenticity), psychological orientations (encompassing scenery and mapping), and physical and environmental factors (such as crowding, noise and seating). Goulding's (2000) marketing orientation combined with her participant observation approach is indeed very valuable in providing a broader framework of observations, both encompassing a customer-oriented approach through the lens of cultural analysis (p. 274).

Some of the questions asked in public opinion polls resemble the original agenda-setting studies from the civic domain. What essentially researchers were trying to derive from these explorations was a hierarchy of importance. In a similar research context, when people in the United States were asked "what do you acquire from your visit to a museum," 57% of the respondents referred to the value of a social experience as they visit museums with friends and relatives; 53% had a strong emotional experience, while 46% said their knowledge increased as a result of their visit (Ostrower, 2005). This quantitative evidence seems in direct correspondence with Falk's typology of facilitators, rechargers and explorers. Furthermore, it manifests a metamorphosis of modern museums as they extend their provisions toward the popular domain.

Belk & Andreasen (1982) argue that the family life-cycle provides explanatory information in regards to leisure selections. Kawashima (1998) adopts this view as a key mechanism that explains leisure selections. The family life-cycle integrates income, age, and employment status at different stages of life and "can reasonably predict leisure patterns because available time and the types of general leisure activities each segment group can choose to be engaged in are shaped by the stages of life" (p. 25). Although not all research involves compatible definitions or sets similar objectives, the overall attention is indicative of evolving organizations striving to understand identity related motivations of their various publics. Many organizations that offer an array of "valuable" cultural experiences depend on their visitors. If the experiences provided are attractive and satisfy the needs of visitors, they will bring more visitors, making the organization more recognizable, as visitors are sometimes the best advertisers of an organization. Therefore attracting visitors constitutes an absolute priority for the organization.

Multiculturalism and Cultural Agendas

The early years of the twenty-first century have seen an increasing flow of economic migrants and war refugees, especially in certain parts of the world. This mobility of populations is expected to intensify in the years to come as third world countries, hit by unprecedented poverty, illnesses, war and natural disasters, seek refuge in the richest countries

of the planet. Therefore, virtually all countries of the so-called developed world constitute immigration destinations. This population mobility on a global scale alters the demographic characteristics of most countries. As certain immigrant groups expand in western societies and this expansion is expected to continue throughout the twenty-first century, cultural providers will face the difficult challenge of designing and promoting new cultural experiences that take into account cultural sensitivies and socioeconomic realities. Among different factors that need consideration, cultural organizations should take into account the following: (a) the poverty factor, (b) linguistic barriers, (c) cultural differences, (d) social biases, (e) limited resources and (f) negligence and lack of strategy.

Different populations move from the developing world for different reasons, but primarily because of poverty and low-quality living conditions that drive them to seek a better fortune for their families and themselves. As they arrive in developed and richer societies, sometimes without property, support and foremost without work prospects, it is apparent that seeking cultural experiences does not constitute a significant priority for them. Often their financial conditions are a significant hindrance, as different organizations and institutions attempt to approach them, offering them their products. Organizations should consider the fact that providing opportunities and different types of incentives for specialized segments comprised of immigrant populations, and particularly their children, constitutes a long-term investment.

Multilingualism has become a trend in major cities of the world. As people settle in new countries, they are called to coexist with indigenous populations. Organizations have to recognize these trends and offer cultural products that overcome linguistic barriers. Linguistic differentiations are usually overcome by second-generation immigrants if they attend the public education system, becoming acculturated in the environment of the host country. Therefore, organizations are expected to have easier access to immigrant communities not only because their managers adapt quickly to changing needs, offering multilingual cultural experiences, but also because future generations of immigrants usually adapt to dominant cultures by learning the language and the customs of the country. Cultural organizations need to consider cultural characteristics of different immigrant segments such as social behaviors (dress, food, and music) as well as identities, beliefs and attitudes. They should seek a cultural understanding, designing and implementing outreach strategies based on the solid foundation of mutual respect. Eventually, culture providers may become key players of acculturation and acceptance, assisting other institutions and immigrant groups to positively adapt in their new homes.

Large scale movement of immigrant populations can cause significant disruptions in host countries, either because certain countries are not adequately prepared to receive thousands of people or because the new

populations overload national systems with additional demands, which constitute challenges even for the most advanced countries of the world. When an organization attempts to access populations of different cultural origins, it should account for indigenous biases and negative predispositions toward groups from other cultures. Appropriate preparations for a coexistence of consumers from different backgrounds should be a part of organizational strategies. One of the most important cultural investments is educating children who will be called to coexist with immigrant children. Both groups will become future consumers of cultural experiences. Although this is a long-term investment, requiring significant time and resources, it is a necessary initiative for the viability of modern organizations. One significant hindrance to attracting minority segments of society is resource limitations. When one takes into account that many cultural services should be provided free of charge or at a very low cost in order to attract certain groups that would not visit the organization under ordinary circumstances, it becomes apparent that the resources factor is crucial for such initiatives and strategies. In this context, there are great differences among nonprofit organizations in contrast to popular entertainment industries.

Finally, one of the most significant problems in attracting minority groups involves negligence and lack of long-term strategy. When organizations cannot envision the benefit from such endeavors or when such investments only materialize after long periods of time, organizations may decide not to allocate their resources to such strategies. Sometimes managers simply lack the capacity to invest in long-term strategies and objectives. Often certain organizations function as public sector, bureaucratic entities, rather than as dynamic and progressive institutions.

Concluding Remarks

As cultural products proliferate and more choices become available, the leisure environment becomes even more competitive and fragmented. The popular entertainment sector claims the lion's share of global cultural markets, while "rational edutainment" providers appeal to smaller, specialized segments of cultural consumers. This discussion on cultural segmentation is subject to various limitations. First, the two sectors display signs of convergence. Organizations that offer learning opportunities increasingly encompass popular entertainment alternatives. In terms of segmented motivations, I adopted two perspectives, the former based on identity considerations emerging from the museum literature and practice, the latter being a part of the media literature and specifically the uses and gratifications approach. Media gratifications are described by a wider typology, including both information and diversion needs.

Increasingly, "rational edutainment" providers borrow some of the tactics and the types of experiences that historically have been developed

by popular entertainment industries. People are not surprised by the widespread use of audiovisual presentations in museum premises. Many different types of multimedia, games and virtual reality are strategically incorporated into museum and gallery exhibitions to attract visitors who are accustomed to popular leisure selections. Despite the useful differentiations about segmented choices and segmented agendas in the cultural sector, there are no experiences that can be described as exclusively "rational," or popular. In most cultural experiences, consumers recognize diverging attributes, cognitive or affective in nature. However, the proportion of different attributes and the way in which they are manifested in consumers' experiences is subject to discussion.

To enhance our understanding of cultural agenda setting, there is a need for research with a primary emphasis on the motivations and orientations of cultural consumers. Although the existing literature provides useful insights into the potential for establishing cultural agendas, carefully organizing the available knowledge in combination with emerging theoretical models might be revealing of new maps of influences. The field of media studies has the capacity to offer comprehensive models that unify existing perspectives, from cultural studies, communication, political economy, anthropology and sociology. Organizations that set strong foundations for long-term, viable relationships with their core public segments consider some of the following questions: To what particular lifestyle does the public respond with the greatest probability of success? What is the socio-economic status of the people on whom the organization has the greatest influence? Taking into account the education factor and a wider relationship of certain individuals with knowledge, which groups have the highest probability of being close to this particular organization? If we take into account the age factor, which age groups are closer to this organization? Which cultural endowments—language, religion, ethnicity, and race—should the organization take into account in order to approach certain groups? How do different groups prioritize their leisure needs, uses and cultural gratifications? And how do different segments consume similar experiences? All these are exploratory questions related to wider issues that organizations should consider as they approach their publics. What becomes clear from such considerations is that organizations should get to know in detail those segments of society to which they primarily appeal, in contrast to other groups that can be engaged peripherally. Researchers notice the intensity of the competition within and across different cultural markets and public segments. Reaching out to new publics and bringing people closer to unfamiliar experiences constitutes a major challenge for various providers. Individuals' choices to invest in particular products precludes other choices, arguably from different domains. Choosing a cultural experience at any given time prevents selections of other cultural possibilities.

Notes

1 How Disney made sure Shanghai Disneyland doesn't put off Chinese visitors. July 12, 2016. Reprinted from *South China Morning Post* print edition. Retrieved from www.scmp.com/lifestyle/travel-leisure/article/1988450/how-disney-made-sure-shanghai-disneyland-doesnt-put-chinese, November 15, 2016.
2 A guide to European museum statistics. Berlin, 2004. Retrieved from www.egmus.eu/fileadmin/statistics/Dokumente/A_guide_to-European_Museum_Statistics.pdf, June 24, 2016.

4 Cultural Agendas, Digital Technologies and Media Platforms

Cultural entities are heavily dependent on digital technologies for setting agendas, and research studies demonstrate their strong interest in digital innovations of different types. Cultural managers know that new cultural strategies for content dissemination must include small devices, such as phones, tablets and laptops, along with audiovisual presentations, games and virtual reality. Virtually all cultural entities address this trend, incorporating different forms of digital technologies in their agenda-setting strategy. As digital communication technologies have become part of the agenda, organizations have had to undergo, in some cases, extreme transformations, and traditional forms of media have been caught up in a massive wave of digital developments. This chapter deals with some of the challenges that modern cultural organizations face as they strive to establish their agenda in a digital environment. Understanding digital technologies is linked to the overall viability of cultural organizations. This is a unique era in human history. Never have humans had such easy access to such a huge body of information and knowledge, but equally, never in human history have people faced such inequalities in information access and distribution.

The digital era arrived in the middle of the twentieth century. A new class of codified symbols led to significant alterations to the cultural domain and human communication evolved in unprecedented ways. Prior to the advent of electricity, information recorded in material form, such as books, newspapers and periodicals, was related to social reformations and the rise of the middle class in the west. This relationship between social restructuring and communication technologies has been approached through multiple social perspectives. The digital world also set in motion new waves of massive social and cultural upheavals. Negroponte (1995) was one of the first thinkers to explain in lay terms that the combination of bits synthesized a digital language, leading to different forms of texts and different types of multimedia. Furthermore, digital media are not just receivers of information; they are also creators and disseminators. Many internet scholars discuss the empowerment thus provided by digital media to virtually all ordinary users.

The Transformation of Cultural Production

Digital media technologies have had a profound impact on all cultural industries, influencing all aspects of production, dissemination and consumption of cultural content. In fact, people have always admired their own technological accomplishments. This observation is inextricably linked to the historic advancement of humanism, which put people at the forefront of cultural and scientific developments. As we examine the role of digital technologies in modern cultural organizations, some basic capacities for agenda building entail: (a) technology as an exhibit and as an experience, (b) technology as a consumer product, and (c) culture from a distance. Technology has become an attraction both as an exhibit and as an experience. And technology can be found at the center of visitors' attention in technology museums, theme parks, industrial units, conference centers, festivals and multiplexes. For example, in the Vieux Port in Montréal, there is sizeable display of IMAX cinema technologies. If visitors wish to be exposed to a cinematic experience of magnified proportions, this particular exhibition accomplishes just that. "The IMAX audience is shown to be dwarfed by the screen, gazing upon the giant moving images with child-like expressions of innocence. These are faces of wonder, faces of surprise. And these images suggest that IMAX is always novel and always a first time viewing event" (Acland, 1997, p. 289). As different aspects of this cinematic experience are explored— corporate, environmental, geographic and technological—what perhaps registers as the most striking is the sensation of the viewers. After all, these gigantic screens were conceived to produce memorable cinematic experiences.

A museum specifically designed to celebrate technology was strategically established in the heart of the Silicon Valley in San José, California. Apparently, this remarkable capital of technological innovations did not follow the cultural transformational trends that profoundly influenced most western cities of the world. They tried to change that in 1998, when they established the Tech Museum of Innovation—popularly known as the Tech. This institution not only celebrates technological achievements but encourages a spirit of entrepreneurship cultivated in an environment that advances various forms of innovations produced in the ultimate incubator of an information-related industrial environment. Furthermore, this investment attempts to place San José in this unique cultural setting (Perrin, 2002).

The capacity of technology to build salience presents significant prospects in organizational research. Apart from contributing to the management and promotion of cultural entities, there is an undeniable interest in technology itself. Technology is attractive and often it becomes an exhibit in and of itself. Setting some of the following questions can produce useful evidence about technology agendas: What experiential and

technological traits render cultural organizations salient? What can managers as well as researchers learn from the symbolic value generated by digital technologies? What limitations should cultural managers take into account?

Museums have not always been accustomed to the use of technology to carry out their missions. For many, neither their managers nor their publics had developed expectations in terms of extensive use of technological tools in museum environments. It was in the late 1960s when some organizations of international scope, such as the Smithsonian in the United States, began to introduce information technology into museums (Economou, 2003). Since the 1970s, things have changed radically for the museums of the world, as global cultural leaders showed the way, followed by regional museums. The widespread penetration of digital technologies into museums has brought a revolution in the management of collections and communication of museums with their audience, although in some cases, uncritical and uninformed investment in technology has not served their mission effectively. The contribution of digital technologies to the management of the museum's collections brought a real revolution, transforming them into modern cultural industries as they became capable of handling a multitude of cultural goods and services. Subsequently, technological trends in museums influence other organizations in the "rational" category, such as galleries and libraries.

While various technologies become recognized as attractions for different visitors, cultural industries have identified specific new technologies that are sold as leisure activities at home. The games industry leads the way, constantly promoting new products aimed at segments that enjoy a leisure experience at home. The success of this particular industry in establishing its symbolic presence is indicative of agenda-setting capacities in this domain. The digital games industry has seen substantial growth over the past two decades, distributing a growing array of new products that are received with a diversified interest in global markets. Because of the massive success of digital games enjoyed both on consoles and online, other organizations have followed this lead in trying to influence home entertainment with multimedia products designed for different groups and with a great variety of content. Edutainment providers have invested a great deal in this category of products, promoting them as educational supplements. And many museums and galleries engage in multimedia productions that target home leisure activities, with a primary emphasis on children's supplementary education. However, the games market is dominated by popular entertainment providers forming strategic alliances with the cinema industry.

Another significant technological development is related to long-distance experiences. The term "long-distance" is one of the clichés of our era. Distance learning/education, remote working, e-shopping, e-banking, and virtual socializing are typical expressions demonstrating

that modern people live their lives from a distance. This is a new condition that most cultural organizations take into account, designing products and services based on long-distance relationships. Many organizations in our networked planet invest in such relationships and services, recognizing that this is a pressing need of the digital world as well as an indisputable reality experienced by most of their consumers. Technology provides new opportunities for access to collections, documentation and independent study of exhibits, and searching museum content remotely, as well as in the maintenance and the structure of exhibitions. Long-distance services provide significant advantages in terms of testability of various cultural products and experiences. By downloading digital content, software, or information, users engage in prior assessment of value, interest and potential for future consumption. In other words, they satisfy initially their need for orientation while testing individual motivations for future interaction with digital content. Previewing a movie online provides an initial assessment of value, orientation and motivation, which may also generate future interest in actual viewership. Furthermore, long-distance engagement with digital content is assessed by the level of interactivity. The capacity for interactivity might elevate salience prior to final consumption. Cultural provisions from a distance are pursued by many industries, as they survey a growing market for different segments, expressing diversified interests for such provisions. From the young professional who attends a university seminar through a personal computer at home, to a leisure consumer who decides to visit a new museum exhibition, a need for education can be satisfied through experiences designed to be consumed from a distance. For those who seek diversion or escape, downloading a movie, a game or a song satisfies these needs without the need to leave the house. Various organizations promote such distance-oriented experiences as technological agendas, generating significant attention.

A Record of Digital Transformations

All cultural organizations have become subject to transformations. Although the degree of change varies, the cataclysmic nature of recent digital developments has swept over the entire sector. First, audiovisual industries and specifically the cinema industry have witnessed massive alteration in the course of a just a few years. Messaris (2010) argues that the film industry has witnessed unprecedented changes. The fate of celluloid has been sealed: it will not survive the twenty-first century. The future of movies is digital. Digital technology brings significant advantages to cinema production, rendering the future of cinema a one-way path. Which changes do we already observe in this historic industry? Messaris (2010) identifies post-production, digital effects and distribution of movies as the core areas affected by the digital era. Digital films

are processed through computers, they can be copied without significant reduction in quality and they can be distributed through networks easily and effectively. Digital technology has given birth to significant expectations in terms of cinema's global industry viability. In the twenty-first century, film faces some of the challenges it faced in the 1950s, when the mass acceptance of television drove the cinema industry to its knees. Today, the film industry finds itself in a similar position, as it is challenged globally by new digital media such as digital games, which claim more leisure time from young people, keeping them at home.

Furthermore, the television industry has been digitally redefined, as it also faces decreased viewership, with young people turning their attention toward the emerging digital media of the internet and game consoles. However, it remains a significant popular entertainment medium, combining extensive penetration in different segments at low cost. Digital television around the world has evolved, becoming an information medium with the capacity to transmit significant volumes of data. Because analogue technology was limited in terms of bandwidth, digital television was promoted to free available bandwidth for emerging industries and other information provisions. Along with the replacement of analogue technology by digital, the television industry did not limit itself to offering just enhanced, high-definition images, but designed and offered multiple new services, similar to those offered by the computer industry and other independent digital platforms. In this new era, technologies of sound and spectacle are not linked exclusively with products distributed by audiovisual industries. The relatively low cost of digital audiovisual production, along with the versatility and easy access of digital media, encourages many cultural executives to include audiovisual services as part of the experiences they design and disseminate. Audiovisual content is available on various devices, in different locations, in different formats, appealing to different groups of consumers.

For example, museums increasingly include more audiovisual content within the museum premises as well as outside of it. According to Bounia & Nikonanou (2008), museums recognize different types of audiovisual content for cultural use: (a) the introductory video, (b) the exhibition video, (c) the video outside the museum, and (d) the educational video. The usability and versatility of digital audiovisual media are primary factors that encourage widespread adoption of such services by a multitude of organizations and institutions, whereas three decades ago, cost and complexity would have rendered such integration of audiovisual productions prohibitive for many "rational edutainment" providers.

Along with audiovisual productions available everywhere, digital games have experienced tremendous growth. In combination with virtual reality applications, digital games are available as a popular entertainment choice both at home and elsewhere, as well as a "rational edutainment" choice in the form of educational games in museums and

galleries. Many organizations include digital games in their strategy as they strive to attract young people both as visitors and consumers. Kokkonis (2010) discusses two leisure trends involving digital games as console gaming has become extremely popular in the twenty-first century, along with online gaming, which has also grown significantly due to improving bandwidth. Digital games constitute a significant home-based activity claiming more leisure time than before, while entertainment providers offer gaming experiences with advanced virtual reality characteristics in theme parks, museum premises and elsewhere.

On the other hand, books have displayed diverging tendencies along with a remarkable resilience. They are still printed on paper, despite various forecasts predicting the opposite. However, the picture is mixed as far as the publications sector is concerned. Without of course being able to safely predict the future, there seems to be a convergence among scholars that books printed on paper still display significant advantages, as a high resolution medium withstanding the pressures of time. They are portable, easy to use and evoke an extraordinary essence of romanticism and elegance. With the advent of digital media, many scholars thought that the need for paper would decrease to the point of leading toward a paperless world. However, the world went the other way, as global demand for paper increased dramatically. Even Bill Gates, a man at the helm of digital developments, argues that reading from a screen is a substantially inferior experience than reading a book printed on paper (Darnton, 2009). Gates implies that there is still a great deal to be done in terms of technological advancement before the need for paper is obliterated. Printed books still claim a significant portion of the global market, although sales data from Amazon.com clearly shows a global and growing interest in e-books read on tablets, mobile phones and other small devices. It is reasonable to expect that global demand for electronic content will continue to rise in the future. According to Darnton (2009), there is particularly strong demand for electronic book content in the field of academic publications (scientific journals) and significantly less in books of wider interest. It seems that electronic publications appeal primarily to specialized segments and pertain to specialized content, such as scientific research. Subscribing to electronic scientific journals makes access to technical content easier and the publishers usually earn their profits from subscriptions charged to university libraries and research institutions. The same principle applies to specialized reference publications, such as encyclopedias, thesauruses, lexicons, and so on. Consumers of such content seek digital access to printed content.

A prominent issue that concerns authors as well as publishers is Google's initiative for the digitalization of the most important libraries of the planet, making their content available on the web. There has been a mixed reception to this project, from enthusiasm and acceptance to skepticism and acrimony. There are many who feel threatened

by the spread of Google's influence on various arenas of the digital world. Microsoft needed 15 years to surpass one billion dollars in profits. Google needed only six years, and has already emerged as one of the world's most significant gatekeepers. It absorbs the lion's share of web advertising, subtracting from profits that would have been claimed by other forms of media. This new reality causes all kinds of frictions (Auletta, 2009). Despite their different perspectives, scholars agree that the book industry has changed dramatically. Some support the democratization of knowledge, as the content of millions of books, including some rare and out-of-print manuscripts, become freely available on the web. On the other hand, many critics are worried about copyright violations. A global discussion about new monopolies established in web services leads to conflicted outcomes, as the management of digital content is a complicated process with unpredictable consequences for future authors and publishers (Darnton, 2009). The fermentation around books especially in the context of content management, digitalization and access is extremely significant for the entire industry.

The New Agendas

Digital media progressively took away some of the power of mass media to broadcast dominant agendas to the masses. Although these influence people's agendas in the civic/political domain, in other domains, attention is divided and diversified as digital media proliferate and segmented needs for orientation are manifested. In the cultural domain, information disseminators can be identified at different levels, from mass broadcasters to organizations, groups, and small teams as well as individual creators. Furthermore, digital media have radically altered traditional forms of narratives, brought convergence, rendered the world smaller and more accessible, upgraded the roles of different publics while bringing individuals into the midst of a chaotic, digital techno-culture. It has elevated the authority of spectacle and made modern people partakers of a global cultural inheritance.

In this digital context, cultural organizations have to be innovative, establishing new types of experiences as their existence and viability depends partially on their understanding of digital culture. In some cases, digital developments test the limits of cultural entities. As the planet becomes smaller, fewer cultural entities aim at mass audiences, with most addressing the needs of segmented audiences, or even targeting their digital messages at the level of the individual consumer. Prerequisites for attracting different segments are the consumers' capacities to connect and consume. This basic understanding divides the planet in terms of the capacity for connections, internet speed, access to computers and other hardware such as tablets and smartphones. Never in human history has the planet been "smaller" than today. Visiting and

experiencing is possible through digital networks, while mass transportation has diminished geographical distances. Traditional mass audiences targeted by media broadcasters during the previous century have been converted to groups of users: readers, listeners, viewers, searchers, visitors, and gamers. The term "user" entails different layers of active participation and interaction with digital media and cultural providers. Readers, listeners and viewers describe core reception activities of modern users, which are also related to the analogue media. However, readers, listeners and viewers in the digital era are very different consumers. Searchers, visitors and gamers are users who have evolved in the context of a digital culture. Because of the competition involved, users' knowledge, perceptions and behaviors as they interact with digital content can be treated as indices of salience. As the capacity for interactivity has increased, it has rendered agenda-setting processes subject to different motivations and needs for orientation. Takeshita (2006) speculated on the development of segmented agendas resulting from digital media appealing to specialized interests. Reviewing some of the available evidence, researchers have become more aware of the multiplication of motivations and orientations in relation to digital media usage. Users interact with digital media content, responding to needs for orientation and various social and psychological motivations. Furthermore, cultural providers have become increasingly aware of users' orientations and motivations and strategically attract different segments of consumers by setting technology-oriented agendas. As we attempt to map out agenda-setting relationships between cultural entities and digital technologies, there are three developments that deserve our attention: (a) promotion agendas, (b) content agendas, and (c) technology agendas.

Promotion Agendas

New promotion agendas relate to digital media platforms, websites, search engines and different types of multimedia. Cultural organizations do not rely exclusively on mass media for their promotion. The digital world offers a multitude of tools for promotion strategies. No cultural entity is considered up-to-date in terms of its promotion agenda, without involving different social media platforms, websites and search engine applications. Similarly, studying the agenda-setting process in the current era cannot be complete without understanding the nature and the functions of different digital media platforms. Individuals, creators, artists, authors and producers maintain their profiles on Facebook, LinkedIn and Twitter, generating content for interested consumers. Websites are designed for specific cultural products, attracting attention to cultural experiences such as films, exhibitions, and books. Museums, cultural institutions and cultural research centers maintain accounts on different

social media platforms, establishing virtual communities of different public segments that become related with the organization.

The easy establishment and the low cost of maintenance of social media communities has led different types of cultural managers to a positive attitude toward these platforms, as all entities strive to become more visible. The agenda-building capacity of social media represents a current area of scholarly and professional interest. Preliminary evidence indicates that social media have a great deal of agenda-setting capacities. For instance, a museum can render a new exhibition salient in the mind of certain public segments that generally follow museum initiatives on Facebook (Zakakis, et al., 2015). Our study on the Acropolis Museum in Athens reveals how content appearing on the museum's Facebook account influences newspaper content both for Greek as well as international newspapers. A number of studies from cultural and other domains demonstrate that social media platforms are capable of establishing segmented agendas for individual followers or entire communities. Certain cultural entities invest in both mainstream media visibility along with social media promotion in order to maximize their overall attention. Such campaign initiatives are expected to produce salience outside the sphere of particular segments, building wider public awareness of their products. Scholars in the civic domain describe this process as agenda melding. The ability of social media to establish major agendas while influencing mainstream media agendas should be subject to further investigation, building on early work such as McCombs, Shaw & Weaver (2014), who differentiate between horizontal and vertical media. Vertical media refer to mainstream, broadcasting media with the capacity to establish agendas for the masses, while horizontal media refer to specialized and social media agendas. Mangold and Faulds (2009) recognize the prevailing expansion of social media, also described as "consumer-generated media." Though the authors draw their applications from the corporate environment, they recognize significant marketing and promotion practices that could be carried over into the cultural domain. Social media allow corporate entities to talk directly to their consumers and, in addition, they provide consumers with a great deal of freedom to talk among themselves. As they do so, they minimize corporate control over these discussions and the messages that circulate. As mass media influences diminish, social media increase their agenda-setting capacities. More people perceive social media content as trustworthy and credible. While recognizing those emerging trends in marketing and promotion, organizations are encouraged to actively shape the new, online discussions by providing information on digital platforms and by engaging customers through the different digital tools. Mangold and Faulds (2009) argue that customers value exclusivity. Therefore organizations should go out of their way to identify the special needs of each group and identify issues that are particularly appealing

to each segment of consumers. Furthermore, cultural managers should strategically encourage positive word-of-mouth communication, without ignoring the value of stories. "Stories can be memorable. The more memorable they are, the more likely they are to be repeated" (p. 364).

Kim (2012) explores the evolution of YouTube as a process of institutionalization. Though it started as an outlet for short, non-professionally made videos, currently, it offers a significant audiovisual promotion platform. YouTube now converges with broadcast television and is increasingly touted as an outlet for professional television productions. The television networks have accepted its role as an internet disseminator for audiovisual content. Since its purchase from Google for $1.65 billion, it minimized its friction with the established media players, resolving problems with copyright and building an innovative platform that generates revenue from advertising. Beginning in 2007, major production companies like MGM, ABC, CBS and NBC started collaborating with YouTube by offering web streaming video services. Television reacted positively toward YouTube's potential as an alternative distribution outlet that captures the interest of younger generations. Cultural alliances between mainstream media and emerging digital media platforms create powerful consortiums for the establishment of significant agendas.

Furthermore, YouTube's capacity to influence mainstream media content has been examined in scholarly work. There is preliminary evidence that nonprofessional video content finds its way into broadcasting media. Apart from hypothesized intermedia influences between services such as YouTube and mass media such as television networks, we should also consider moderate alternatives. For example, Kim (2012) argues that for "documentary directors like Robert Greenwald, YouTube shortens the time gap between production and distribution, increasing impact and introducing new possibilities for strategic design" (p. 63). Although the influences of such platforms vary, from available content that remains largely unnoticed to material that reaches wide distribution, its flexibility, access and recognition are already established assets.

The National Opera of Greece, an organization that consistently appeals to small, cultural segments with specialized backgrounds and aesthetics, has led new promotion campaigns in order to introduce people to less familiar leisure experiences. The National Opera campaign was conceived in a two-fold manner. The first was to take opera singers outside the opera house and into public places where people gather on a daily basis, like public squares, metro stations and especially schools, performing for pupils and their teachers. These initiatives aimed at introducing a largely unknown experience to everyday people in the hope that some might be enticed to attend such an event in the opera house. However, the second aspect incorporated social media platforms, like YouTube. Indeed, different waves of public attendance became possible through short videos of public performances uploaded onto social media.

This generated additional attention, rendering a specialized experience accessible. In one of their public promotion endeavors, two opera singers boarded a flight and surprised travelers by unexpectedly standing in the aisle and singing a part from *La Traviata* for the passengers.[1]

Social media are by nature interactive, as users acquire information, participate in discussions, express opinions and disseminate original content. The ability of users to establish their own agendas is undisputed, as many studies in the fields of public relations, management and marketing have examined mediated word-of-mouth influences on organizations and other users. This influence is quite significant, forcing managers to monitor negative opinions expressed online about organizational initiatives and to provide initially automated responses, followed later by personalized messages, to minimize negative word-of-mouth communication. Mediated word-of-mouth agendas should not be taken lightly and must be scrutinized in terms of their capacity for salience.

While new agenda-setting explorations are underway, we must also consider the role of search engines as enhanced deliverers of salience. Google, for example, has emerged as a dominant agenda-setting and gatekeeping player that merits our attention. This global corporate giant plays two roles simultaneously. On the one hand, it directs the traffic of purchased information in order to lead searchers' attention toward certain corporations and their products, a role that closely resembles gatekeeping. At the same time, in an agenda-setting role, it ranks organizations in consecutive pages, displaying them according to their significance. Any organization that does not appear in the first page is perceived as less significant than others.

If, for example, I search for a museum in my current location, Google will direct me to information of dual significance. It will display museums in a ranking order without losing the focus on the geographic area from which I conduct my search. It will also direct my attention to museums that have paid for Google advertising. These functions of Google, especially in organizational and product advertising, can be scrutinized in the context of dominant theories such as agenda setting and gatekeeping. In terms of digital media influences, these content agendas are a glimpse of the future, where salience is redefined through digital gatekeeping interventions with geographically defined and segmented implications. Corporate digital advertising seems to be relying on Google services, such as paying for rendering certain keywords (images, brands and reputation building elements) salient in platform searching, while directing users' searching traffic to particular websites.

Websites play a major role in promotion agendas, with every cultural provider establishing an online presence. They present a vast variety of possible online communications. Some organizations use them as bulletin boards, posting their announcements, and providing factual information about the organization, its people and its offerings. However,

websites have evolved dramatically beyond this limited function of mere online pamphlets, and an organization using its site in this way underutilizes a very powerful medium. Cultural managers should consider three core principles of website design strategy. First, because of their significant capacity to set agendas and influence other types of media, websites are routinely used by powerful individuals, organizations and institutions to establish their symbolic presence, esteem and reputation. Second, the capacity for website agenda setting is related to various other factors: economic, sociopolitical and cultural. Websites complement cultural providers in their varying capacities for agenda setting. Therefore, website agendas display varying degrees of significance in different social settings. Third, websites are expected to reflect the identity of the organization. Often website presentations provide distorted images of the organization, its mission, its facilities and its cultural products or services. These distorted representations can either provide an exaggerated or a diminished picture of the organization. There are many examples of visitors seeking an experience from a website, only to be extremely disappointed upon arrival to find that the organization's environment and offerings do not look at all as they did online. The opposite can also be the case, with visitors pleasantly surprised upon arrival, discovering a wealth of available experiences that were actually downplayed in online presentations. Website portrayals matter.

Marty (2007) examines one of the core issues in this field: the relationship between online and in-person visitation. Reviewing different cases, he focuses on a wonderful initiative undertaken by the Minneapolis Institute of Art. As the crew restored one of its masterpiece paintings, the entire process was broadcast online and in real time. This online cultural experience was so popular that the entire process was repeated a few years later. Different groups of interested visitors interacted with the website. "Using a variety of interactive tools, online visitors can 'strip away' layers of paintings, examining earlier versions through infrared or X-ray lens, and determine the exact material composition of any pigment used on a painting" (p. 338).

Promotion through websites is expected to yield significant results in terms of visitation, sales, participation and various other types of public attention. One of the central questions that concerns cultural managers deals with the relationship between website and real visitation. Are online visitors encouraged to visit the premises of the organization? Or is there any chance that online visitation might discourage people from becoming active participators, leaving the comfort zone of their living room? There is no significant evidence that online visitors are discouraged to subsequently become museum visitors. One might assume that this evidence applies to other cultural entities, though additional research is needed to verify this relationship. For example, there might be some differences between museums and libraries. If a researcher can

discover useful content on the website of a library, is there any motivation to visit the library premises as well? Convenient searching for data on a library website might deter an individual from visiting the library building. Library officials perhaps need to consider this in examining their digital strategies. What other types of content—or experiences—does a library offer to attract potential visitors?

Marty (2007) poses the following rhetorical question: "If people can look at pictures of beaches online, will they still vacation in Florida?" The logical expectation, derived from this particular example, is that the former supports the latter. No virtual visit of a beach could ever replace an actual visit in the beach. However, organizations vary in terms of the experiences they offer. In most cases, one would expect that visiting the website of an organization cannot replace a visit to the organization itself. Nevertheless, Marty highlights the complex relationship between online and actual visitors. It is common knowledge that those who are consistent museum visitors tend to visit the museum's website prior to their visit, to gain background information and cultural content. However, the relationship tends to be even more complex than that. As web technologies continue to develop, there is increasing convergence between the virtual and the real, while the boundaries between the two become blurred. Although there is clearly a relationship between different types of visitors, online visitation deserves additional scrutiny in segments that value distance forms of visitation. In a follow-up study, Marty (2008) explored the idea of online visitation as a substitute for a real visit. This line of research provides significant insights for managers of different cultural organizations and institutions as they invest in promotion agendas. While more cultural resources become available on sophisticated websites, how does this trend influence traditional forms of visitation and participation? From a sample of 1,200 participants, approximately 40% indicated that an online visit might function as a substitute for an actual visit. However, the majority of respondents disagreed with this view, with most clearly viewing the two types of visits as different and not interchangeable experiences. These findings indicate that though some visitors—clearly not the majority—might substitute an online visit with an actual visit, most people would go to a website to acquire a preliminary understanding of specialized cultural content to prepare for and thus better facilitate and enrich their experience of the actual visit. In a case study about the British Museum, similar questions were explored while several attributes were scrutinized as promotion agendas. The researchers found that people use various digital platforms and websites to seek information on the Museum's opening hours and its temporary exhibitions. Information and communication technologies are also important, underlining that digital innovations and technological displays constitute significant promotion agendas. Other attributes that people pay attention to include the role of the Museum's

staff, the management of its facilities and outreach initiatives. Finally, voluntary contributions serve as an indication of importance (Jaffry & Apostolakis, 2011). Understandably, promotion agendas are not just about platforms and digital media, but also various types of content used by cultural providers to emphasize distinct attributes that raise awareness and attract visitors' attention. These preliminary findings support organizational investments in promotion agendas.

Websites, Google, social media, blogs, portals and many other platforms can be described as new promotion venues. Although cultural providers imitate one another, following the lead of the most established and reputable players in the field, additional evidence is required to shed light on how new types of digital promotion impact consumers as well as how different matrices of salience influence one another. Several research questions come to mind: To what extent do Google's services aid the transfer of salience for users interacting with digital content? To what extent is this particular manifestation of salience related to other conventional notions of salience? How does Google's role as a digital gatekeeper influence other, more conventional gatekeeping processes? How do different digital tools and platforms interact with one another? Also, what is the agenda-building capacity of small organizations? To what extent do segmented agendas influence public salience, both perceptional as well as behavioral? Any organization can establish a social media presence or build a website, but to what extent can horizontal media agendas influence public salience on a wider level?

Content Agendas

With the advent of digital media, production of content has been revolutionized. Traditional means of content production, selection and dissemination were seriously challenged as digital media proliferated and new digital platforms became available. In the early 1990s, mainstream media were still recognized as the premier agenda setters and recent evidence clearly demonstrates that the agenda-setting process still remains a significant media influence, disputing any hypotheses in regards to diminishing effects (McCombs, 2014).

However, there have been significant alterations in the production of salience. Consider, for example, the capacity of ordinary individuals or small groups to start a blog, create a small community on a social media platform, or establish a website promoting a particular interest. Furthermore, consider the vast capabilities for information dissemination through different platforms and with different devices: smart phones, tablets, laptops, and so on. Burgess (2006) eloquently describes the nature of participatory media, as bloggers' discourse proliferates online. From the democratization of culture to the advent of blog journalism with its various repercussions on mainstream media content, cultural

theorists intervene in this expanding global discussion, offering a wide variety of arguments for or against the participatory discourse trend. Burgess (2006) draws from a diverse cultural studies tradition to discuss everyday production of discourse, participation and creativity. She discusses the "Lomography" movement, the ability of everyday people without technical expertise to record on camera random daily occurrences. Advice given to lay photographers includes the following: "Take your camera everywhere you go; use it any time—day and night … don't think, be fast, you don't have to know beforehand what you capture on film … don't worry about the rules" (p. 205). Current movements for "vernacular creativity" are described as "an ideal" as well as "a heuristic device" (p. 206). They involve digital storytelling, defined in different, sometimes contradictory, terms. Given the space and the opportunity, what do everyday communicators talk about? Burgess (2006) points out that when we listen to the ordinary voices empowered by digital media, "we begin to realize that if 'ordinary' people have the opportunity to create content for public consumption for the first time, they choose to use this opportunity to talk about what the serious business of the human experience—life, loss, belonging, hope for the future, friendship and love—mean to them" (pp. 211–212).

The capacity for setting agendas is virtually infinite, though not everyone is equally successful in doing so to significant effect. However, many ordinary producers, small groups with special interests, or regional cultural entities, are quite successful through a reasonable strategy for content production and dissemination. Cultural organizations create new content agendas by strategically providing access, digital tools and assistance to their consumers, with the aim of facilitating new forms of cultural production created by everyday people, constructing different kinds of narratives with new meaning and significance.

Aleksei Bogdanov (2003), examining the famous Hermitage Museum in Russia, outlined a number of initiatives related to new content provisions. For example, organizing a special exhibition of the technologies incorporated into the Winter Palace throughout the twentieth century is indicative of new content initiatives that emphasize two popular areas of visitors' interest—technology and digitization. Bogdanov stresses the need for accessibility and dissemination while pointing out that since the Soviet Union collapsed, the Hermitage content has been sought by researchers and visitors worldwide. A collaboration with an emblematic American corporation, IBM, carries a valuable symbolism on its own. Bogdanov presents the benefits of the Museum's alliance with a corporate technology giant as the Hermitage upgrades its various offerings in terms of its sophisticated web presence, digitized content and exhibitions as well as its overall relationships with visitors. As early as 1996 and with an initial investment of $2 million, this strategic alliance created "a studio for producing imaging, a museum information system, a study

centre for information technologies, and a website" (p. 28). Bogdanov stresses the value of virtual tours and exhibitions, the Museum's informational objectives encompassing valuable texts and panoramic images. However, one of the most interesting strategies of the Hermitage involves their investment in e-commerce. According to Bogdanov, "preliminary studies indicated that the highest consumer demand from online museum stores was in the United States. Filling orders from Russia would be difficult as American consumers expect prompt service, and shipping and customs would have been complicated if managed from Russia. It was therefore decided to meet all international orders from the United States through a supplier in California" (p. 29). It seems that this old cultural institution that lived through the entire period of the Soviet era has evolved with a renewed sense of liberalism and an imperative need to set its new agendas in the twenty-first century.

In this context, small museums, galleries, film directors and producers, game designers, authors and content developers have the capacity to promote and disseminate their agenda, achieving varying degrees of salience. Marty (2011) explores the availability of digital collections through museums' websites. Many museums have invested in sophisticated web technologies that render their collections accessible by visitors through multimedia applications. Understanding visitors' motivations and expectations as they access collections remotely empowers cultural executives in their agenda-setting strategies. Furthermore, museums, libraries and archives allow for personalized interactions; visitors are allowed to "create" their own collections or artifacts, bibliographic or archival material. Although access to collections, bookmarking and tagging along with the creation of customized digital records for personal use takes different forms, there is evidence that there are significant limitations to specialized visitors, researchers and teachers, while young visitors display a superficial relationship with the available content (Marty, 2011). As organizations provide this specialized capacity, they set an agenda that merits additional scrutiny both in terms of the groups that seem to interact with the organization as well as the usability of such services. The fact that the mere capacity for personalized access to collections is easily established does not always imply efficiency and a mutually beneficial strategy. The long-term benefits for the organization also need careful evaluation.

Srinivasan, et al. (2009) discuss the nature of digital museums and the diversity of the content they manage as different cultural institutions present different voices in the context of a new museology perspective. The authors discuss some of the core assumptions that influence the generation of content, like the relativity of knowledge and truth and the social aspects of learning. They stress the notion that museums and libraries converge digitally as they make it a priority to provide access to their publics through system convergence. This "technical interoperability of

retrieval systems" enhances users' capacity to find and manage different types of content from various sources (p. 269). Investments in convergent digital content management systems allow different organizations to share their content with one another while exchanging information of critical value and expertise. New content agendas pursued by libraries, archives and museums should be approached critically. Srinivasan, et al. (2009) present some disadvantages, such as the silencing of those who lack the skills, specialized knowledge and capacity to contribute to cultural discourses. Specialized discussions evolve through the participation of experts. Furthermore, different forms of cultural biases may be propagated as the voices of the few prevail over those who choose to remain silent or do not know how to contribute effectively. The researchers conclude that mere digitization and access may not be adequate to empower participants as they strive to make sense of specialized content. These content agendas should be pursued under the premise that organizations should relinquish control of content to communities of participants and interested stakeholders while providing a truer sense of empowerment.

Chen, et al. (2005) explore the capacity for digital imagery for the preservation of significant cultural artifacts. They argue that in many parts of the world, valuable cultural depositories cannot be accessed by visitors and scientists alike. In some cases, they become vulnerable or damaged. Furthermore, we increasingly witness news reports of extremist groups targeting and destroying some of the most extraordinary cultural treasures for reasons that remain incomprehensible to the population at large. Certain artifacts are particularly vulnerable, such as paintings and sculpture. Furthermore, "fragile handwritten records in a plethora of styles and scripts on clay and stone and wood and canvas and cave walls, on parchment and paper and papyrus" are subject to decay and destruction (p. 275). The authors present significant evidence in favor of digitization of cultural artifacts. Constructing a digital imagery of significant works of art, texts and ancient records can be recognized as a new content agenda. Digital imagery of cultural treasures can contribute toward the preservation, access, study and new modes of interaction with content that under ordinary circumstances would be out of reach.

Charitonos, et al. (2012) explore the relationship between students' interactions on Twitter and their experiences with museum exhibitions. The authors support the idea that the use of certain social media enhances the overall museum experience by allowing children to archive their dispositions as well as extend their cultural experience. They suggest that participation in microblogging and social media activities "improved students' impressions, participation and enthusiasm during the trip itself" (p. 817). This interaction enhances students' negotiation with museum content as online discourses empower them with considerable flexibility in their navigation endeavors. The researchers point out that

visitors' interactions in physical space is quite complex by itself. However, online interactions contribute additional complexities that visitors consider as they navigate through them. Although this work merits our attention because of its educational value, I would argue that "rational edutainment" providers offering additional outlets for interactions and discourse exploration use social media both as a technological and a new content agenda. Often, these two agendas are rendered inseparable as content and platforms converge, providing digital interactions that in turn the organization can use to advance its esteem.

In the field of culture, every organization, large or small, engages in audiovisual productions, which enhance its agenda-setting capacity. Researchers point out that an individual artist working with a decent camera and a personal computer can produce professional videos that subsequently can be distributed online. Although expensive, sophisticated productions can only be financed by large cultural entities, even small organizations and producers can include in their strategy professional productions that advance an agenda of image building. Museums include audiovisual content in their services within their premises as well as outside of them. Different types of cultural organizations strategically provide different kinds of information subsidies to different media outlets as they attempt to influence media agendas. These provisions of content present various cultural products and experiences, such as new books, music, audiovisual content, exhibitions, games, and educational programs, with the primary intent of raising awareness and rendering the organization salient.

In a recent study of the new Acropolis Museum in Athens, it was discovered that despite its vast and significant collection derived from the distant past, the newly established museum invested in a new content agenda to become visible and subsequently salient (Zakakis, et al., 2015). This emerging landmark organization replaced the old Acropolis Museum, a historic organization lacking the capacity for image building. As the new museum opened its doors in 2009, the financial crisis in Greece deepened and the economic outlook of the country looked dim. However, despite the adverse economic and social environment, the new Acropolis Museum became an aggressive salience builder even before its public opening. Zakakis, et al. (2015) followed in the footsteps of a study of emerging corporate firms in regards to building media visibility (Rindova, et al., 2007). "One of the main research questions posed was: what did the firms do and what did the media say about them?" (p. 345). The literature indicates that emerging corporate entities routinely invest in new content agendas in order to attract media attention. The Acropolis study showed that the museum clearly imitated corporate actions, promoting seven categories of content that subsequently became visible in media content: (1) development of cultural/educational services, (2) advertising and marketing, (3) visitor/customer relations, (4) partnerships,

(5) symbolic actions, (6) special events and (7) supporting services. This new content agenda was promoted in the form of museum actions, disseminated not only through press releases but also on different social media platforms. Content availability became a key element that led to increased visibility. From the different categories of content promoted by the museum, development of cultural/educational services emerged as the most significant attribute, followed by advertising/marketing and supporting services. The authors concluded that these particular symbolic actions are related to esteem building. Research shows that museums are not by nature weak agenda setters. They have the capacity to generate tremendous attention. However, managing valuable treasures or remarkable cultural assets may not be enough to achieve salience (Zakakis, et al., 2012). Modern museums routinely invest in new content agendas as they take advantage of different digital media. In this context, any form of innovation in relation to education, marketing initiatives and various services provided to visitors can enhance the media visibility of an emerging or established cultural organization. Research originating from the corporate domain indicates that there are categories of symbolism with a special capacity for salience building. Although in the field of culture, the available literature does not provide in-depth testimonies, researchers should test such notions by borrowing established management tools developed in the corporate domain. For example, the Reputation Institute, a global research center providing services to corporate clients for corporate reputation assessment and performance, devised a measurement instrument known as Reptrack.[2]

This seven-dimensional attribute measurement includes reputation tracking indices such as: leadership, performance, products and services, innovation, workplace, governance, and citizenship. In the cultural domain, the nature and value of experiences seems to be one of the key elements that merit assessment. Furthermore, different types of education related attributes emerge as significant determinants of salience that cultural consumers evaluate. As we learn from the experienced evaluators of corporate symbol creators, generating assessment of experience-related attributes along with organizational characteristics can provide useful agenda-setting insights in regards to new content agendas. Although performance and products/services attributes may need some additional consideration to become suitable for cultural evaluations, leadership, innovation, and cultural infrastructures along with experiences and educational provisions certainly merit significant future attention, as noted cultural symbolism with a great capacity for agenda building.

However, new content agendas also take other forms. Johns (2006) addresses the theme of new content agendas in the digital games market. For example, the idea of "weightless economies," coined by various economists, also applies in the cultural domain, especially with organizations heavily investing in digital multimedia, games and software

production. "They point to the possibilities of the cost-free reproduction and distribution of e-goods such as software" (p. 152). These remarkable developments of the last twenty years have changed the ways in which ordinary individuals as well as major cultural industries establish their agendas both on a mass scale, but most notably for particular segments sharing a specific common interest. Digital media and various digital platforms empower them as they bypass the mainstream media gates in an effort to achieve salience. Elaborating on the growth potential of digital games, Johns (2006) observes that "the emergence of new technologies enabling the informational content of games to be compressed into formats suitable for distribution over the Internet is opening a potentially huge market for online distribution" (p. 175).

Cameron (2003) draws from different schools of thought as she treats content and technology as a unified form. Indeed content, form and technology can be viewed as convergent agendas that produce diversified streams of meaning. The author capitalizes on the postmodern premise that no fixed sense of the truth exists. Various platforms, tools and digital media have evolved, producing nonlinear narratives that can be read in various ways. Customized searching patterns enhance self-perceptions and unpredictable versions of interpretations. Online collections offered through a variety of digital applications by an increasing number of museums should be scrutinized in terms of customized, individualized patterns of searching and consumption. Some users point to Amazon.com, which serves the customized needs of customers by offering products that reflect their previous choices. Curators, teachers and archive managers try to assess individualized preferences manifested through searching and browsing behaviors. In the context of content agendas, assessing interpretative schemata, reading and decoding choices, through postmodern lenses, is always a sensible task for managers and cultural executives. Such theoretical exercises pertain primarily to cultural theorists. However, content agendas can be indicative of customized choices as indicators of potential similar future selections. Cameron (2003) is certainly right in arguing that digital provisions have redefined the relationships between museums and users. However, recognizing certain types of content in relation to searching and consumption patterns empowers cultural providers in terms of outlining well designed content agendas.

Technology Agendas

The term "innovation" describes a multitude of traits. In many cases, it includes technological applications and digital communication media. Regardless of the value and the advantages offered by different innovative technologies, cultural providers recognize that framing their organization as "innovative" or "technologically advanced" adds to the overall image of cultural entities. There is a symbolic value in technology; innovative

organizations convey significance. Although I examine the utility of different technologies, our primary focus is on technological frames and attributes promoted by cultural managers. Many cultural organizations recognize in digital technologies significant promotional advantages. It is a matter of organizational strategy to invest in new technology agendas. Recognizing the value of technological agendas, cultural executives are sometimes caught in waves of technological trends, even though they may not always have sufficient expertise to reach appropriate decisions or execute well-thought out technology strategies. Furthermore, digital tools are sometimes incorporated without a clear sense of the intended experience, interaction and narratives. Technology, like anything else in life, constitutes a cultural construction. The manner in which technology is immersed in the construction of experiences can produce very different interactions in intended as well as unintended ways. If not utilized effectively, its promotional dimension might not be successful either. Therefore, when considering the prospect of adopting new technologies, cultural executives should "begin with an acknowledgement of the extent to which media technology is historically specific, culturally constructed and, therefore, continually contested" (Parry, 2005, p. 343). Certain theorists describe a "technology trap," the notion that museums and other cultural entities can adopt and promote different technologies for their own sake. Therefore, adopting a critical stance toward such innovations functions as a filter for "self-serving applications of technology" (p. 334).

Starting out with this appropriate disclaimer, technological agendas are of paramount importance in today's leisure and cultural market. Sometimes a technology agenda signifies a total facelift and redefinition of an organization that seeks new momentum in its marketing effort. In other situations, cultural providers add technological applications to expand their narrative building capacities. They strive to tell their stories in different ways. Furthermore, we should not underestimate the "wow" effect. Sometimes organizations just try to attract, impress and expand their customer base. Researchers should consider various motivations that lead to investments in technology. Technology agendas are evaluated by different stakeholders and critics, while most consumers retain a positive disposition toward different digital exhibitions. In most cases, their approval becomes manifested in visitation data, box office records and consumption in general.

Bakhshi and Throsby (2012) offer a holistic typology for incorporating technologies in nonprofit organizations, following an objective-based approach. This typology includes artistic, access, educational, knowledge and social objectives. Artistic pursuits entail curatorial and quality concerns. Access refers to the various groups and segments that the organization serves by rendering its experiences widely available. Educational missions include the various programs and services provided by museums, libraries and galleries that supplement formal education curricula.

Knowledge can be a synonym for research and informational provisions. Social objectives pertain to inclusion, strengthening communities and encouraging participation by as many people as possible. The authors recognize in these five goal-oriented dimensions the primary endeavors that cultural providers recognize in relation to their overall mission. Their cultural objectives can be enhanced by investments in technology, innovative use of digital media and a strategic implementation of new ideas. Furthermore, Bakhshi and Throsby (2012) present four types of innovations that serve organizational missions and objectives. These are innovations that enhance audience reach, contribute toward the development of art forms, generate value, and support management and governance. They present several case studies providing evidence for every form of innovation and how they empower different organizations in their efforts to expand their mission envelope. Rendering the organization as innovative can change the entire outlook of short-term functions as well as long-term objectives. Furthermore, examining which technological and innovative traits are more likely to generate attention constitutes a significant research question for scholars and executives alike.

Reading (2003) explores the incorporation of digital interactive technologies in Holocaust museums. Holocaust museums set distinct missions connected to memory narratives aiming at keeping people constantly aware of the horrors that humans can inflict on others. They manage content that involves pain and suffering. There is an international trend in Holocaust museums increasingly adopting interactive media to present individual narratives from World War II. The relationship of interactive media to memory preservation remains at the core of this discussion. Museums as memory institutions have historically relied on technologies that enhanced their memory-preserving capacities. Therefore digital interactive tools enhance the primary mission of these organizations, especially when Holocaust survivors are given the roles of educators, narrators and storytellers. The ways these technological agendas are incorporated into museum exhibitions causes significant divisions among critics. Those in favor of technological inclusion discover significant advantages in digital technologies, as visitors become immersed in memory related experiences. Others contend that immersion, especially in a Holocaust museum, is not always the desired experience. Reading (2003) adopts a critical stance toward digital interactive media observed in the premises of the Simon Wiesenthal Museum of Tolerance in Los Angeles. The Multimedia Learning Center provides different choices to visitors who wish to explore different aspects of the Holocaust, while their multimedia design follows a constructivist perspective. Initial observations indicate varying degrees of participation. Because of the painful nature of the subject matter, some visitors are reluctant to interact with this particular content. Interactivity in memory-related content may be a useful tool for preserving certain memories and educating

audiences, but most importantly, warning visitors as to potential future atrocities that people are called to avoid. The ways technology is incorporated into museum exhibitions deserves special attention by curators, executives and media experts when some forms of interactive content may be unacceptable or even offensive. Reading (2003) "suggests that the process is not simply related to the content, or to the technology, but to the social uses of technology and the social construction and inheritance of historical events" (p. 81).

Investing in technology is not necessarily expensive, but some technologies are quite prohibitive for certain organizations. There are many opportunities for setting technological agendas without investing extravagant amounts of money. Small organizations without significant financial resources benefit from low-cost digital innovations. Medić and Pavlović (2014) present the advantages of QR codes and mobile applications in museums as inexpensive and versatile technologies that enable text presentations, interactive games, website promotion, audiovisual presentations and augmented reality. Furthermore, visits can be customized in terms of "choosing a path," "location awareness," personalized preferences, pursuing individual research interests and "affinity mapping" (p. 170). Customization and interactivity are touted as significant technological advances that allow visitors to navigate in museum exhibitions according to personal preferences, aesthetics and pace.

Technological agendas in the "rational" domain have gained researchers' attention relatively recently. Among many "rational edutainment" providers, museums, galleries, and libraries have reframed their overall missions in remarkable ways, trying to appeal to larger segments and younger visitors. In this, innovative digital technologies became a top priority. Similar cultural shifts have been observed in popular entertainment domains, which, from the early days of mass media, invested in various significant technologies that changed the world. The cultural domain is extremely diverse and unequally distributed, while popular media are usually affiliated with global conglomerates and huge resources. Even prior to the digital era, television, cinema, popular music and radio started joining forces to establish major global alliances, to minimize costs, risks and competition while increasing their strategic position in their respective markets. Cinema in the 1950s invested in new technology agendas to counteract competition from the emerging television industry. As a result, 3D and Cinerama technologies emerged during that period without, however, achieving what cinema executives thought they would. This trend intensified after the advent of the digital era, as technology contributed a great deal in that direction. "Convergence" became a trendy term. Indeed, convergence in digital platforms, content and ownership contributed to a consolidation of popular media in different countries and markets. Technological agendas still play a dominant role in popular media and cultural industries. Hollywood

invests millions of dollars in innovative techniques that revolutionize the cinematic experience but subsequently utilizes these inventions as marketing tools. So moviegoers not only watch the film but also receive a lot of information about the making of the movie as a separate narrative carrying its own value and promotion capacity. Table 4.1 presents some of the most significant movies ever produced because of the incredible innovations that their creators had to invest in to tell these visually demanding stories. From *Avatar*, to *Matrix* and the *Lord of the Rings* trilogy, these cinematic experiences became known not just because of their stories, but because of their groundbreaking technological innovations. These impressive technological agendas rendered the cinematic experiences memorable and prominent.

Museums, galleries, and libraries have followed the example of their popular counterparts but on a smaller scale. Hornecker & Stifter (2006) describe a case of a new technology agenda undertaken by the Austrian Technical Museum in Vienna as a part of an exhibition on the history of the media. The exhibition included "traditional object exhibits, computer-enhanced hands-on exhibits, and a large space dedicated to modern media. As part of the exhibition visitors can buy a smartcard that stores collected or self-created data into a 'digital backpack' that visitors can later-on access online" (p. 135). This initiative promoted by the museum offers a good example of cultural agenda setting entailing new technology or digital innovation agendas. The mere availability of digital innovations is expected to upgrade the exhibition itself.

Carrozzino and Bergamasco (2010) present a popular technology agenda which has gained the attention of many organizations—virtual reality. Indeed, cultural executives evaluate the prospects of investing in innovative platforms both as a means of digital interaction as well as a

Table 4.1 Significant technological innovations in movie making

Film	Innovation
Avatar (2009)	Fusion camera system
Star Trek V: The Final Frontier (1989)	Previsualization
Upside Down (2012)	"Master" and "slave" camera technology
Ender's Game (2013)	Rigs for zero gravity stunts
Back to the Future Part II (1989)	VistaGlide motion-control camera
The Lord of the Rings trilogy (2001–2003)	MASSIVE software
Jurassic Park (1993)	Dinosaur input device
The Matrix Reloaded (2003)	Universal capture
Edge of Tomorrow (2014)	New autodesk Maya plug-in
Gravity (2013)	Light box

Source: http://www.hitfix.com/news/10-tech-breakthroughs-in-film.

promotion tactic. They catalogue virtual reality applications in terms of the degree of users' immersion in the created environment as well as a typology of four dimensions: visual, acoustic, haptic, and motion. Virtual reality has numerous applications in different fields, including the military. For many years, simulators have been used as a standard training program for fighter pilots. However, variations of virtual reality applications have been adopted by cultural providers. For example, the designers of the Museum of Pure Form allow museum visitors to interact with sculptures. Several European museums participated in the project, which is indicative of the interest that surrounds virtual reality. The haptic experience was described by visitors as "amusing" (p. 455). Additional spin-off projects were developed from this initial virtual reality design, demonstrating the potential for interactive virtual reality applications in different types of art museums and opera houses. The authors discuss the basic lessons acquired from these initial efforts and the best practices that need to be assessed for efficient and enjoyable interaction, such as cost factors, the space required in museum premises, as well as the degree of cooperation between curators and technology experts.

Yoon, et al. (2012) evaluate augmented reality applications in science museums. The term "augmented reality" has been defined in different ways using a variety of tools and techniques. The authors refer to "the users' physical experience with the augmented device as 'augmented reality.'" (p. 521). There are other forms of "digital augmentation," when computer-generated images are "superimposed upon the physical environment" (p. 521). In this study, they explore informal learning processes in science museums as information- and knowledge-seekers scout the available exhibits while extracting useful educational content. Indeed, augmented reality can be used as an effective tool for informal learning. These types of technological applications designed for informal learning objectives appeal to various groups, such as parents who make it a priority to offer these opportunities to their children, as well as to segments of visitors who display a learning lifestyle.

Various exhibitions at the Smithsonian Institution teamed up with popular culture providers using widely recognized stories, such as the *Harry Potter* and *Star Wars* series, in order to maximize their appeal and attract mass audiences. Incorporating new technologies can be beneficial to small, less prominent organizations, if they manage to stand next to the big players with the intent of gaining additional visibility. In these settings, managers and curators cannot always accomplish their mission without the necessary expertise and competence in digital media. Forming alliances with technology-oriented providers can be beneficial for all parties involved. In the "rational" domain, digital technologies enhance the educational process. The small library in Veria, a medium-sized provincial town in Greece, secured funding from the Bill and Melinda Gates Foundation, and became a case study for what a successful alliance can achieve even for a small cultural organization. The Veria library is now a

happening place with a strong emphasis on technology, education and socialization. According to a press release from the Gates Foundation, "the library conducts computer courses that teach real-world skills such as how to use software, create a resume, share videos online, and participate in social networking. It teaches seniors how to perform online searches and use social networking sites, helps immigrants adjust to their new homes, and gives teenagers a safe after-school location to complete homework and meet with friends."[3] The library has significantly expanded its appeal to visitors and friends by providing multimedia laboratories along with spaces for creativity, reflection and, of course, reading. Technology and innovation played a critical role in its promotion strategy.

While researchers survey the most significant cultural providers of the world, both from the "rational edutainment" as well as the popular entertainment domains, their visitation may be seen as related to technological exhibits, applications or inventions. As the study of cultural attributes evolves, agenda-setting researchers should pay attention to various aspects of technological and innovative agendas. Promotion agendas gain ground as most providers utilize the numerous tools of the internet: websites, search engines and social media. Indeed, there are many opportunities for agenda setting, especially for small organizations and unknown creators. Taking advantage of new digital platforms and available multimedia applications upgrades these entities in terms of their promotion capacity. Content agendas involve streams of symbolic provisions that generate attention. In this chapter, we visited many noted examples of content agendas. From discourses created by ordinary individuals, such as posting photographs and non-professional videos, to organizational initiatives, like the restoration of a painting, broadcast online and in real time, different types of messages present interesting opportunities for salience. All content is not created equal in regards to its agenda-setting capacity. Certain messages are more promising than others. Therefore, message disseminators are called to evaluate the potential of every message as a source for salience. Finally, technology agendas have been examined as a significant category of attributes. Technologies and innovations stand out in terms of their cultural prominence. They represent a privileged domain of symbolic structures that elevate organizations in hierarchies of significance. Thereby, critical attention to various forms of innovations is justified and valid.

Notes

1 Posted by Aegean Airlines, May 29, 2014, www.youtube.com/watch?v=Jdq8zPXy7gI.
2 Reputation Institute website visited June 23, 2016 at www.reputationinstitute.com/reputation-measurement-services/reptrak-framework.
3 Bill and Melinda Gates Foundation, Press Release. Website visited June 23, 2016 at www.gatesfoundation.org/Media-Center/Press-Releases/2010/08/Veria-Central-Public-Library-Wins-Access-to-Learning-Award-2010.

5 Agenda-Setting Influences and Effects in the Cultural Domain

Agenda-setting researchers have explored various types of "objects," such as news items, political candidates and leaders, corporations and institutions. In the domain of culture, there are new "objects" that deserve our attention. The agenda-setting literature expands significantly beyond the civic and the corporate domains, while researchers scrutinize the capacity for salience of at least three distinct types of "objects:" cultural organizations, authors and cultural experiences. In the context of cultural organizations, there are various available choices, including museums, galleries, cinema studios, media production companies, book publishers, television, thematic and recreational parks, and so on. Furthermore, a wide array of cultural products/experiences merits scholarly attention, such as exhibitions, books, movies, games, television programs, and so on. Finally, the author category refers to individual creators, such as writers, directors and artists.

Cultural objects are comprised of multidimensional arrays of symbols with different capacities for salience, which are subject to different content hierarchies in the context of specific audience communities and public segments. So, an author may be well known and perceived as significant in the context of a particular community or public segment, recognized by distinct characteristics and attributes. In the sphere of popular entertainment, organizations, creators and products may be recognizable and perceived as significant by many different segments with diverging characteristics. Thereby the dynamics of salience operate differently in different contexts. Cultural agenda setting encompasses media agendas of cultural products/experiences, creators/authors and organizations/institutions influencing public agendas across different public segments as well as within specific groups at various levels: object, attributes and networks of traits. As different types of media establish agendas in relation to significant products, organizations and creators, they transfer salience while influencing how different publics recognize, perceive and make decisions in relation to individuals' leisure time.

Cultural agenda-setting explorations constitute an outward expansion of agenda-setting theory, as scholars recognize a primarily centrifugal trend of theory development (McCombs, 2014). Agenda-setting

researchers have largely ignored the cultural domain over the past 45 years. It seems that critical and cultural theorists became the primary stewards of this field, while empirical researchers displayed only minimal interest. Discovering this new terrain for empirical explorations of agenda-setting questions creates a whole new realm of opportunities, as cultural industries and their products represent a significant portion of the global economy and maintain a popular interest expressed on a global scale. People spend more than a third of their entire lifetime on different types of cultural and leisure activities. One might argue that in terms of significance, culture represents a prominent aspect of the human existence. Furthermore, cultural explorations might present researchers with the prospect of expanding agenda-setting applications into this different domain, while several lessons acquired from culture might be beneficial for the "traditional" domains, including the sphere of political communication. In the process, new mechanisms might become apparent, explaining internal processes and theoretical dynamics, or what researchers refer to as a centripetal development of the theory (McCombs, 2014).

Cultural Hierarchies and Prominence

Salience in the cultural domain, expressed in the form of different types of hierarchies, is notable in media content and public symbolic structures. Consider how many "objects" the media rank according to their perceived significance: political figures, institutions, governments, countries, economies, and so on. In the organizational realm, corporations, corporate figures, products and services are ranked according to their prominence. In the context of education, consider the various available college and university rankings. Culture is no exception as far as this trend is concerned. Museums, galleries, artists, and cultural experiences of different types are ranked according to their perceived significance. Media salience in the cultural domain is expressed at various levels and with different indicators. For example, major mainstream media rank the most significant museums of the planet. CNN had a special coverage of the twenty most visited museums of the world.[1] Based on the quantitative indicator of the number of visitors, CNN ranked the Louvre as first, followed by the National Museum of National History and the National Air and Space Museum, both a part of the Smithsonian Institution. It is not surprising that the organizations listed are located in some of the most significant cities of the world, such as Washington D.C., New York City, London, Paris, Rome and Beijing. As we have already discussed, symbolic alliances merit our attention in terms of salience. Historic metropolitan areas are not just cosmopolitan tourist destinations but also symbolic structures that carry significance of their own. Often cultural organizations are ranked along with other symbolic

assets that carry distinct meaning and add additional salience to the cultural "objects" under scrutiny.

Specialized media convey different versions of hierarchies of cultural prominence. The Lonely Planet blog uses surveys of its Facebook and Twitter communities in regards to people's most popular museum destinations.[2] In this case, salience is assessed as a form of perception. The different versions of salience based on different sources and different evaluation techniques are indicative of its constructed nature. Although this has been self-evident from the beginning, the availability of different types of data and the different methods of mediated processing create an array of catalogues of prominence available for all tastes and segmented preferences.

Table 5.1 The world's most visited museums, 2013

1. The Louvre, Paris, France
2. The National Museum of Natural History, The Smithsonian Institute
3. The National Air and Space Museum, The Smithsonian Institute
4. The Metropolitan Museum of Art, New York
5. The British Museum, London
6. Tate Modern, London
7. The National Gallery, London
8. Vatican Museums, Vatican City
9. American Museum of Natural History, New York
10. The Natural History Museum, London
11. The National Museum of American History, The Smithsonian Institution
12. The National Palace Museum, Taipei
13. The National Gallery of Art, Washington, DC
14. The National Museum of China, Beijing
15. The Centre Pompidou, Paris
16. The Musée d'Orsay, Paris
17. The Victoria & Albert Museum, London
18. The National Museum of Korea, Seoul
19. The Geological Museum of China, Beijing
20. The Science Museum, London

Source: CNN, 2013.

Table 5.2 The world's most significant museums

1. The Louvre, Paris
2. The British Museum, London
3. The Musée d'Orsay, Paris
4. The Museum of Modern Art (MOMA), New York City
5. The Metropolitan Museum of Modern Art, New York City
6. Galleria degli Uffizi, Florence
7. Museo del Prado, Madrid
8. Vatican Museums, Rome
9. Smithsonian Museums, Washington DC
10. Tate Modern, London

Source: Lonely Planet, 2010.

To stress this point even further, consider yet another publication, *Business Insider,* which consults with international travelers for their assessment of the best 25 museums of the world.[3] Data were gathered by the service TripAdvisor, targeting travelers with a primary emphasis on the value of special collections and artifacts that visitors should consider prior to their visit. Table 5.3 presents yet another ranking based on travelers' assessments of special value exhibits. The *Business Insider* assessment can be described as more diversified as well as segmented. The number of cities represented is certainly more representative of the major destinations of the world. At the same time, it is segmented, as its evaluation is based only on people who are international travelers, and thus expresses the view of a group with very distinct habits, socioeconomic status and leisure interests.

What all three assessments have in common, apart from a small number of museums that are included in all of them, is the central notion that the organizations presented in such mediated evaluations indicate their symbolic significance, an element that all museums strive for in today's media saturated world. Although museums represent a particular type of cultural entity, virtually all cultural industries, products and creators

Table 5.3 The 25 best museums in the world, according to travelers

1. The Art Institute of Chicago, Chicago, USA
2. The National Museum of Anthropology, Mexico City, Mexico
3. State Hermitage Museum and Winter Palace, Saint Petersburg, Russia
4. The Getty Center, Los Angeles, USA
5. Accademia Gallery, Florence, Italy
6. The Musée d'Orsay, Paris, France
7. The Metropolitan Museum of Art, New York City, USA
8. The Acropolis Museum, Athens, Greece
9. The Prado Museum, Madrid, Spain
10. Yad Vashem's Hall of Names, Jerusalem, Israel
11. The National WWII Museum, New Orleans, USA
12. The National Gallery, London, UK
13. The Vasa Museum, Stockholm, Sweden
14. The National Gallery of Art, Washington DC, USA
15. The British Museum, London, UK
16. The Hagia Sophia Museum, Istanbul, Turkey
17. The Instituto Ricardo Brennand, Recife, Brazil.
18. The Borghese Gallery, Rome, Italy
19. The Musée du Louvre, Paris, France
20. The Rijksmuseum, Amsterdam, The Netherlands
21. The Smithsonian National Air and Space Museum, Washington, DC, USA
22. The Museum of Qin Terra-Cotta Warriors and Horses, Lintong, China
23. The Inhotim, Brumadinho, Brazil
24. The Museum of New Zealand, Wellington, New Zealand
25. The Gold Museum in Bogotá, Colombia

Source: Business Insider, 2014.

are ranked according to their mediated significance. Consider, for example, a list ranking the 50 most significant movies ever made, including *Casablanca, The Triumph of the Will, Gone with the Wind, Star Wars,* and *There Will Be Blood*—ranked as number one.[4] Or consider the most significant authors of all time,[5] which includes Dante, Shakespeare, Hugo and Tolstoy, among many contemporaries. The *Guardian* presented a similar list of the twenty most influential books,[6] or the most significant painters of all time.[7] Such hierarchies exist for virtually all "objects" under scrutiny in the cultural domain: organizations, creators and products.

Agenda-setting researchers in this domain are presented with great opportunities for future explorations, while answering significant questions that interest media theorists and cultural practitioners alike. How is salience achieved in the cultural domain? Are the mechanisms that lead to salience in the field of culture similar to other domains, such as the civic and the corporate domains? Are there culture specific mechanisms that public relations and marketing professionals apply in this particular field? Which attributes or combinations of attributes do they promote to achieve salience? The limited available research provides some preliminary evidence but there are significant prospects for useful answers. Finally, are there any observable overlaps between this and other domains? Answering the last question might provide evidence for agenda-setting phenomena that apply across different domains, drawing lessons for different types of entities: political, corporate and cultural.

Table 5.4 The most influential books of all time

- *A Brief History of Time* by Stephen Hawking
- *A Vindication of the Rights of Woman* by Mary Wollstonecraft
- *Critique of Pure Reason* by Immanuel Kant
- *Nineteen Eighty-Four* by George Orwell
- *On the Origin of Species* by Charles Darwin
- *Orientalism* by Edward Said
- *Silent Spring* by Rachel Carson
- *The Communist Manifesto* by Karl Marx and Friedrich Engels
- *The Complete Works of William Shakespeare*
- *The Female Eunuch* by Germaine Greer
- *The Making of the English Working Class* by EP Thompson
- *The Meaning of Relativity* by Albert Einstein
- *The Naked Ape* by Desmond Morris
- *The Prince* by Niccolò Machiavelli
- *The Republic* by Plato
- *The Rights of Man* by Thomas Paine
- *The Second Sex* by Simone de Beauvoir
- *The Uses of Literacy* by Richard Hoggart
- *The Wealth of Nations* by Adam Smith
- *Ways of Seeing* by John Berger

Source: *Guardian*, 2015.

Salience: An Evolving Construct

Salience has emerged as a key construct of agenda-setting theory and is actively sought by all cultural organizations. The central idea, that the media attribute significance to any "object" or "issue," has guided scholarly explorations for almost half a century. This key notion has been recognized for its multi-dimensional character, which explains the mechanics of subsequent public perceptions of symbolic significance. In the past, salience has been explained in terms of several of its aspects. For example, Kiousis (2004) defines salience as issue or object attention, prominence and valence. Valence is linked to affective attributes and has progressively become synonymous with tone. In many studies, people have been asked to record their positive, negative or neutral disposition toward different "objects." These core characteristics of salience have influenced most previous agenda-setting explorations, especially in the civic domain. However, additional considerations should be taken into account because of the peculiarities of the cultural domain as well as the dramatic developments in the realm of digital media and digital platforms that have revolutionized the ways in which we communicate with one another.

Through our limited research endeavors, we know that media salience takes different forms, since the advent of digital media. The following indicators of salience seem to apply especially to the cultural domain. In terms of media salience, a distinction between vertical media salience and horizontal media salience is warranted. The rapid proliferation of different types of media outlets, some still targeting mass audiences and therefore retaining a mainstream mass distribution of content, while other, newer forms of media have evolved along with the digital world, targeting primarily, but not exclusively, segmented audiences with specialized interests and needs. (McCombs, Shaw, & Weaver, 2014).

Furthermore, public salience has evolved as a concept. Digital media, including various forms of digital platforms, have empowered media users with enhanced capacities for interaction, including visitation, searching and gaming activities. Modern consumers of digital content are thus often described as users rather than receivers. The public salience construct takes different forms primarily because of evolving media consumers. Along with conventional conceptualizations of public salience, additional descriptions emerge as researchers recognize that people attribute significance to different objects through alternative perceptional engagements as well as different types of behaviors, involving decision making, searching, visiting, playing and interacting with people and the media. In this context, I propose four indices of public salience: conventional public salience, word-of-mouth salience, mediated trends salience and behavioral public salience.

Media Salience

In terms of media salience, I draw from McCombs, et al. (2014) a useful differentiation of media outlets that takes two forms: vertical and horizontal.

Vertical Media Salience

Vertical media salience represents a conventional conceptualization of salience described extensively in the literature, basically along three distinct dimensions: attention, prominence and valence (Kiousis, 2004). I differentiate between vertical media and other forms of media salience as this category pertains primarily, but not exclusively, to mass media and their capacity to set mass agendas. In the field of culture, vertical media describe various types of mainstream media that appeal to mass audiences with diverse global representations as well as across segments with wider interests in the context of national markets.

Attention, prominence and valence constitute three standard operational layers of media salience that researchers have routinely used throughout the theory's history. Attention represents one of the most common operational measurements. The underlying assumption that guided its evolution is linked to repetition, attention and volume of coverage. Therefore, the volume of coverage—an object or issue repeatedly appearing in media content—becomes indicative of significance. Many studies have consistently utilized this operational definition of salience to capture different meanings of significance (McCombs, 2014). Prominence describes the positioning of an issue or object: Does it appear in the front page of a newspaper or in prime-time broadcasts? The positioning of the object is indicative of significance. Valence and tone have been used interchangeably by researchers as they both describe the positive, negative or neutral coverage of a particular object. Although there is a limited number of agenda-setting studies in the field of culture, evidence has started to accumulate that points toward numerous applications both for practitioners and scientists alike.

Horizontal Media Salience

The proliferation of digital media compels researchers to assess the dynamics of mass agendas versus segmented agendas. Digital developments have allowed for the emergence of various media outlets and digital platforms that generate specific contents, sometimes with a segmented value and interest. The term "horizontal" might describe social media outlets or digital platforms generating specialized content addressing the needs of niche audiences. Furthermore, it might imply content characteristics and therefore a specialized appeal.

In the field of culture, there are numerous outlets with specialized content that address the needs of specific segments of society. There are numerous museum outlets that aim at segments with a primary interest in the museum experience. Many museums publish their own magazines, addressing the needs of their own community, such as the *Smithsonian Magazine*, the International Council of Museums' *ICOM News*, the Victoria and Albert Museum's *V&A Magazine* and many others, aimed at friends of museums, or people who often seek museum experiences or educators who routinely use museum resources. These groups seek specialized, segmented information centered around their special interests. Therefore, alternative media of this nature are expected to set cultural agendas within the public segments with which they are closely related.

Specialized cultural media outlets are produced by virtually every cultural organization. The cinema industry, for example, invests a great deal in specialized media outlets. Some of them present reviews, whereas other media disseminate specialized information about specific products. In this category belong digital as well as traditional publications such as *Senses of Cinema, Cinema Technology* magazine, *Cineaste, Film Comment, MovieMaker* and many others.

Horizontal media salience can be operationalized along the same dimensions described earlier for vertical media salience: namely, attention, prominence and valence. Although similar descriptions apply in segmented contexts, prominence might acquire different forms. Along with traditional front-page titles and prime-time broadcasts, salience can be measured through search engine rankings of different cultural "objects" sought after by users with special interests. Such rankings include a variety of "objects" including organizations, products and creators, along with specialized media publications. As relative significance is attributed to the positioning of different pieces of information, Google and other digital platforms become segmented agenda setters with significant impact on public salience.

Public Salience

The public salience construct has evolved significantly since the advent of digital media because consumers have acquired different capacities for interaction. I have proposed four different indicators of public salience, based on different conceptualizations of digital activity on the part of consumers: conventional public salience, word-of-mouth salience, mediated trends salience and behavioral public salience.

Conventional Public Salience

Throughout the history of agenda-setting theory, public salience has been measured as a record of public perceptions. People were systematically

asked about "the most important problem faced by the country today."[8] Public opinion polls were conducted to assess people's perceptions in regards to social concerns, and researchers ranked these issues according to the public's perceived significance. Later on, survey research focused on political personalities and their public appeal. In the twenty-first century, public perceptions were surveyed in regards to corporate and cultural objects, including museums and films. Consider a public opinion poll presenting the following central question: "Name the most significant reason you are visiting this organization today." The public's responses would be revealing of motivations that led to leisure decisions. Conventional public salience is inextricably linked to the history of agenda setting, emphasizing public perceptions as its primary operational definition. The public's perception of prominence "materializes" into attitudes and opinions. As the public acquires different perspectives, perceptional records have served as the primary indices of the public agenda.

Word-of-Mouth Salience

The web has dramatically shifted our conceptualization of salience because it has given people numerous opportunities to express their attitudes and opinions. Since 2005, the advent of social media has allowed for groups or communities of individuals from different geographic locations to engage in discussions around specific topics that pertain to particular interests, tastes and consumption habits. These mediated discussions often establish alternative topics of discussions or thematic areas that acquire a value of their own without the intervention of mainstream media.

Furthermore, virtually all digital outlets interact with visitors, seeking their comments and subjective evaluations of experiences they have had. Cultural consumers very often provide assessments of their experiences, which in turn are used by potential consumers to gauge the potential value of cultural products. The marketing literature provides evidence in regards to digital word-of-mouth influences on future consumers' decisions. Therefore, ordinary museum visitors, movie fans, readers or participators provide digital valence in regards to their experiences of a book they read, a movie they watched, a museum they visited or a theme park where they spent time with family and friends. Based on the available research evidence, we know that potential consumers seek such ordinary assessments of cultural consumers that will help them form their opinion about a cultural experience or reach their own decision about investing their time and money. Digital word of mouth merits researchers' attention as organizations strive to establish their digital presence and build their organizational agenda. Although word of mouth complements professional reviews (critical valence), future studies should examine their relative value, competing tendencies and degrees of convergence. For example,

hotels routinely ask their visitors to record their views about their experience and to express their degree of satisfaction with the services they received. Hotel websites openly provide these reviews, which often serve as a guide for future visitors. This rating activity of users, visitors, viewers, players and many other types of consumers constitutes a new form of public salience. Although it might be influenced by media and other interpersonal sources, it encompasses personal and deeply experiential components. Digital word of mouth aggregates individual public perceptions, forming a potentially significant pillar of the public agenda.

For example, imagine a corporate or cultural organization that was heavily advertised by media sources, but received negative word-of-mouth evaluations. Marketing scholars argue that digital word of mouth might constitute one of the most critical factors influencing public perceptions of this particular organization. Most organizations are subject to word-of-mouth assessments as modern consumers have access to different types of social media as well as organizational platforms to provide their assessments. Furthermore, cultural offerings are evaluated so that organizations can engage in critical upgrading of the available experiences. Hausmann (2012) conducted a case study on the role of word of mouth on German museums. She focuses particularly on word of mouth expressed in social media environments and recognizes its potential impact on visitation. She argues that world-of-mouth communication "is particularly effective due to the fact that a single recommendation—for example on Facebook or Twitter—can reach an unlimited number of recipients" (p. 41).

Furthermore, the quality of each visit is the best advertisement that will bring new visitors as word of mouth gets around (Murphy, Mascardo & Benckendorff, 2007). Research shows that early adopters of new products rely heavily on positive word of mouth prior to making decisions. In these early stages of decision-making, marketing research highlights the significance of positive word of mouth, while at the same time negative word of mouth is eliminated (Lam, Lee, & Mizerski, 2009). There is considerable space for development in terms of word-of-mouth salience as organizations evolve rapidly. From a theory perspective, word-of-mouth salience emerges as a hybrid indicator of prominence in the public mind. Because of its mediated nature, scholars might be perplexed in terms of its nature. As a new form of salience, different observers might treat it as a media record whereas others might focus on its public nature. Regardless of various views, hybrid forms of salience are mediated in nature, and influenced by many factors, both media related and interpersonal alike.

Mediated Trends Salience

Along with surveys recording traditional notions of public reactions, and digital expressions of word of mouth, search engines go even further,

providing yet another hybrid form of public salience. Mediated trends salience can be distinguished from conventional public salience as users recognize the prominence of objects by searching for them. This hybrid notion of salience incorporates both the elements of perception as well as behavior. Perceiving a topic as relevant and therefore salient is related to a searching choice and, thereby, a behavioral web activity. This particular indicator is usually provided by global conglomerates such as Google. For example, the Google Trends service provides a longitudinal record of the most significant "objects" searched for by people on the Google platform. The aggregate searching choices of millions of individuals provided by Google constitute a mediated trends indicator. Google provides various other helpful indicators, such as the geography of the largest volume of searchers, related topics that have been searched for, and of course, a timeline of searching activity. Many researchers acknowledge the value of searching trends as indicators of salience. The value of such indicators can be very useful in correlating searching patterns on the web with other social indicators. There is increasing evidence that organizations use this evidence in relation to conventional media salience, as well as public attendance, visitation, voting and various other forms of consumption. The following figure ranks major museums according to the Google Trends service of the most searched-for museums by Google users from around the world.

The volume of global searching patterns is just one way of recording mediated trends salience. However, there are numerous other sources of mediated trends information available to agenda-setting researchers. Web users engage in different consumption activities, revealing what is

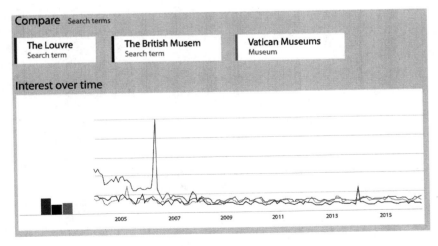

Figure 5.1 Volume of searches on the Google platform for the Louvre, the British and the Vatican museums.

Data source: Google Trends (www.google.comtrends).

relevant and therefore salient in terms of the available digital content. Google Analytics provides detailed website information, and different web services provide rankings of websites according to web visitation data. Corporate analysts rely on web analytics as they evaluate their corporate web presence, and cultural organizations are no exception. Website visitation of various cultural organizations or products is indicative of significance, as the number of visitors' hits provides information about demographic characteristics as well as technical data about web usage from different geographic areas. Furthermore, web visitation data and their relative ranking constitute a measure of salience, which is recognized as an intangible corporate asset. Along the same lines, the number of viewers of audiovisual content available on the YouTube service (which also belongs to Google) is indicative of significance of audiovisual content, especially if visitors try to acquire pre-purchase information that might influence future attendance of films, concerts or exhibitions. Although a great variety of audiovisual content is available, there is a great deal of difference in terms of its symbolic significance. Salience here takes the form of the number of hits. A case study of art-house movies showed that prior exposure of specialized films on the YouTube platform is related to box office revenues (Symeou, et al., 2015). The aforementioned examples do no exhaust the vast possibilities of mediated trends salience. The web accumulates information on users' habits, cultural consumption, searching patterns and other forms of visitation, which provides useful indicators of what people deem significant in the current digital environment. Both practitioners as well as theorists can benefit from this wealth of digital information; as they construct new hypotheses drawing from a wealth of digital information, their work can shed new light in relation to the ongoing pursuit of salience.

Behavioral Public Salience

Various cultural industries routinely use visitation, attendance and participation in various forms as expressions of significance. As I have already shown, CNN identified the most significant museums of the world as the most visited museums of the world. The two notions are not identical and many museum experts will quickly point out that museums are multidimensional entities providing multiple indicators of significance through the value of their collections, compelling stories, and significant artifacts, along with various intangible factors such as their history, the nature of their collaborations and their overall research activity. Furthermore, significance is conveyed through personalities, location, climate, cultural surroundings, significant investments in technology, infrastructure and many other attributes that in certain contexts become of central importance. No single indicator can become synonymous with salience. On the other hand, visitation, because it is

an expression of interest, motivations and gratifications, has become a reliable indicator of museum perceptions. Though it does not constitute a synonym for public salience by itself, it can become a convincing symbolic representation of it. Arguably, visitors recognize many of the above attributes, including location, the collection itself, infrastructure and many other assets and use this information to decide to visit a particular organization. Furthermore, Falk (2011) demonstrates that museum visitation seems to be an identity related choice, also driven by a combination of traits, such as socioeconomic factors, social class and various personal needs. Prentice, Guerin, & McGugan (1998) describe several personal motivations for museum visitation, such as "to be entertained, to learn, because they are on holidays, as a social family outing, and visiting a particular exhibition" (p. 484). Various constructs are linked to museum visitation, as individuals rank organizations according to a perceived prominence, related either to museum image formation or visitors' prioritized personal needs. Furthermore, cultural theorists have argued that engaging in leisure activities, such as a museum visit, is often perceived as attributing to individuals special symbolic value and self-worth. Thereby, leisure choices, including museum visitation, are related to social position and status (Bourdieu, 1993; Veblen, 1899).

Examining museum visitation as a form of salience, we recognize that the visitation construct is not synonymous with salience but it does prominently incorporate elements of salience. Burton, et al. (2009) recognize this difference as a tension between visitors' "stated preference"—what people indicate that they might do in terms of their future visitation – and their "revealed preference"—their actual visit (p. 27).

Personal and identity defined factors are not always related with organizational salience in determining the prospect of visitation. However, they seem to jointly influence visitors' decisions. Although visitation constitutes a multidimensional construct, it serves as a useful indicator of public salience, provided that we are aware of the identity and socioeconomic variables that affect specific segmented behaviors. At the same time, image formation and reputation are also related to it, along with various traits of prominence often described by visitors (Hausmann, 2012; Dates & Illia, 2009). As I have already demonstrated, recent research has shown that museum visitation is correlated with media attention of Greek museums (Bantimaroudis, et al., 2010; Zyglidopoulos, 2012). What are the implications of these findings? Among various lessons that can be drawn, perhaps it shows that despite valuable collections, significant artifacts, a vibrant location, an enticing climate, superb cultural surroundings and state of the art infrastructures, a museum might not be able to maximize its visitation potential without attracting significant media attention.

Behavioral public salience can take other forms, in some cases resembling museum visitation indices. For example, movie attendance and

therefore box office revenues can be operational devices related to salience. Film theorists, along with museum experts, will raise their eyebrows if box office revenues or movie attendance become synonyms of salience in isolation. They will surely point out that attending a movie is not always indicative of its quality, its artistic value or its long-term influence in this particular field. People attend movies for various reasons, both identity-related and socially-constructed. Furthermore, various individual needs and gratifications are satisfied as viewers seek certain film experiences. Popular films seem to satisfy primarily a need for entertainment, diversion and escape. Art-house film viewership is often a segmented activity sought by individuals with particular cultural appetites. As is the case with museums, what drives cinema viewership constitutes a multivariate construct that is not always related to the perceived value of a movie. However, a movie succeeding in the box office is bound to receive additional attention, regardless of its artistic worth, also described as critical valence (Symeou, et al., 2015). Therefore, movie attendance and box office indicators constitute forms of public salience, though they should be approached with caution and it should be understood that are just one narrowly defined aspect of public salience.

In the context of behavioral public salience, cultural consumption, such as sales of books, paintings or recorded performances should be treated in a similar fashion to visitation and attendance. What drives the volume of book sales of an author is subject to various factors, but being identified as a bestselling author is a form of salience in itself, which subsequently generates additional attention. Although book sales are not by definition a testament to the artistic value of a particular text, as soon as the volume of sales is established, it becomes an additional indicator of symbolic prominence. Therefore, despite other considerations of worth, behavioral salience in the form of visitation, attendance and sales bring added value to the creators of such experiences. Furthermore, organizations and cultural creators gain additional attention from publicizing their successful visitation, attendance or sales. Positive public reaction in the form of behavioral salience generates additional media or public prominence with subsequent waves of salience. Cultural managers know that best-selling authors generate additional future sales because of this symbolic added value, which generates additional attention and revenues.

What Are the Main Influences of Cultural Agenda Setting?

Preliminary evidence of cultural agenda setting, namely the ability of media to transfer salience in regards to organizations, products and creators to the public, seems to apply equally well in the cultural domain as in other domains, such as the civic and corporate. This finding deserves

scholarly attention along three dimensions: knowledge, perception and behaviors. However, testing this assumption at the behavioral level naturally encompasses the other two. From a corporate perspective, public salience operationalized at these three levels is sought after by managers and cultural executives. The central question that guides strategic choices and marketing operations revolves around the central objective of public salience. Agenda-setting theory provides some useful insights that can be complemented with evidence from other fields. Evidence of cultural agenda setting has been assembled at different stages in relation to Greek museums (Bantimaroudis, et al., 2010; Zyglidopoulos, et al., 2012) and art-house films disseminated in the Greek cultural market (Symeou, et al., 2015). These large-scale longitudinal studies have assessed public salience at the behavioral level. Two smaller-scale case studies focused on agenda-setting practices of specific organizations: the Museum of Olympia (Zakakis, et al., 2012) and the Acropolis Museum (Zakakis, et al., 2015). The combined evidence from all five studies provides interesting insights as to how cultural entities and the media can influence salience.

Agenda Setting and the Greek Museums

Greece is a country on the European periphery, but it represents an interesting cultural market. Culture and tourism represent two significant market sectors, often described as the heavy industry of the country. Because of its unique natural environment and its 3,000-year history, Greece is globally recognized as an archaeological park, where travelers experience many different facets of history: prehistoric, classical antiquity, Macedonian, Roman, Byzantine, Ottoman and the modern period. Naturally, studying agenda setting and Greek museums is a logical quest in a place like Greece. Museums offer strategic advantages for market development and growth. Two studies focusing on Greek museums provided standard measurements of their mainstream media salience, assessed on two levels: as objects and attributes (Bantimaroudis, et al., 2010; Zyglidopoulos, et al., 2012). Both studies acknowledge that certain Greek museums strive to become visible in media content, following international trends in museum transformations. This gradual transformation of museums due to market pressures progressively leads toward an integration of different advertising and public relations tools. Certain museums move faster in this direction. The Acropolis Museum is a good example of an emerging organization that utilizes various communication tools in versatile ways, but not all Greek museums are equally equipped to seek attention in a digital, mediated environment, and there are significant differences between metropolitan museums and those active in rural areas. In Greece, researchers observe an increased competition among cultural organizations as they strive to attract the

attention of different public segments with the strategic aim of rendering the organization salient. There is also intense competition for available funding for cultural causes, which has led to the adoption of different marketing techniques and promotion of cultural goods. In two studies of Greek museums, the selection of museums as "objects" is important for at least three reasons: a) there is a theoretical concern as to whether agenda setting can be applied outside the civic and corporate domain and specifically in the context of the cultural domain; (b) there are various applications of the theory in global markets of culture, offering useful tools to museum directors and curators; (c) especially in the case of Greece, the promotion of museums can be a strategic choice, as cultural assets of the country are promoted with the aim of achieving additional recognition and prominence. A significant part of the Greek economic output is linked to culture and tourism. Modeling media attention and valence along with various control variables might offer useful predicting mechanisms for visitation. The "objectification" of museums in agenda-setting studies is of interest as museums have been subject to cultural modifications both in terms of their identities as well as their overall missions. Furthermore, museum studies, especially in Europe, have been dominated by cultural studies approaches and critical perspectives, while empirical observations from a media studies angle are quite rare. Different bodies of research favor analyses of social systems, class differentiations and a political economy of culture. The current endeavor, despite its limitations, advances the possibility of yet another perspective in cultural research. It must be understood that museums cannot be easily objectified for agenda-setting explorations. By nature, they are complex entities. In these two case studies of Greek museums, their core hypotheses outline a relationship between mainstream media salience and public salience. Although this seems like a clichéd relationship, in reality it is a very novel ideal for many museums of the world. To be able to clearly demonstrate that an increase in media visibility is often translated into increased visitation is an extremely valuable premise, provided that researchers control for other factors that intervene in the hypothesized relationships. In other words, museums ranked highly in a hierarchy of media visibility and attention are correlated with higher numbers of visitors. Our longitudinal exploration revealed that there is approximately a one month time lag between media visibility and visitation. This is a lesson with many applications for cultural managers and creators alike. For example, a new exhibition properly promoted through different campaign techniques will start receiving additional visitation due to its publicity, about four weeks later.

The two phases of the study included seven and twelve museums respectively. The first study was designed exclusively at the first level, examining organizational salience and its relationship to museum visitation. The follow-up study was designed at the second level, including

a classic attribute: valence. The aim of attribute analysis was to assess whether the positive tone of coverage is correlated with museum visitation. Therefore, newspaper content was coded and divided into three categories: a positive, negative, or neutral disposition toward Greek museums. The second study provided additional revelations in regards to visitation. Media attention and positive media attention represent two different predictors of visitation. Strategically attracting media visibility is a worthy task, but museums will not be able to fully capitalize on their mediated significance unless they generate positive valence. Sometimes, media valence can be described as a general index of positive dispositions toward the organization while another indicator, critical valence, incorporates the specialized attribute of the view of experts. Cultural markets routinely rely on the word of experts who have gained their position as symbol interpreters. Both studies revealed that media attention as well as the positive coverage of museums is related to increased visitation, while confirming agenda-setting hypotheses at both levels (Bantimaroudis, et al., 2010; Zyglidopoulos, et al., 2012).

Art-House Films and Agenda-Setting Influences

As we examine the notion of cultural agenda setting, the entire cultural domain is under scrutiny: organizations, creators, and products. Despite limited evidence, there are diversified testimonies from different industries. Cinema, for example, represents an extremely vibrant global cultural industry. Its products are equally diversified, addressing the needs and aesthetics of different public segments around the world. The lion's share of this business pertains to popular, mass entertainment and therefore involves huge budgets, aggressive advertising and brand-based artists and creators, who are often involved in the production process.

The evidence presented in this book pertains to segmented films, appealing to specialized tastes. This market of art-house film became the testing ground for agenda setting. To unmask influences that otherwise would have been blurred by sizable budgets and global exposure, art-house films present a good case as segmented media attention can be assessed in relation to movie attendance. This concept was tested in the context of the Greek cultural market of imported, as well as domestic, art-house films (Symeou, et al., 2015). The film market is extremely diverse and displays a high level of uncertainty. Film consumers navigate through extremely nebulous information in order to find guidance about the relative quality of a new film. The film environment is extremely unpredictable in terms of consumer aesthetics, tastes and styles. Furthermore, "the experiential nature of cultural products further enhances the need for orientation by individuals. Because cultural goods are experience goods, their consumers cannot evaluate them before the actual purchase." (Symeou, et al., 2015, p. 735). This particular attribute

of experience goods raises the level of uncertainty that surrounds them. In the movie market, there are professional providers of valence, popularly known as critics. Their role in this study was described as "critical valence" because they provide professional assessments of the potential quality of films. Often these assessments are quantified (on a scale from one to five) and therefore are easily incorporated into quantitative analyses. Critical valence is provided to diminish the relative uncertainty of a potential film viewer. Critics display a professional proximity with the film production system and therefore they provide evaluative guidance, which potential consumers can take into account (Hirsch, 1972; Debenedetti, 2006; Shrum, 1991). They possess technical expertise and therefore are able to provide assessments taking into account contextual elements, genres, narrative analyses and industrial involvement. Because of their established position in the film industry as professional gatekeepers, their critical valence is utilized by individuals to diminish their need of orientation, while in the process they have an undisputable influence on box office performances (Basuroy, et al., 2003; Eliashberg & Shugan, 1997; Zuckerman & Kim, 2003).

This agenda-setting study of art-house films converged with previous museum studies on both levels: increased media attention of art-house films is related with higher levels of movie attendance, while positive critical valence is related with increased consumption. There was a remarkable convergence between the cultural "objects," despite the very different experiences they provide. In both cases, media visibility was assessed through the archives of three national, mainstream Greek newspapers available both in print as well as online. They devote a sizeable portion of their cultural sections to cultural productions of different types, which is indicative of the significance of culture both in terms of journalistic choices as well as market activity. These three newspapers, *Kathimerini*, *To Vima* and *Ta Nea*, function like gatekeepers, influencing other regional media and their content selections. Based on previous research, one might speculate that they influence television content as well as other internet sources, such as blogs and social media. These records of vertical media salience serve as an initial testing ground for cultural agenda setting. However, the world is moving in other directions. It is widely speculated that horizontal media are game-changers. Future research should focus both on combined influences of different types of media (agenda melding) as well as the exclusive influences of horizontal media.

Other Factors that Influence Museum Visitation and Movie Attendance

Cultural agenda setting, the notion that media salience influences public salience, in this case visitation and attendance, takes into account

many intervening factors that influence public salience in all its forms. The Greek museum studies revealed, for example, that the size of a museum, its location, its type of governance and its promotion strategy constitute significant factors that merit our attention. Furthermore, macro-economic conditions, random events and seasonality are significant variables that provide long-term assessments of the movement of museum visitors. For example, seasonality deals with a peculiarity of the Greek museum market, in that it receives most of its visitors during the summer months, while visitation decreases significantly during the winter months. Controlling for various intervening variables is necessary in order to draw any evidence in regards to the agenda-setting process. Furthermore, the type of organization also emerged as a factor influencing visitation. Although most museums in Greece are controlled by the Ministry of Culture, there are variations in the ways they are managed. It is expected that different "types" of organizations, in terms of their governance and management styles, will affect their prospects for media attention as well as visitation. Furthermore, a museum's location needs additional consideration. The geography of each organization can either enhance or hinder its prospects for visitation. Evidence shows that Athenian museums enjoy significant advantages because of their location. Athens is a metropolitan area of approximately four million people recognized by people around the world as a global tourist destination. It is the birthplace of democracy and the home of the famous Acropolis on which the Parthenon, with its imposing structure, overlooks the densely populated capital of Greece. By definition, Athenian museums have strategic advantages because of their location versus other significant museums, located in rural areas, away from airports or lacking significant access to public transportation. Income is a standard control variable. Variations in peoples' disposable income are expected to affect their leisure spending and perhaps curtail their leisure activities away from home. Another factor that was investigated is the role of foreign visitors. Greece is a popular tourist destination.

The movie market is even more complex. In this study, several factors were scrutinized. The presence of famous actors, along with awards that either the director or members of each cast had previously received, were deemed to be significant influences on box office performance. Furthermore, alternative competition from other art-house films or blockbuster movies available during the same time period was systematically scrutinized. A prior release of the movie's trailer on YouTube became a significant indicator of digital media distribution, likely to enhance movie viewership and boost box office performance. The budget of each film constitutes a common factor included in most film market studies, along with the size of the distributor and the number of screens on which a film is released. Furthermore, as in the museum studies, financial information such GDP per capita during the time of the study and the

Greek economic crisis that has plagued the entire country for several years became intervening variables that received attention. Finally, we focused on the element of seasonality, as there is evidence that more people watch movies during the summer, Christmas or Easter holidays. Modeling many intervening factors is indicative of the complexity of the hypothesized relationships and the fluidity of cultural markets. However, taking into account all these relationships, the core findings retain their robustness both for museums and films. In other words, ranking museums and films according to their significance in mainstream media content is correlated with visitation and attendance respectively.

Organizational Agendas and Media Agendas

Two case studies focused on specific organizations, providing additional substantive information on agenda-setting influences. A case study examining the media attention of the Museum of Olympia and the Acropolis Museum reveal that organizational agendas can influence media and potentially public agendas. Active organizations in terms of what they do as well as what they say about themselves—in other words, consistently supplying content to the media—influence media gatekeepers and increase their positive media valence. On the other hand, passive organizations, in terms of strategically supplying content related to their cultural agenda, are much less visible in media content, while the coverage they occasionally receive by the media is less related to their organizational agendas. In these cases, media gatekeepers render the museum visible, but without the organization exercising any influence over what others say about its organizational activities. Furthermore, certain organizations, though active in terms of producing new and interesting cultural products, are less keen on promoting and publicizing their cultural initiatives. Certain museums, for example, although they organize quality exhibitions and manage some of the most valuable treasures worldwide, lack a clear strategy in regards to disseminating the necessary information in a compelling manner that would render the organization and its mission visible. Although cultural activity including a constant renewal of content and experiences is a "must" for attracting attention, it might go unnoticed if museum executives lack a well-thought out strategy for agenda building. An active organization in terms of cultural production along with a strategy for promotion might lead to a higher media ranking and therefore a higher relative value in the context of its market competition.

Two case studies provide interesting insights into different promotion strategies as well as agenda-setting capacities exercised by different cultural organizations. The case of the Museum of Ancient Olympia is about significant media attention devoted to a museum, not due to a museum agenda but the result of random events that took place in the

summer of 2007. The catastrophic forest fires that swept throughout the Peloponnese, apart from the unprecedented loss of human life and devastation, seriously threatened and partially destroyed ancient Olympia, one of the most significant archaeological sites of Greece. This entire area carries symbolism of global significance, as the history of the Olympic Games is traced back to this location. This catastrophic natural event dominated the media agenda. A four-year longitudinal analysis revealed that less than 25% of media attention is attributed to the museum's own activities and cultural initiatives, with the vast majority of coverage traceable to external events and gatekeepers. Despite the fact that the cultural executives of ancient Olympia manage a site with significant cultural treasures, enjoying easy recognition inherited from the distant past, media analysis reveals low media attention and "a blurry public image" (Zakakis, et al., 2012). This case study reveals the vast opportunities for image promotion and agenda building that this particular cultural entity possesses, as its cultural assets offer a great deal for agenda establishment both in Greece as well as internationally. At the same time, this longitudinal study revealed that external events and gatekeepers have determined this particular cultural agenda. What lessons have we acquired from this small study? Having significant treasures, recognizable history and managing the greatest symbolic assets of the world might not be enough to establish a noticeable cultural agenda in a modern, digital global context. Furthermore, cultural managers need to systematically carry out a long-term agenda-setting plan in order to lead in a hierarchy of cultural agendas. At the same time, if a strategic plan and a great deal of effort and resources is necessary for a cultural entity enjoying global recognition due to its assets, correspondingly more effort is needed for small, less well known organizations on the peripheries of the world, as they try to establish their agendas in such competitive global settings.

On the other hand, the new Acropolis Museum in Athens presents a different agenda-setting story. The study on the Acropolis Museum shows that media attention and valence can be achieved through strategic selection of content. This new museum opened its doors to the public in 2009. From the very beginning, it led an aggressive campaign to establish its symbolic presence in the cultural market. As an emerging organization, managing the ancient landmark of the Athenian Acropolis with its famous temple, the Parthenon, its executives provided information in the same way as emerging corporations strategically attempt to influence media content in order to establish their public image (Rindova, et al., 2007). It is interesting to acknowledge that the Acropolis Museum opened its doors to the public as the country was being plunged into a severe financial crisis that has burdened most of its population for many years. The very existence of the new museum is loaded with all kinds of symbolism, most notably in relation to the Elgin marbles, held in the British Museum, in London, since Lord Elgin removed the artifacts

from the Parthenon between 1801 and 1805. Many Greek governments have led popular campaigns for the return of the Parthenon marbles to Greece.

Because the new museum was established as a legal entity of semi-public status, it enjoys a greater degree of freedom in terms of carrying out its own public campaign than most Greek museums. In this case study, researchers set out to investigate what particular symbolic actions promoted by the museum's executives influenced media content. Evidence accumulated from the museum's press releases on its official website and Facebook mirror site showed a strong correlation with the respective coverage of the museum by Greek and international newspapers. More importantly, specific content selections promoted by the museum itself were picked up by the media, replicating the museum's agenda in their content. Museums can indeed be powerful political and corporate players, influencing media content in a profound way.

The Acropolis Museum uses both traditional media as well as digital platforms to achieve its communication objectives. It seems that investing heavily in its visibility and media attention constitutes a strategic choice. Rindova, et al. (2007, p. 44) point out that "the frequency of action is associated with perceptual dominance." Furthermore, "a firm's level of actions increases journalists' exposure to stimuli pertaining to the firm and makes the firm and its actions potentially more available in their memories." Museum executives seem to follow the same logic. Rindova, et al. (2007, p. 54) emphasize the value of "innovative actions" in generating "positive evaluations." They argue that not all attributes should be treated as equal in terms of their symbolic value. Therefore, the museum's promotion of new service development is perhaps indicative of good use of strategy. They suggest two processes which seem to apply to the case of the Acropolis Museum. Promoting certain market actions in the form of symbolic initiatives seems to be related to the museum's salience. Second, such promotion of symbolism is related to "value creating potential." Emphasizing innovative actions renders the organization "highly distinctive" and therefore likely to acquire esteem (Rindova, et al., 2007, p. 58). Cultural organizations can benefit from these findings as they attempt to build their media agenda. Small museums especially can benefit from the bigger cultural players. Some of them face major challenges in terms of their location and access to resources. However, investing in particular symbolic actions for promotion might generate an agenda that the media will subsequently establish as salient.

Cultural Agenda Setting and Future Explorations

As critical and cultural approaches have dominated in the field of cultural industries, major concerns of various scholars have dealt with class differences, the role of gender in leisure activities, the encoding and decoding

processes of different texts, the structures of meaning acquired through different forms of representation, the role of personal identity in leisure choices, and postmodern constructions of symbolic realities. There is a broad convergence that cultural producers satisfy a significant array of uses and gratifications and thereby this old theory finds new terrains of applications in the expanding cultural domain. In this vast literature of cultural activity, and with a primary emphasis on societal and ideological ontologies, empirical approaches have been downplayed in the wider cultural dialectic. Although the primary concerns of cultural theorists are not in dispute, the agenda-setting process explains phenomena that develop in modern liberal markets of the world. Most industrialized cultural production originates in global centers, which possess strategic assets and display significant market advantages, and is then exported and consumed throughout the world. Assuming that this global cultural environment is taken for granted, the agenda-setting theory explains the dynamics of salience. This is a construct of vast importance in the modern, mediated, digital world. Along with various other motivations and gratifications, salience is presented as a key element that explains the formation of perceptions and behaviors in the cultural domain. To the extent that leisure choices involve cultural experiences, salience constitutes a significant predictor of leisure activities. As we have seen so far, salience remains a key notion in the cultural sector as well as in other domains. In cultural markets, the question "who sets the agenda" explains how modern consumers in liberal markets of the world navigate in a symbolic digital sea with myriads of digital experiences available for consumption, and decide which experiences are the most important, and perhaps relevant, for their perceived needs and gratifications. "How the agenda is set" is a question that provides evidence about attributes, frames and mechanisms that attract the attention of consumers.

In this small book, I have surveyed some preliminary findings in regards to cultural agenda setting. This evidence shows that various organizations, not traditionally considered dominant agenda setters, have a significant capacity to build their own agendas, attracting media attention and subsequently visitors and consumers. Notions of salience in this context have evolved, encompassing knowledge, perceptions and behaviors. Media salience has evolved because digital media have evolved dramatically over the past twenty years. In this new domain, scholarly investigations of the future might find merit in exploring the changing nature of both vertical and horizontal media salience. The former is known from the agenda-setting literature, as it explores the agenda-setting capacity of mass media. However, the cultural domain includes various different publics with segmented tastes, attitudes and behaviors. Various specialized, digital media cater to the needs of culturally defined groups, offering relevant information about organizations, authors and available experiences. Understanding these special segmented relationships

between the media and their publics might reveal new mechanisms for agenda building.

In addition, the digital era has radically transformed public salience. Previously passive consumers have become users, searchers, gamers, visitors and communicators, all with some capacity for agenda setting. In this context, I have proposed four new indicators of public salience: conventional public salience, word-of-mouth salience, mediated trends salience and behavioral public salience. Variations of current notions of public salience encompass the elements of searching, liking, buying, visiting and participating. Future explorations should consider various forms of user interaction with cultural content, as agenda-setting mechanisms convey prominence and significance to different creations and symbolic structures.

Third Level and Agenda Melding

Agenda setting has evolved over the years, assuming different directions both in terms of theory development, as well as in the realm of market applications. From the original Chapel Hill Study (1972) to consecutive progressions from the early 1970s until the late 1990s, the theory dealt with the process of the transfer of salience on two levels: the object and the attribute level. Various scholars around the world tried to tackle some of the basic questions, such as who sets the agenda, along with the more complicated ones, such as how agendas are set.

The cataclysmic developments in the realm of digital media were bound to affect digital processes of the transfer of salience. Recently, scholars have proposed a third level of agenda-setting analyses. In this proposition, the term "network" emerges as key terminology, describing the coexistence or cooccurrence of objects with attributes that render objects significant. At the second level, scholars recognized significant attributes of organizations. Their mere existence in media content was significant on its own. However, combinations of objects or attributes cooccurring simultaneously provides new possibilities for explaining the transfer of salience in the digital context.

Vargo, et al. (2014) describe the third level of agenda setting as follows: "The NAS model is based on an associative network model of memory, which asserts that individuals tend to make associations among different elements in their minds in order to make sense of social realities" (p. 299). Although a hierarchical order of salience remains a significant element of the digital environment, the associative dimension is indicative of an evolution of salience. The associative nature of salience relates to the interactive nature of digital platforms. The third level examines networks of both issues/objects and attributes.

Guo & McCombs (2016) have recently published a collection of studies dealing with new formations of media agendas. They argue that

networks of attributes convey significance while the networks collectively are recognized as salient. Various objects became the subject of observations, but a study on Oregon wineries is particularly relevant to the current presentation as it resembles the museum and cinema studies on cultural agenda setting. Weidman (2016) assessed agenda-setting influences of information sent to the media by Oregon wineries. Her network agenda-setting assessment of two streams of content reveals "positive correlations between the winery attribute agenda and the media attribute agenda, suggesting the salience of network relationships of attributes can be transferred from those outside the media to the media agenda, even in a special interest subject area" (p. 217). Weidman's work represents an initial effort to explore network agenda-setting influences pertaining to the wine industry, an object of specialized interest in relation to horizontal media. These are outlets that "reach out for audiences with known special interests in sports, fashion, politics, travel or other topics" (Shaw & Weaver, 2014, p. 145). In this respect, Weidman (2016) builds on the cultural agenda-setting literature at the third level. Research on cultural entities at the third level of agenda setting presents significant prospects for theory building. Recognizing patterns of cultural traits that routinely enhance salience presents numerous advantages to cultural executives. As a matter of fact, the process of salience rarely depends on single traits and linear transfer processes. By definition, digital communication is much more complex than that. Modern digital content analysis tools allow researchers to recognize multiple attributes, their relative importance, their recurrence in different texts and their patterns of recognition by different segments of the public. Indeed, the lessons that researchers can derive from such explorations have significant applications for theory building and strategy development. In the words of the early fathers of the theory:

> With the widespread diffusion of social media, agenda-setting theory can be applied to a much wider array of channels and more easily to an array of content extending far beyond the traditional focus on public affairs. Scholars have the opportunity to examine the transfer of salience between many different kinds of agendas. Even within the dominant news media agenda-public agenda dyad, numerous operational definitions of these agendas are emerging.
> (McCombs, Shaw, & Weaver, 2014, p. 788)

Along with the proposed third level of agenda-setting analysis, the process of agenda melding represents yet another approach of studying salience in current, digital settings. Of central importance is the role of alternative media, described as "horizontal" media. McCombs, Shaw, and Weaver (2014) aggregate the effect of salience as the sum[9] of vertical media agenda setting with horizontal media agenda setting plus

personal preferences (p. 795). Although this proposal is in its initial stages, the originators of agenda setting recognize the capacity of alternative media to set agendas as well as strong possibilities for divergence among vertical and horizontal media agendas.

It is understood that although these propositions have been minimally tested in the context of the civic domain, there is no significant evidence emerging from the field of culture. Indeed, there are numerous opportunities for cultural agenda-setting explorations, as organizations routinely invest in social media strategies for advancing their agendas. Future studies could shed significant light on the differential capacities of horizontal media to set agendas, their contrasted agenda building power in relation to vertical media and the degree of divergence among different types of media agendas. Organizations may find it extremely beneficial in terms of strategy to assess agenda melding effects on image building and their long term establishment of salience.

In this digital global environment, new skills, data and methods are necessary to answer some of the prevailing questions, despite their re-formulations, that determine the grand issue of significance, which is pursued by cultural providers, gatekeepers and stakeholders. Therefore, despite the cataclysmic developments of our digital era, agenda setting remains one of the key influences in people's mediated existence.

Notes

1 http://edition.cnn.com/2013/09/05/travel/top-global-museums/, published November, 27, 2013, accessed January 11, 2017.
2 www.lonelyplanet.com/blog/2010/06/12/the-best-museums-in-the-world/, published June, 12, 2010, accessed January 11, 2017.
3 www.businessinsider.com/top-25-museums-in-the-world-2014-10?op=1, published October 17, 2014, accessed January 11, 2017.
4 http://whatculture.com/film/50-most-important-movies-ever-made?page=1, accessed January 11, 2017.
5 www.imdb.com/list/ls005774742/, published April 1, 2015, accessed January 11, 2017.
6 www.theguardian.com/books/2015/oct/14/public-vote-for-academic-book-that-changed-the-world, published October, 14, 2015, accessed January 11, 2017.
7 www.theartwolf.com/articles/most-important-painters.htm, accessed January 11, 2017.
8 Gallup (2016). "What do you think is the most important problem facing this country today?" www.gallup.com/poll/1675/most-important-problem.aspx, accessed January 11, 2017.
9 Agenda melding = vertical media agenda setting correlation (squared) + horizontal media agenda setting (squared) + personal preferences.

Epilogue

When I started writing this small book on cultural agenda setting, I could never have imagined that, since the acceptance of my proposal by Routledge, life as we know it in the place I live with my family would have changed so dramatically. I left the United States in 2000 and settled on Lesvos, one of the largest Greek islands in the northern part of the Aegean archipelago. Mytilene, the capital of Lesvos, a city of approximately 35,000, is the home of the University of the Aegean, the university I have been working for since September of 2000. However, after sixteen years of living in Lesvos, in a quiet, serene, rural setting, where the deep blue of the Aegean Sea dominates the surroundings throughout the year, last summer, everything started to change. A massive flow of refugees from war-stricken countries such as Syria, Iraq, Afghanistan and other places in the Middle East and North Africa discovered the narrow passages between Turkey and the Greek Aegean isles, especially Lesvos, in a quest to reach Europe and start a new life there.[1] Encountering, for over a year, thousands of people from places where violence, death and war devastation dominated their lives has been a monumental experience. During the summer of 2015, I often saw parents reaching the shores of Lesvos in small boats and then, carrying young children on their shoulders, walking seventy to eighty kilometers to reach the harbor of Mytilene. Their expectations of a better life, away from war, poverty and exploitation, often collapsed in congested borders, harbors and refugee camps.

As a media researcher, I could not help but notice the role of mobile phones and social media sites in facilitating the mobility of refugees. They were willing to pay up to 5 Euros to recharge their smartphones. Indeed, one of the basic services offered by UNHCR[2] and various other nonprofit relief organizations that arrived later in Lesvos was recharging the refugees' mobile phones. It was as if people's entire existence depended on them. This movement of populations, which attracted global media attention, was presented in different media platforms with radically different aims and agendas. Although I have no empirical evidence at hand, a superficial glance is revealing of a significant divergence of agendas. The refugee agenda was primarily established on certain social

media sites that allow an uninhibited flow of information among like-minded individuals and virtual communities, with a clear objective in this case of reaching Europe at any cost. How was this goal set? Who fueled those dreams? What mechanisms came into place that rendered these objectives salient in their minds and for how long? These questions about personal agendas should certainly be subject to empirical inquiry. Furthermore, this is a horizontal, segmented, social media-oriented agenda, cut off from mainstream influences, at least at first sight.

On the other hand, mainstream media agendas, especially in Europe, adopted very different perspectives. Some of them adopted a humanitarian view, emphasizing the refugees' dramatic quest for dignity, for basic human rights, for freedom. They offered captivating images of suffering, of human sorrows, of injustices happening in the European context. Media gatekeepers urged policymakers and ordinary citizens to offer a helping hand to fellow human beings in dire need. At the same time, other media agendas adopted a radically different framework. A discourse advancing the rationale of closed borders, an agenda of fear and isolation became attractive to certain groups across the continent. These are just a few examples of divergent agendas unfolding in the same continent across different mainstream media and social media platforms. Arguably, the most dominant of these agendas can be linked to the policies that prevailed across the European Union, both in terms of central decisions reached in Brussels, as well as national initiatives undertaken by different governments.

As I have witnessed the refugee phenomenon, I ponder on the degree of multiple outlets, platforms and tools offering a vast multiplicity of possible agendas, often leading to a remarkable mosaic of views across different segments. Among the new questions that horizontal agendas bring to the fore are various subcultural discourses pertaining to the spread of populism, pseudoscience and conspiracism.

This is indeed a very different, mediated world, a staggering contrast to the agenda-setting lessons I enjoyed as a doctoral student in Austin, Texas in the late 1990s. At the same time, it remains open to debate which agendas are dominant in terms of influencing not just public agendas, the perceptions and behaviors of ordinary consumers, but also the global institutions, policymakers, industrial gatekeepers, and significant storytellers of our digital age.

What do my concluding thoughts have to do with the cultural domain and its agendas? I have been concerned with those industrial producers who set different types of agendas in cultural markets, who tell us how to spend our limited free time and disposable income. Through these various experiences emphasizing diversion, entertainment and escape, the public mind becomes preoccupied to such a degree that it excludes other significant social agendas from penetrating our daily discourse. However, when reality hits people so hard, as it hit the people of Lesvos

during the past year, suddenly leisure recedes into the background and different hierarchies of priorities become salient. This year in Lesvos, significance was not based on media representations but on what eye-witnesses saw and what people were willing to do in response.

I do not wish to undervalue the significance of diversion and escape. Leisure has its place. It represents a much-needed aspect of human existence. However, I am very skeptical about its increasing dominion over everything we define as free time. To the extent that these cultural agendas overpower our will against more obvious priorities, such as getting to know our neighbors, showing compassion to those who suffer, and enjoying our friendships, I strongly feel that we need to use all available critical tools to re-evaluate both some of the agendas as well as certain agenda setters in this vast cultural domain. As I pondered on those experiences, Neil Postman came to my mind. To the extent that television and digital audiovisual media emerged as the primary platforms and arbiters for different public discourses—politics, leisure, religion—there has been a civilizational shift in the way people learn, communicate, understand and make choices. Postman's (1985) provocative critique of television— and popular media at large—is that everything has become entertainment. The most serious things in life are treated as games. Politics and religion have become forms of entertainment. The written word, which was handled in the past by political thinkers and religious philosophers, has been replaced by superficial images with a primary emphasis on feelings and sentimental reactions. Postman died before the advent of social media. I wonder how he would have responded to the superficiality of modern politicians and preachers. People don't read; they search the Google platform. They tend to avoid the laborious process of research. Instead they talk with their friends on Facebook. Many consider Facebook a more worthy source of information than newspapers. And although they are provided with unprecedented access to information, they cannot always navigate in a sea of knowledge while discerning between valuable and useless information. Because of their inability to critically distinguish between documented information and pseudoscientific garbage, they become subject to mediated delusions. People do not vote as informed citizens. They participate in a game. They crave entertainment. And in the process, the written word and rationality itself have been undervalued. As television decontextualizes every experience, logic loses its ground. Different forms of delusions become the new norm as consumers cannot discern between what can be documented in contrast to what is just uploaded. As amusement became our number-one priority, even the visibility of death does not produce a reaction. Mediated amusement seems to have become people's ultimate agenda, displacing living itself.

As I conclude this small book, I have underlined the significance of promoting valuable cultural agendas. "Rational" cultural agendas merit our attention as a partial antidote to the cataclysmic effects of popular

passivity and leisure isolation. I have used numerous examples from museums, galleries and libraries because I believe they deserve to be a part of the agenda. They represent the weak players in this vast, highly competitive cultural domain. They offer some of the most valuable information, often transmitted from the depths of history. However, compared to their popular counterparts, they lack the vast resources of global conglomerates. Sometimes, what makes museums, libraries and galleries less attractive is the very fact that they offer experiences that demand our active attention, our energy, our prior preparation. However, those attributes render their offerings worthy of our exploration.

As our entire existence is flooded by popular media, popular messages that eventually become massive waves of populism, somehow we need to reevaluate our agendas. Popular media have established the notion that the world's complex social problems can be explained through simplistic conversations; that our friends on Facebook have all the relevant answers; that a simple Google search is adequate to explain complex medical problems, political dilemmas, macroeconomic findings. In fact, none of the preceding could ever be possible.

I argue that new sets of "rational" agendas are needed in the western world. For starters, we need to explain to our children that our social world is by nature complex and is getting more so. Devoting all our free time—or one third of our existence—to diversion-related content and experiences alone is not going to empower us with the knowledge we need. People's involvement with digital gadgets may create an illusion of busyness, activity and sophistication, but they may lead in the exact opposite direction—passivity, killing time and oversimplification.

I understand that modern people depend on technologies, digital platforms and multimedia while displaying a constant need for entertainment, for spectacle, for escape. As those traits dominate in public life, setting "rational edutainment" agendas might help us and our children to supplement our popular cultural diets with some valuable alternatives. We might be able to insert more activity instead of passive entertainment, more knowledge and valuable information in contrast to just diversion and escape. In this context, we should qualitatively rank some cultural providers as creators of substantive forms of education, empowerment and understanding. Furthermore, our "rational" agendas should entail some foundational principles. For example, quality education always comes at a cost. Nothing of value is cheap. It requires active seeking, hard work and some forms of sacrifice. Other types of information that do not require active seeking and labor, are in most cases, without significant value and utility.

Passive entertainment, diversion and escape are significant human needs. Seeking these types of experiences is a valid human exploration. However, I tend to adopt Postman's concern in terms of entertainment becoming a domineering experience, sought everywhere, all the time,

by everyone. When an entire existence is overpowered by a constant need for entertainment, Postman recognizes an imbalance of societal proportions. There is no time left for anything else or anyone else. People become single-dimensional in their quest for meaning. Somehow, this western assumption that entertainment is the ultimate source of meaning becomes a drug or a false god. At the same time, the entire planet has become subject to turmoil, injustices, wars, environmental crises. While the world is on the edge, large segments of its affluent populations just watch television, play games online, or post messages on Facebook.

In this book, I have tried to explain the notion of cultural agenda setting—the fact that the media establish hierarchically the significance of leisure organizations, creators and experiences. However, as I conclude my presentation, I would like to propose a significant shift in cultural agendas. Schools, parents, preachers and other gatekeepers need to join forces in favor of "rational" agendas, actively promoting not just watching, playing and searching, but visiting, participating and interacting. This cultural agenda shifting should incorporate meeting with real people away from home such that we get away from ourselves and closer to the needs of others.

As we evaluate different experiences, we need to recognize that not all symbols are similar in value. We need to encourage teachers, curators and even politicians to discern between valuable and less valuable symbols; to offer textual alternatives to those messages that turn the serious problems of the world into mere entertainment; to explain that valuable symbols are costly and demand hard work; in an effort to counteract simplistic explanations, audiovisual delusions, populism and cheap religion, new generations of gatekeepers must provide new tools for the comprehension of a rapidly changing, information saturated and volatile world. As the media continue to tell us what to think about, we are called to teach ourselves what to think about the media and arguably protect some of our limited free time, devoting our attention to family, friends, people in need, as well as thought-provoking texts that have enduring value. Even before the critical words of Neil Postman against an entertainment-oriented world, a society where individuals are preoccupied with themselves, their personal needs, their personal pursuit of happiness, the most significant figure in human history declared those memorable words: He said: "It is better to give, than to receive." Perhaps we should revisit this valuable agenda for the sake of the world and ourselves.

Notes

1 Networks of smugglers stationed in Turkey were organizing the refugees' crossover into European Union territory. For their services, they received exorbitant fees of thousands of US dollars for each refugee they smuggled into Europe.
2 Office of the United Nations High Commissioner for Refugees.

Bibliography

Abercrombie, N., & Longhurst, B. (1998). *Audiences: A sociological theory of performance and imagination*. London: Sage Publications.

Acland, C. (1997). IMAX in Canadian cinema: Geographic transformation and discourses of nationhood. *Studies in Cultures, Organizations and Societies*, 3(2), 289–305.

Adorno, T. (1991). Culture industry reconsidered. In J.M. Bernstein (Ed.), *The culture industry: Selected essays on mass culture* (pp. 98–106). London: Routledge.

Andreasen, A. R., & Kotler, P. (2008). Strategic marketing for non-profit organizations, 7th Ed. Upper Saddle River, NJ: Prentice Hall.

Athique, A. (2014). Transnational audiences: Geocultural approaches. *Continuum*, 28 (1), 4–17.

Arthur, D., Sherman, C., Appel, D., & Moore, L. (2006). Why young consumers adopt interactive technologies. *Young Consumers*, 7(3), 33–38.

Auletta, K. (2009). *Googled: The end of the world as we know it*. London: Virgin.

Bakhshi, H., & Throsby, D. (2012). New technologies in cultural institutions: Theory, evidence and policy implications. *International Journal of Cultural Policy*, 18 (2), 205–222.

Bantimaroudis, P., & Zyglidopoulos, S. (2014). Cultural agenda setting: Salient attributes in the cultural domain. *Corporate Reputation Review*, 17(3), 183–194.

Bantimaroudis, P. (2011). *Cultural Communication: Organizations, theories, media*. Athens: Kritiki (In Greek).

Bantimaroudis, P., Zyglidopoulos, S., & Symeou, P. (2010). Greek museum media visibility and museum visitation: An exploration of cultural agenda setting. *Journal of Communication*, 60(4), 743–757.

Basuroy, S., Chatterjee, S., & Ravid, S. A. (2003). How critical are critical reviews? The box office effects of film critics, star power, and budgets. *Journal of Marketing*, 67(4), 103–117.

Belk, R. W., & Andreasen, A. (1982). The effects of family life cycle on arts patronage. *Journal of Cultural Economics*, 6(2), 25–35.

Bogdanov, A. (2003). Technologies and the Hermitage: New opportunities. *Museum International*, 55(1), 27–32.

Bond, N., & Falk, J.H. (2012). Who am I? And why am I here (and not there)? The role of identity in shaping tourist visit motivations. *International Journal of Tourism Research*, 15(5), 430–442.

Bourdieu, P. (1984). *Distinction: A social critique of the judgement of taste.* Cambridge, MA: Harvard University Press. (Original work published 1979).

Bourdieu, P., & Darbel, A. (1991). The Love of art: European art museums and their public. Cambridge: Polity Press. (Original work published 1969.).

Buchmann, A. (2010). Planning and Development in Film Tourism: Insights into the Experience of Lord of the Rings Film Guides. *Tourism and Hospitality Planning & Development*, 7(1), 77–84.

Bulkow, K., Urban, J., & Schweiger, W. (2013). The duality of agenda-setting: The role of information processing. *International Journal of Public Opinion Research*, 25(1), 43–63.

Bounia, A., & Nikonanou, N. (2008). The use of moving pictures in Greek museums: Video as a tool for interpretation. In A. Bounia, N., Nikonanou, & M. Economou (Eds.), *Technology in the service of cultural heritage* (pp. 363–371). Athens: Kaleidoskopio (In Greek).

Bouza, F. (2004). The impact area of political communication: Citizenship faced with public discourse. *International Review of Sociology*, 14(2), 245–259.

Burgess, J. (2006). Hearing ordinary voices: Cultural studies, vernacular creativity and digital storytelling. *Continuum: Journal of Media & Culture Studies*, 20(2), 201–214.

Burton, C., Louviere, J., & Young, L. (2009). Retaining the visitor, enhancing the experience: Identifying attributes of choice in repeat museum visitation. *International Journal of Nonprofit and Voluntary Sector Marketing*, 14, 21–34.

Bustamante, E. (2004). Cultural industries in the digital age: Some provisional conclusions. *Media, Culture & Society*, 26(6), 803–820.

Cameron, F. (2003). Digital futures I: Museum collections, digital technologies, and the cultural construction of knowledge. *Curator: The Museum Journal*, 46(3), 325–340.

Campbell, R. (1988). *Media and culture: An introduction to mass communication.* New York: St. Martin's Press.

Carroll, C., & McCombs, M. (2003). Agenda setting effects of business news on the public's images and opinions of major corporations. *Corporate Reputation Review* 6(1), 36–46.

Carroll, C. E. (2010). *Corporate reputation and the news media: Agenda-setting within business news in developed frontier and emerging markets.* New York: Routledge.

Castells, M. (1989). The informational city: Information technology, economic restructuring and the urban-regional process. Oxford: Blackwell Publishers.

Carrozzino, M., & Bergamasco, M. (2010). Beyond virtual museums: Experiencing immersive virtual reality in real museums. *Journal of Cultural Heritage*, 11, 452–458.

Chaney, D. (1996). *Lifestyles.* London: Routledge.

Charitonos, K., Blake, C., Scanlon, E., & Jones, A. (2012). Museum learning via social and mobile technologies: (How) can online interactions enhance the visitor experience? *British Journal of Educational Technology*, 43(5), 802–819.

Chen, C-C., Wactlar, H.D., Wang, J.Z., Kiernan, K. (2005). Digital imagery for significant cultural and historical materials. *International Journal on Digital Libraries*, 5(4), 275–286.

Cohen, C. B. (1963). *The press and foreign policy.* Princeton: Princeton University Press.

Cuadrado, M., & Frasquet, M. (1999). Segmentation of cinema audiences: An exploratory study applied to young consumers. *Journal of Cultural Economics*, 23, 257–267.

Dates, M., & Illia, L. (2009). The audit and management of a museum's media image. *Museum Management and Curatorship*, 24(1), 47–71.

Darnton, R. (2009). *The case for books: Past, present and future.* New York: Public Affairs.

Dawson, E., & Jensen, E. (2011). Towards A Contextual Turn in Visitor Studies: Evaluating Visitor Segmentation and Identity-Related Motivations. *Visitor Studies*, 14(2), 127–140.

Debenedetti, S. (2006). The roles of media critics in the cultural industries. *International Journal of Arts Management*, 8(3), 30–42.

Deephouse, D. (2000). Media reputation as a strategic resource: An integration of mass communication and resource-based theories. *Journal of Management*, 26(6), 1091–1112.

DiMaggio, P. (1987). Nonprofit organizations in the production and distribution of culture. In W.W. Powell (Ed.), *The nonprofit sector: A research handbook* (pp. 195–220). New Haven: Yale University Press.

DiMaggio, P., & Useem, M. (1978). Social class and arts consumption: The origins and consequences of class differences in exposure to the arts in America. *Theory and Society*, 5, 141–161.

Earl, P., & Potts, J. (2013). The creative instability hypothesis. *Journal of Cultural Economics*, 37(2), 153–173.

Economou, M. (2003). *Museum: Warehouse or living organisation? Museological questions and issues.* Athens: Kritiki. (In Greek).

Eliashberg, J., & Shugan, S. M. (1997). Film critics: Influencers or predictors? *The Journal of Marketing*, 61(2), 68–78.

Evatt, D., & Ghanem, S. I. (2001). Building a scale to measure salience. Paper presented at the World Association of Public Opinion Research annual conference, Rome, Italy.

Falk, J.H. (2009). *Identity and the museum visitor experience.* Walnut Creek, CA: Left Coast Press.

Falk, J. H. (2011). Contextualizing Falk's identity-related visitor motivation model. *Visitor Studies*, 14(2), 141–157.

Falk, J.H. (2013). Understanding museum visitors' motivations and learning. In I. B. Lundgaard & J. T. Jensen (Eds.), *Museums: Social learning spaces and knowledge producing processes* (pp. 106–127). Copenhagen: Kulturstyrelsen–Danish Agency for Culture.

Falk, J. H., & Dierking, L.D. (2013). *The museum experience revisited.* Walnut Creek, CA: Left Coast Press.

Finn, S. & Gorr, M.B. (1988). Social isolation and social support as correlates of television viewing motivations. Communication Research, 15, 135–158.

Florida, R. (2014). *The rise of the creative class.* New York: Basic Books.

Garnham, N. (2005). From cultural to creative industries: An analysis of the implications of the "creative industries" approach to arts and media policy making in the United Kingdom. *International Journal of Cultural Policy*, 11(1), 15–30.

Ghanem, S. (1997). Filling in the tapestry: The second level of agenda setting. In M. McCombs, D. Shaw & D. Weaver (Eds.), *Communication and Democracy* (pp. 3–14). Mahwah, NJ: Lawrence Erlbaum.

Ghemawat, P. (2001). Distance still matters: The hard reality of global expansion. *Harvard Business Review*, September, pp. 1–12.

Gibson, C. (2002). Rural transformation and cultural industries: Popular music on the new south Wales far north coast. *Australian Geographical Studies*, 40(3), 337–356.

González, A.M., & Bello, L. (2002). The construct "lifestyle" in market segmentation: The behavior of tourist consumers. *European Journal of Marketing*, 36(1/2), 51–85.

Goulding, C. (2000). The museum environment and the visitor experience. *European Journal of Marketing*, 34(3/4), 261–278.

Greenwood, D.N., & Lippman J. R. (2010). Gender and Media: Content, Uses, and Impact. In J. Chrisler & D. McCreary (Eds.), Handbook of Gender Research in Psychology: Volume 2: Gender Research in Social and Applied Psychology (pp. 643–669). New York: Springer.

Guo, L., & McCombs, M. (2016). *The power of information networks: New directions for agenda setting research.* New York: Routledge.

Hausmann, A. (2012). The importance of word of mouth for museums: An analytical framework. *International Journal of Arts Management*, 14(3), 32–43.

Hesmondhalgh, D. (2013). *The Cultural industries.* London: Sage.

Hill, L., O'Sullivan, C., & O'Sullivan, T. (2003). *Creative Arts Marketing.* London: Butterworth-Heinemann.

Hirsch, P. M. (1972). Processing fads and fashions: An organization-set analysis of cultural industry systems. *American Journal of Sociology*, 77(4), 639–659.

Hirschman, E. C., & Pieros, A. (1985). Relationships among indicators of success in broadway plays and motion pictures. *Journal of Cultural Economics*, 9(1), 35–63.

Holbrook, M. B., & Schindler, R. M. (1994). Age, sex, and attitude toward the past as predictors of consumers' aesthetic tastes for cultural products. *Journal of Marketing Research*, 31(3), 412–422.

Hood, M. G. (1983). Staying away: Why people choose not to visit museums. *Museum News*, pp. 50–57.

Hooper-Greenhill, E. (1992). *Museums and their visitors.* London: Routledge.

Hooper-Greenhill, E. (1995). *Museum, media, message.* New York: Routledge.

Hornecker, E., & Stifter, M. (2006). Learning from interactive museum installations about interaction design for public settings. Conference proceedings of the 20th conference of the computer-human interaction special interest group (CHISIG) November 20–24, 2006, Sydney, Australia. Proceedings ISBN: 1-59593-545-2.

Hsieh, S., O' Leary, J.T., & Morrison, A.M. (1992). Segmenting the international travel market by activity. *Tourism Management*, June, 13(2), 209–223.

Hummon, D. M. (1988). Tourist worlds: Tourist advertising, ritual, and American culture. *The Sociological Quarterly*, 29(2), 179–202.

Huston, A.C., Donnerstein, E., Fairchild, H., Feshbach, N.D., Katz, P.A., Murray, J.P., Rubinstein, E. A., Wilcox, B. L., & Zuckerman, D. (1992). *Big world, small screen: The role of television in American society.* Lincoln, NE: University of Nebraska Press.

Illia, L., Bantimaroudis, P., & Meggiorin, K. (2016). Corporate agenda setting at the third level: Comparing networks of attributes in corporate press releases and media coverage. In L. Guo & M. McCombs (Eds.), *The power of infor-*

mation networks: New directions for agenda setting research (pp. 190–205). New York: Routledge.

Illia, L., Sonpar, K., & Bantimaroudis, P. (2014). Framing impressions in corporate communication: The mediatization of corporate messages. In J. Pallas, L. Strannegård, & S. Jonsson (Eds.), *Organizations and the media: Organizing in a mediatized world* (pp. 192–204). New York: Routledge.

Iyengar, S., Peters, M.D., & Kinder, D.R. (1982). Experimental demonstrations of the "not-so-minimal" consequences of television news programs. *American Political Science Review*, 76(4), 848–858.

Jaffry, S., & Apostolakis, A. (2011). Evaluating individual preferences for the British Museum. *Journal of Cultural Economics*, 35, 49–75.

Jenkins, H. (2004). The cultural logic of media convergence. *International Journal of Cultural Studies*, 7(1), 33–43.

Johns, J. (2006). Video games production networks: Value capture, power relations and embeddedness. *Journal of Economic Geography*, 6(2), 151–180.

Kabanoff, B. (1982). Occupational and sex differences in leisure needs and leisure satisfaction. *Journal of Organizational Behavior*, 3(3), 233–245.

Katz, E., Haas, H., & Gurevitch, M. (1973). On the use of the mass media for important things. *American Sociological Review*, 38(2), 164–181.

Kawashima, N. (1998). Knowing the public. A review of museum marketing literature and research. *Museum Management and Curatorship*, 17(1), 21–39.

Keane, M. (2009). The capital complex: Beijing's new creative clusters. In L. Kong & J. O'Connor (eds.), *Creative Economies, Creative Cities: Asian-European Perspectives* (pp. 77–95). Dordrecht, Springer.

Kim, J. (2012). The institutionalization of YouTube: From user-generated content to professionally generated content. *Media, Culture & Society*, 34(1), 53–67.

Kiousis, S., & McDevitt, M. (2008). Agenda setting in civic development: Effects of curricula and issue importance on youth voter turnout. *Communication Research*, 35(4), 481–502.

Kiousis, S. (2004). Explicating media salience: A factor analysis of New York Times issue coverage during the 2000 U.S. presidential election. *Journal of Communication* 54(1), 71–87.

Kiousis, S., Bantimaroudis, P., & Ban, H. (1999). Candidate image attributes: Experiments on the substantive dimension of second level agenda setting. *Communication Research* 26(4), 414–428.

Kokkonis, M. (2010). Digital entertainment: Computer games and videogames. In M. Kokkonis, G. Paschalides, & P. Bantimaroudis (Eds.), *Digital Media: The Culture of Sound and Spectacle* (pp. 339–399). Athens: Kritiki (In Greek).

Kotler, N. (2001). New ways of experiencing culture. *Museum Management and Curatorship*, 19(4), 417–425.

Kotler, P., & Armstrong, G. (2010). *Principles of marketing*. Upper Saddle River, NJ.: Prentice Hall.

Kotler, N., & Kotler, P. (2000). Can museums be all things to all people?: Missions, goals, and marketing's role. *Museum Management and Curatorship*, 18(3), 271–287.

Kotler, N., & Kotler, P. (2004). Can museums be all things to all people? Mission, goals and marketing's role. In G. Anderson (Ed.), *Reinventing the*

museum: Historical and contemporary perspectives on the paradigm shift (pp. 167–186). Oxford: Altamira Press.

Kotler, N., Kotler, P., & Kotler W. (2008). *Museum marketing and strategy: Designing missions, building audiences, generating revenues and resources.* San Francisco: Wiley.

Kawashima, N. (1998). Knowing the public: A review of museum marketing literature and research. *Museum Management and Curatorship*, 17(1), 21–39.

Konlaan, B., Bygren, L., & Johansson, S-E. (2000). Visiting the cinema, concerts, museums or art exhibitions as determinant of survival: A Swedish fourteen-year cohort follow-up. *Scandinavian Journal of Public Health*, 28, 174–178.

Laamanen, J.P. (2013). Estimating demand for opera using sales system data: The case of Finnish national opera. *Journal of Cultural Economics*, 37(4), 417–432.

Lam, D., Lee, A., & Mizerski, R. (2009). The effects of cultural values in word-of-mouth communication. *Journal of International Marketing*, 17(3), 55–70.

Lampel, J., Lant, T., & Shamsie, J. (2000). Balancing act: Learning from organizing practices in cultural industries. *Organization Science*, 11(3), 263–269.

Lash, S, and Lury, C. (2007). *Global cultural industry: The mediation of things.* Cambridge, UK: Polity.

Lee, C-K., Lee, Y-K., & Wicks, B. E. (2004). Segmentation of festival motivation by nationality and satisfaction. *Tourism Management*, 25(1), 61–70.

Lippmann, W. (1922). *Public opinion.* New York, NY: Macmillan.

Lowry, G. D. (2004). A deontological approach. In J. Cuno (Ed.), *Whose Muse? Art Museums and the Public Trust* (pp. 129–149). Princeton, NJ: Princeton University Press.

Lucas, K., & Sherry, J. (2004). Sex differences in video game play: A communication-based explanation. *Communication Research*, 31(5), 499–523.

Mangold, W.G., & Faulds, D. J. (2009). Social media: The new hybrid element of the promotion mix. *Business Horizons*, 52(4), 357–365.

Marty, P. (2007). Museum websites and museum visitors: Before and after the museum visit. *Museum Management and Curatorship*, 22(4), 337–360.

Marty, P. (2008). Museum websites and museum visitors: digital museum resources and their use. *Museum Management and Curatorship*, 23(1), 81–99.

Marty, P. (2011). My lost museum: User expectations and motivations for creating personal digital collections on museum websites. *Library & Information Science Research*, 33(3), 211–219.

Matthes, J. (2005). The need for orientation towards news media: Revisiting and validating a classic concept. *International Journal of Public Opinion Research* 18(4), 422–444.

Matthes, J. (2008). Need for orientation as a predictor of agenda-setting effects: causal evidence from a two-wave panel study. *International Journal of Public Opinion Research* 20(4), 440–453.

Macdonald, G., & Alsford, S. (1995). Museums and theme parks: Worlds in collision? *Museum Management and Curatorship*, 14(2), 129–147.

McCombs, M.E., & Shaw, D.L. (1972). The agenda setting function of mass media. *Public Opinion Quarterly*, 36(2), 176–187.

McCombs, M.E. (2004). *Setting the agenda: The mass media and public opinion.* Cambridge, UK: Polity Press.

McCombs, M.E. (2014). *Setting the agenda: The mass media and public opinion* (2nd ed.). Cambridge, UK: Polity Press.

McCombs, M.E., & Stroud, N. (2014). Psychology of agenda-setting effects: Mapping the paths of information processing. *Review of Communication Research*, 2(1), 69–92.

McCombs, M.E., Shaw, D.L., & Weaver, D.H. (2014). New directions in agenda-setting theory and research. *Mass Communication and Society*, 17(6), 781–802.

McKercher, B., & du Cros, H. (2003). Testing a cultural tourism typology. *International Journal of Tourism Research*, 5(1), 45–58.

Mckercher, B., Ho, P. S., Cros, H. D., & So-Ming, B. C. (2002). Activities-Based Segmentation of the Cultural Tourism Market. *Journal of Travel & Tourism Marketing*, 12(1), 23–46.

McNichol, T. (2005). Creative marketing strategies in small museums: Up close and innovative. *International Journal of Non Profit and Voluntary Sector Marketing* 10(4), 239–247.

McQuail, D. (2010). *McQuail's mass communication theory* (6th, ed.). London: Sage.

Medić, S., & Pavlović, N. (2014). Mobile technologies in museum exhibitions. TURIZAM, 18(4), 166–174.

Meijer, M., & Kleinnijenhuis, J. (2006) Issue news and corporate reputation: Applying the theories of agenda setting and issue ownership in the field of business communication. *Journal of Communication*, 56(3), 543–559.

Merritt, E. E. (2006). *Museum financial information*. Washington, D.C.: American Associations of Museums.

Messaris, P. (2010). Digital Hollywood: Technology, economics, aesthetics. In M. Kokkonis, G. Paschalides & P. Bantimaroudis (Eds.), *Digital media: The culture of sound and spectacle* (pp. 19–46). Athens: Kritiki (In Greek).

Miller, B. L. (1991). The selected papers of Charles Willson Peale and his Family: Vol. 3. The Belfield farm years, 1810–1820. New Haven, Conn.: Yale University Press.

Mott, D. R., & Saunders, C. M. A. (1986). *Steven Spielberg*. Boston: Twayne Publishers.

Murphy, L., Mascardo, G., & Benckendorff, P. (2007). Exploring word-of-mouth influences on travel decisions: Friends and relatives vs. other travelers. *International Journal of Consumer Studies*, 31(5), 517–527.

Napoli, J., & Ewing, M.T. (2000). The Net Generation: An analysis of lifestyles, attitudes and media habits. Journal of International Consumer Marketing, 13(1), 21–34.

Negroponte, N. (1995). *Being digital*. New York: Vintage.

Nelson, P. (1970). Information and consumer behavior. *Journal of Political Economy*, 78, 311–329.

Nelson, P. (1974). Advertising as information. *Journal of Political Economy*, 82, 729–754.

Noam, E.M. (2009). *Media ownership and concentration in America*. New York: Oxford University Press.

Nolan, L.L. & Patterson, S.J. (1990). The active audience: Personality type as an indicator of TV program preference. *Journal of Social Behavior and Personality*, 5, 697–710.

O'Brien, V. (1996). *The fast forward MBA in business*. New York: John Wiley and Son.

Olkkonen, R., & Tuominen, P. (2006). Understanding relationship fading in cultural sponsorships. *Corporate Communications*, 11(1), 64–77.

Okazaki, S., & Hirose, M. (2009). Does gender affect media choice in travel information search? On the use of mobile Internet. *Tourism Management*, 30, 794–804.

Ostrower, F. (2005). *Diversity of cultural participation: Findings from a national survey*. Washington, D.C.: Urban Institute.

Parry, R. (2005). Digital heritage and the rise of theory in museum computing. *Museum Management and Curatorship*, 20(4), 333–348.

Perrin, A. (2002). Making Silicon Valley: Culture, representation, and technology at the Tech museum. *The Communication Review*, 5(2), 91–108.

Peter, J.P. & Olson, J.C. (1994). *Understanding consumer behavior*. Burr Ridge, IL: Irwin.

Pine, J., & Gilmore, J.H. (2011). *The Experience Economy: Work Is Theater and Every Business a Stage*. Boston: Harvard Business School Press.

Porter, M. (1990). *The competitive advantage of nations*. London: Macmillan.

Postman, N. (1985). *Amusing ourselves to death: Public discourse in the age of show business*. New York: Penguin.

Prentice, R., Guerin, S., & McGugan, S. (1998). Visitor learning at a heritage attraction: A case study of discovery as a media product. *Tourism Management*, 19 (1), 5–23.

Ravid, S. A. (1999). Information, blockbusters, and stars: A study of the film industry. *The Journal of Business,* 72(4), 463–492.

Reading, A. (2003). Digital interactivity in public memory institutions: The uses of new technologies in Holocaust museums. *Media, Culture & Society*, 25(1), 67–85.

Reese, S.D., & Danielian, L.J. (1989). Intermedia influence and the drug issue: Convergence on cocaine. In P. Shoemaker (Ed.), *Communication campaigns about drugs: Government, media and the public* (pp. 29–45). Hillsdale, N.J.: Lawrence Erlbaum.

Richards, G. (1999). European cultural tourism. In D. Dodd & V. Hemel (Eds.), *Planning Cultural Tourism in Europe* (pp. 16–32). Amsterdam: Boekman Foundation.

Rindova, V. P., Petkova, A. P., & Kotha, S. (2007). Standing out: How new firms in emerging markets build reputation. *Strategic Organization*, 5(1), 31–70.

Rogerson, C.M. (2012). Urban tourism, economic regeneration and inclusion: Evidence from South Africa. *Local Economy*, 28(2), 188–202.

Roberts, M., & Bantimaroudis, P. (1997). Gatekeepers in international news: The Greek media. *The Harvard International Journal of Press/Politics*, 2(2), 62–76.

Rojek, C. (2000). Leisure and culture. London: Macmillan.

Salganik, M., & Watts, J. D. (2009) Web-based experiments for the study of collective social dynamics in cultural markets. *Topics in Cognitive Science* 1(3), 439–468.

Savage, M., Barlow, J., Dickens, P., & Fielding, T. (1992). Culture, consumption and lifestyle. In M. Savage, J. Barlow, P. Dickens, & T. Fielding (Eds.), *Property, bureaucracy and culture: Middle-class formation in contemporary Britain* (pp. 99–131). London: Routledge.

Severin, W., & Tankard, J. (2000). *Communication theories: Origins, methods and uses in the mass media* (5th ed.). Upper Saddle River, NJ: Pearson.

Shaw, D. L., & Weaver, D. H. (2014). Media agenda setting and audience agendamelding. In M. E. McCombs (Ed.), *Setting the agenda: The mass media and public opinion.* Cambridge, UK: Polity.

Skinner, S. J., Ekelund, Jr., R. B., & Jackson, J. D. (2009). Art museum attendance, public funding, and the business cycle. *American Journal of Economics and Sociology*, 68(2), 491–516.

Srinivasan, R., Boast, R., Furner, J., & Becvar, K. (2009). Digital museums and diverse cultural knowledges: Moving past the traditional catalog. *The Information Society*, 25(4), 265–278.

Shrum, W. (1991). Critics and publics: Cultural mediation in highbrow and popular performing arts. *American Journal of Sociology*, 97(2), 347–375.

Siegel, D. S., & Vitaliano, D. F. (2007). An empirical analysis of the strategic use of corporate social responsibility. *Journal of Economics & Management Strategy*, 16, 773–792.

Smith, P., & Riley, A. (2008). *Cultural theory: An introduction*, (2nd Ed.). Malden, MA.: Blackwell Publishing.

Smith, L. H., Discenza, R., & Baker, K. G. (2005). Building sustainable success in art galleries: An exploratory study of adaptive strategies. *Journal of Small Business Strategy* 16, 29–41.

Strasburger, V., Wilson, B.J., & Jordan, A.B. (2009). *Children, adolescents and the media*, (2nd ed.). Thousand Oaks, CA.: Sage.

Stroud, N. J. (2011). *Niche news: The politics of news choice.* New York: Oxford University Press.

Symeou, P.C., Bantimaroudis, P., & Zyglidopoulos, S. (2015). Cultural agenda setting and the role of critics: An empirical examination in the market for art-house films. *Communication Research*, 42(5), 732–754.

Takeshita, T. (2006). Current critical problems in agenda-setting research. *International Journal of Public Opinion Research*, 18(3), 275–296.

Thyne, M. (2001). The importance of values research for nonprofit organizations: The motivation-based values of museum visitors. *International Journal of Nonprofit and Voluntary Sector Marketing*, 6(2), 116–130.

Todd, S., & Lawson, R. (2001). Lifestyle segmentation and museum/gallery visiting behavior. *International Journal of Nonprofit and Voluntary Sector Marketing* 6(3), 269–277.

Twitchell, J. (2004). *Branded Nation: The Marketing of Megachurch, College Inc., and Museumworld.* New York: Simon & Schuster.

Van Aalst, I., & Boogaarts, I. (2002). From museum to mass entertainment: The evolution of the role of museums in cities. *European Urban and Regional Studies*, 9(3), 195–209.

Van Eick, K., & Mommaas, H. (2004). Leisure, lifestyle, and the new middle class. *Leisure Sciences*, 26(4), 373–392.

Van Loon, R., Gosens, T., & Rouwendal, J. (2014). Cultural heritage and the attractiveness of cities: Evidence from recreation trips. *Journal of Cultural Economics*, 38(3), 253–285.

Van Riel, C. B. M., & Fombrun, C. J. (2002). Which firm is most visible in your country? An introduction to the special issue on the global RQ-project nominations. *Corporate Reputation Review*, 4(4), 296–302.

Vargo, C., Guo, L., McCombs, M., & Shaw, D. (2014). Network issue agendas on Twitter during the 2012 U.S. presidential election. *Journal of Communication*, 64(2), 296–316.

Veblen, T. (1899). *The theory of the leisure class*. New York: MacMillan.

Von Rimscha, B.M. (2013). It's not the economy, stupid! External effects on the supply and demand of cinema entertainment. *Journal of Cultural Economics*, 37(4), 433–455.

Vyncke, P. (2002). Lifestyle segmentation: From attitudes, interests and opinions, to values, aesthetic styles, life visions and media preferences. *European Journal of Communication*, 17(4), 445–463.

Weaver, D. H. (1977). Political issues and voter need for orientation. In D. L. Shaw & M. E. McCombs (Eds.), *The emergence of American political issues* (pp. 107–119). St. Paul: West.

Weaver, D. H. (1980). Audience need for orientation and media effects. *Communication Research*, 7(3), 361–376.

Weaver, D. H., Graber, D. A., McCombs, M. E., & Eyal, C. H. (1981). *Media agenda-setting in a presidential election: Issues, images, and interest*. New York: Praeger.

Weidman, L.M. (2016). Attributes of a cultural/consumer product: Oregon wine. L. In Guo & M. McCombs (Eds.), *The power of information networks: New directions for agenda setting research* (pp. 206–220). New York: Routledge.

Weiss-Blatt, N. (2016). Role of techbloggers in the flow of information. In Guo & M. McCombs (Eds.), *The power of information networks: New directions for agenda setting research* (pp. 88–103). New York: Routledge.

Williams, R. (1975). *Television: Technology, and cultural form*. New York: Schocken Books.

Yoon, S., Elinich, K., & Wang, J. (2012). Using augmented reality and knowledge-building scaffolds to improve learning in a science museum. *Computer-Supported Collaborative Learning*, 7, 519–541.

Yucelt, U. (2001). Marketing museums: An empirical investigation among museum visitors. *Journal of Nonprofit & Public Sector Marketing*, 8(3), 3–13.

Zakakis, N., Bantimaroudis, P., & Bounia, A. (2012). Media framing of a cultural disaster: The case of ancient Olympia. *Museum Management and Curatorship*, 27(5), 447–459.

Zakakis, N., Bantimaroudis, P., & Zyglidopoulos, S. (2015). Museum promotion and cultural salience: The agenda of the Athenian Acropolis Museum. *Museum Management and Curatorship*, 30(4), 342–358.

Zucker, H.M. (1978). The variable nature of news media influence. In, B.D. Ruben (Ed.), *Communication Yearbook, 2*. (pp. 225–240). New Brunswick, NJ.: Transaction.

Zuckerman, E. W., & Kim, T. Y. (2003). The critical trade-off: Identity assignment and box- office success in the feature film industry. *Industrial and Corporate Change*, 12(1), 27–67.

Zyglidopoulos, C. S., Symeou, P., Bantimaroudis, P., & Kampanellou, E. (2012). Cultural Agenda Setting: Media Attributes and Public Attention of Greek Museums. *Communication Research*, 39(4), 480–498.

Index

Acropolis (Museum) 48, 73, 106, 115, 127, 138, 142, 143, 144–145
agenda building 19, 21, 39, 52, 77, 85, 99, 106, 111, 116, 143, 144, 147, 149
agenda melding 18, 106, 141, 147–149
agenda setting: second level 16, 139; third level 147–148
art-house films 20–21, 30, 33, 58, 137–138, 140–141, 143
attendance 20, 35, 38, 41, 52, 68, 107, 134–137, 140–143
attention 129–130, 136, 140–146
attributes 16, 19, 44, 46, 56, 61, 66–68, 124, 128–129, 138, 147–148
augmented reality 122

behavioral Public Salience 129, 131, 135–137, 147
Bourdieu Pierre 25, 32, 34, 35, 45, 78, 90, 136
British Museum 41, 110, 126, 144

Centre Pompidou 5, 73, 74, 126
cinema 5, 8, 9, 17, 28, 40, 49, 57, 66, 83, 85, 99, 101–102, 121, 131, 137, 140
content agendas 111–117
conventional Public Salience 131–132
convergence 52, 53, 59–61, 84, 120
creative class 6, 40
critical valence 33, 132, 137, 140–141
cultural agenda setting 12, 24–26, 96, 124, 137–141, 145–148
cultural capital 25, 34–35, 78, 90
cultural domain 25, 33–34, 39–42, 66–68
cultural economics 47, 61
cultural gatekeepers 21

cultural hierarchies 125
cultural industries 39, 42–46
cultural studies 19–20, 43–44, 139
cultural theorists 42–46

demographic agendas 76–81
digital culture 51, 61, 104
Disney 74

eventful city 76
experience economy 7–8

Falk, John 34, 91–93, 136
Florida, Richard 6, 9, 40
Frankfurt School 42, 44, 62, 66

geographic agendas 72–76
Google 103, 107–108, 111, 134, 135
Greek museums 20, 136, 138–140
Guggenheim 37, 38, 42, 49

Harry Potter 31, 47, 56, 122
Hermitage 112, 113, 127
Hesmondhalgh, David 44
High culture 44, 45
Holocaust museums 119
horizontal integration 49, 50
horizontal media salience 130–131

identity 34–35, 90–93, 136
impression management 19
intermedia agenda setting 16
issue 13–15, 23, 129, 132, 147

Kiousis, Spiro 129–130

Lesvos 150–151
lifestyle(s) 79, 82–84
Louvre 37, 38, 41, 49, 74, 125, 126, 128, 134
low culture 44, 45, 62

McCombs, Maxwell xi–xiii, 13–15, 18, 129, 148
mediated trends salience 129, 133–135
motivations 24–28, 33–36
multiculturalism 93–95
Mytilene 150

need for orientation 21–22, 24–25, 33–36
network agenda setting 148

object 14–17, 19
obtrusivity 15–16
Olympia (Museum) 138, 143, 144
organizational agendas 143

personality(-ies) 82–84
popular agendas 84–93
popular entertainment 62–66
Postman, Neil 152–154
prominence 125, 129–130, 136–137
promotion agendas 105–111

rational agendas 84–93, 153–154
"rational edutainment" 62–66
refugees 93–95, 150–151
relevance 22–23, 26, 28–30, 35

seasonality 20, 48, 142, 143
semi-public goods 58, 61
Shaw, Donald 13–15, 18, 129, 148

Smithsonian 42, 48, 51, 90, 100, 122, 126, 127, 131
Symeou Pavlos 20, 33, 58, 135, 137, 138, 140

technology agendas 117–123
tone 17, 129, 130, 140
transfer of salience 15, 18, 32, 33, 68, 111, 147, 148

uncertainty 22–23, 26, 28, 30–33, 35
uses and gratifications 85–87

valence 17, 21, 52, 129–130, 139–141
Veria (Library) 76, 122
vertical integration 49
vertical media salience 129–130, 141

Weaver, David 18, 22, 23, 28, 30, 35, 106, 129, 148
websites 52, 105, 109, 111, 113, 123, 133, 135
Weidman, Lisa 17, 30, 148
word-of-mouth salience 129, 131, 132–133, 147

YouTube 21, 52, 107, 135, 142

Zakakis, Nikos 54, 106, 115, 116, 138, 144
Zyglidopoulos, Stelios 20, 24, 28, 29, 32, 46, 136, 138, 140